SILVER PIXELS

an introduction to the

digital darkroom

TOM ANG

SILVER PIXELS

an introduction to the
digital darkroom

TOM ANG

Amphoto Books
An imprint of Watson-Guptill Publications/New York

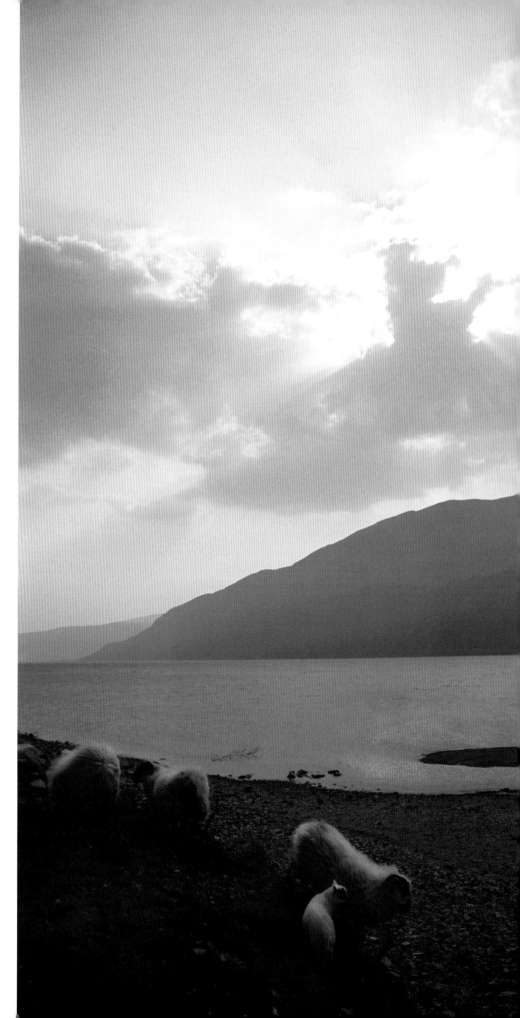

This book is dedicated with love
to Louise and Cicely

Text © 1999 Tom Ang
Photographs and digital images © 1999 Tom Ang

First published in the United States in 2000 by
Amphoto Books, an imprint of Watson-Guptill Publications,
a division of BPI Communications, Inc.,
1515 Broadway, New York, NY 10036

Design: Tom Ang

**Library of Congress Catalog
Card Number: 99-65563**

ISBN 0-8174-5889-1

Printed in Singapore by Imago

1 2 3 4 5 6 7 8 9/ 08 07 06 05 04 03 02 01 00

CONTENTS

Introduction

Silver pixels – the hybrid photography. It means a richer photography. It means more choice, more opportunities to experiment and create, more flexibility in approach ... and a lot more fun. It also initiates us into novel methods of achieving old ends and it gives us new ends – with endless possibilities between. In short, hybrid photography is the most exciting and engaging thing to happen to putting marks on paper since photography crawled out of its nappies.

So what exactly is hybrid photography? Hybridisation means the bringing together of two things you might not expect (but have every hope) would get on with each other. In the case of digital technologies and photography, the outcome has exceeded all expectations. After a shaky courtship, when photographers thought digital meant 'death' as in 'death-ray', the party has hotted up. Dragging the computer into the darkroom is now delivering the best of both worlds – maybe even the best of all possible worlds – for photographers.

Do not fear that all those hard-won darkroom skills – those precious secrets handed down from darkroom guru to studio acolyte – will be wasted. Far from it; the more you know about conventional photography, the better equipped you will find yourself to tackle hybrid photography. Yet there are still effects which are still best achieved in the darkroom. All this, and more, we will explore in this book. It is not, however, a recipe book for old processes: you'll find many excellent and complete manuals on these. Nor is it an introduction to image-manipulation software: you'll find numerous manuals, all hundreds of pages long, which explore every nook and cranny of the software application.

This book aims to thrill you into action and to offer many ideas. It assumes you know some photography and that when someone mentions a mouse, you don't jump up on a chair. It assumes you love creating fine images. If so, you are in for a great treat and a long adventure: digital photography and the art of the silver pixel is truly fun – of the kind Noel Coward meant when he said 'Work is much more fun than fun' – and now is the time to start.

Tom Ang
London

How to use this book

Digital technologies have enormously expanded the potential of photography. SILVER PIXELS is your introduction to the exciting potential of combining conventional photography with digital photography.

The book begins by explaining the choice between conventional and digital photography with the emphasis on practical outcomes. We discuss the equipment needed and give an introduction to the central question of resolution. Next we take a tour through the major effects available, both in black & white and colour. If, at any point, there is a technical term you do not understand, the glossary at the back of the book will help you out. Scanning and the subject of resolution receive extra attention.

The aim is to ensure that you keep control of the creative techniques, to empower you to explore an exciting new world of digital effects. These effects can be as subtle or as extreme as you desire, based on conventional imaging or breaking away: the aim here is to teach you about the possibilities and potentialities so that you become an accomplished worker of silver pixels.

There are many practical hints and advice scattered throughout the book: all have been gained from the author's own experience, supplemented by discussions with other professionals as well as augmented by learning about the problems and worries that trouble the readers of magazines such as 'What Digital Camera'.

Although Photoshop has a major presence in this book, that is only because it is the premier software tool for the silver-pixel worker: the book is not specific or exclusive to Photoshop. Indeed, one of the strengths of silver-pixel work is that you can achieve a given image or effect in many different ways, very few of them exclusive to one software package or other. While this book is not a software manual, you will nonetheless find lots of practical information and hints to help you use and elaborate your own techniques for your images.

The practical sections are complemented by technical discussions colour reproduction and output to print. To round off, the reference section contains an extensive glossary as well as suggestions for further reading from books and roaming on the World Wide Web.

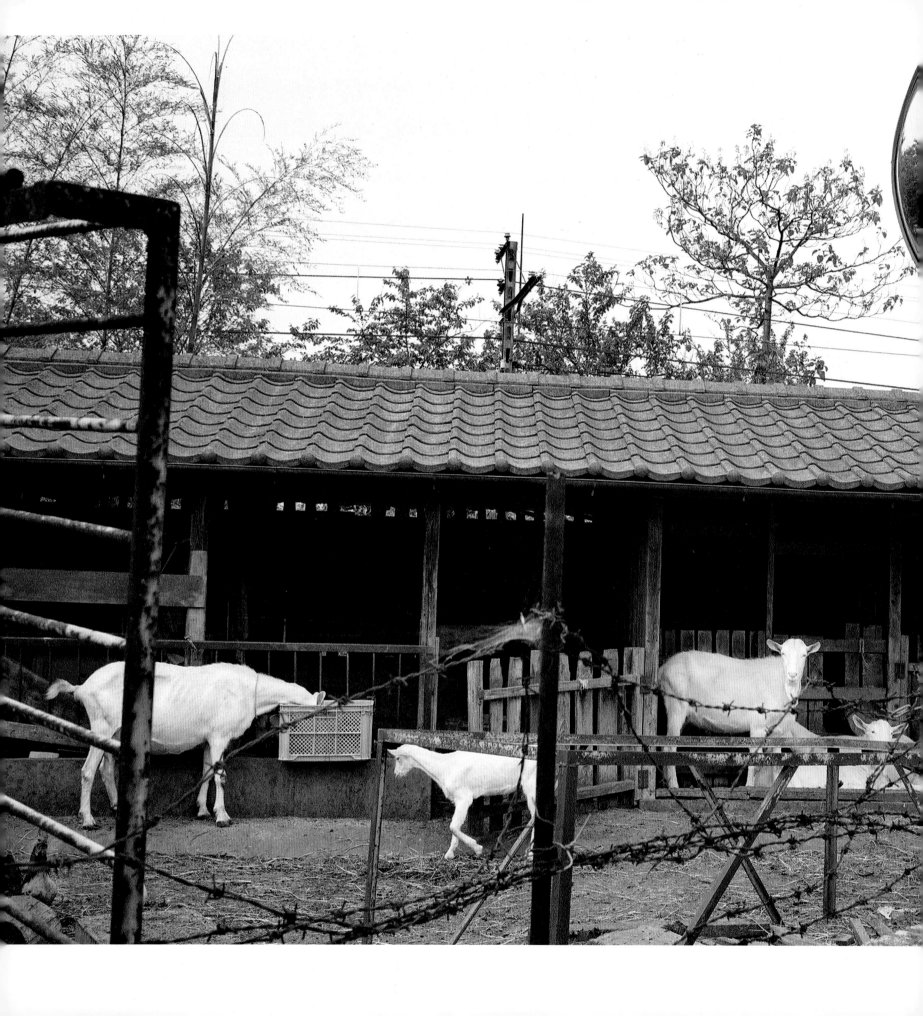

MAKING
A START

Digital photography ... even
the name is a hybrid: you
will find new concepts to
become familiar with and
there will be new terms to
learn and techniques to
control. There will also be
new equipment and
other items to purchase
and learn how to use. This
chapter gives you the basic
information you need.

Classical or digital?

The mere fact of asking the question 'Digital or classical?' heralds a new kind of photography. It seems natural to call it 'silver pixels' as it is a hybrid of silver-based photography with the pixel-based structure of digital images.

Hybrid paths

Hybrid photography is the cross, and a fertile one at that, between classical photography and digital ways of working. In fact, it is well-nigh impossible to think of a purely digital process. (If you want the philosophy, it is because analogue processes are ontologically prior to – i.e. they come before – digital processes, except perhaps at the quantum level.) In fact, all digital cameras and scanners start off with analogue signals and almost output devices such as TV monitors and printers work along analogue, i.e. classical, lines.

However, leaving the precision behind, when we talk of hybrid photography we generally mean that we start with a normal photograph such as a negative or transparency or print. We then turn the image into a digital equivalent, i.e. we assign values to certain qualities of the image. Once we have the image in digital form we can work with it in a computer. Following this, we can turn it back into an analogue form in a variety of ways.

The emergence of silver pixels is rather like the joining up of two gardens. Now, although you may end up in the same place as before, there's an extra dimension in the augmented choice of how to get there: the routes are more varied, each with its own character and advantages. Life, in short, is richer for it. It is this variety that really gives us exciting new pathways to the final print.

This image, taken at the Chelsea Flower Show, looks as if it has been greatly manipulated – at least it has been inverted. But in fact it is essentially all silver-based: a black & white print made directly from Polapan film, an 'instant' black & white film that produces a positive – i.e. right-reading – transparency. Printing from Polapan directly onto Grade 0 printing paper (necessary because of Polapan's high contrast) results in a negative print, which was scanned and finally given a warm tint in the computer. I did not scan the original Polapan because its very heavy silver content makes it difficult for the scanner to penetrate the image.

Canon F-1n with 28mm f/2 lens @ f/5.6, 1/60sec on Polaroid Polapan ISO 125 film, printed direct from the positive

The task in this era is to understand the nature of these paths, to understand the implications of the different choices. If we are agreed we want a print on a piece of paper at the end of the day, we need to ask which path is the best way to get there. Do we go digital all the way or combine a bit of silver-based with a bit of digital? All this naturally begs the question of what we mean by 'best': giving the best quality result, or producing the result most easily or most economically? Here we discuss briefly what 'best' might mean for your own aims and ways of working.

Choices to make

How you pick your way through the pathways should depend, above all, on your tastes. Do not let either technology or finances take the lead. You may love to paddle about in the dark creating prints and listening to the sound of running water. If so, do not forsake it just because everyone else is sitting in front of a computer screen. Besides the direct contact with the very atoms making up your image, there is a special satisfaction in being to apply craft-based skills – the kind of abilities that can only be gained by years of trial and success: at its best, darkroom work is the photographer and the materials functioning as a team.

On the other hand, you may have wanted to escape from the claustrophobic dark all your life – well, now is your chance. With silver-pixel working, you can get someone else to do the film processing, after which everything else happens in the light, in the comfort of your desk-top. But working with a computer is, for many people, akin to a violent sport in which the computer can deliver the knock-out blow – a system crash – at any time, and you will be powerless to predict when that blow will fall and powerless to prevent it. (A recent survey found that 1 in 4 usually sanguine Germans had violently hit or damaged their computer when it misbehaved.) But the fact is, one needs something like craft skills to deal with computers. Modern machines are so complicated, so rich with possibilities it is no longer the case that either they work or they don't.

Computer craftsmanship is akin to other craft skills that depend on understanding rather than force to achieve results, that depend on co-operation with the materials and tools rather than coercion to work well. If you take the trouble to look after your computer, to understand that, like any other system, it has to get used to any changes imposed on it, then you'll find yourself working with the machines rather than hitting your head on the desk in frustration.

Another consideration is permanence: a photographic print that has been toned with selenium or gold and properly processed using a quality fibre-based printing paper will hold its image unchanged for many decades, even over a century, if reasonably well cared for. Prints made using today's ink-jet or other media cannot boast of anythin like such longevity – even the most careful preservation regime cannot ensure stability of the image beyond just one year or two – and that's at best, assuming the new generation of said-to-be long-life inks are used on pure rag stock. On another tack, if it's skills you want to sell a command of hybrid photography is a highly saleable commodity in a world which increasingly relies on virtual – and thereby digital – forms of information, someone with a broad portfolio of skills will find ready customers.

Pros and cons

Some of the issues for deciding between the classical and digital pathways are given here.

The Classical Pros:
• Can be archivally permanent, especially toned black & white
• Physical qualities superior e.g. feel of paper, texture of surface
• Print any size up to about 20x24" with little difficulty
• Storage cheap and not dependent on electronics
And the Cons:
• Need darkroom
• Need long time to set up
• Chemicals have limited life and change character over time

The Digital Pros:
• Easy to experiment and wide range of effects available
• Perfect duplication of files is easy
• No use of chemicals
• Very short set-up time needed
• Easy to catalogue
And the Cons:
• Prints not archivally permanent
• Unreliable electrical devices and storage devices
• Possible obsolescence of storage media
• Quality limits set by scanning stage
• Need to learn new skills

The new pathways

The choice of pathway
determines not only how
much you spend but
how you work

Rolleiflex SL66 with
80mm f/2.8 lens @
f/5.6 on Ilford FP4 film
at ISO 125

One day a mundane row of pinned-up test-prints
on a notice-board was transformed into a
fascinating play of light and shadows by the sun: a
scan of the high-contrast, medium-speed negative
does not give great results: the highlights are
empty and shadows hold little detail. The above
image is a superior scan, made from a print –
one that was made with highlights burnt in and
shadows lifted for more detail.

Enough of generalisations: here are the specifics you have been waiting for. This takes you through a route that combines top quality with affordability together with plenty of room for growth, using the best of the two worlds.

Essentially, you start off with 35mm film and the next steps through processing will be familiar. Once you have a good image on film, the pathway branches: either you enter the darkroom or turn on your computer. One leads to a normal print which can then be taken to the computer before its final production. Likewise, the results of work on the computer can find itself back in the darkroom before it reaches its final form for consumption.

Why 35mm?

Little has changed since 1914 when Oskar Barnack sliced a ciné film in half and invented the 35mm format: it promised then, and does so now, the best combination of image quality and portability. And we have the advantage today of being able to use what is just the most extravagantly excellent equipment: we are unbelievably spoilt for choice. Many optics, freely available over the counter – and not just ones from the top marques – routinely stretch the limits and capabilities of both film and photographers. And even the most modest outfits can produce professional-quality results. Even better, modern 35mm films have more than enough image quality to cover a full-page of standard magazine format and, at a stretch, will cover a double-page spread.

So start with 35mm film: ISO 100 colour film gives you reasonable speed together with image quality that is seldom found wanting. I have always preferred Kodak Ektachrome films of various types, particularly the Elite or Panther range, but of course the Fujichromes and Agfachromes are also excellent.

For black & white work, modern ISO 400 films are superlatively good. By 'modern' I mean the new types of coating, such as T-Max 400, Ilford Delta 400. My personal favourite is the Ilford XP range, a chromogenic film, i.e. its image is composed of clouds of dye, not of grains of silver. Its latest incarnation, XP2-Super is even better than previous versions.

And, by the way, no digital camera costing less than the price of a fair-size saloon car can get anywhere near the image quality that is routinely achieved by the humble 35mm film and good-quality auto-focus compact cameras.

Standard processes

Evolution in film technology tends to drive processing towards greater uniformity, predictability and a narrower range of options … which may account for the interest in image manipulation. On the other hand, it has led to a steady improvement in quality and consistent performance. Processing your film at some street-corner store almost anywhere in the world can give more predictable results than professional laboratories in major centres twenty years ago could deliver. This reliability ensures that you get as much from the film as possible.

And with silver-based imaging, there is no need to fire up the computer to see what's cooking. There is no question about whether the format of the file is okay, whether one can read the data-storage medium or not. You simply have all you need, in the palm of your hand.

The road divides

At this point you have a choice to make. To turn the lights off or power up the computer. In the darkroom you are, relatively speaking, still the lord and master: you can work ancient brews and cook up your own or you can work with modern chemicals that get to work with minimal fuss. You can use auto-focus enlargers with automatic exposure devices or you can turn a milk-churn into a home-made enlarger. You can make your T-shirt sensitive to light or you can use polyethylene-coated papers. Working with the computer, your choices are limited to a few dull dilemmas: whether to work with elegant and élite Apple Mac computers or cheap and numerous PC compatible computers. Whether to spend lots and be self-contained or spend moderately and farm out demanding jobs to laboratories. We will consider these questions in some detail on pages 18 – 23.

Scanning the horizon

The 35mm format and computers meet each other at the film-scanner. This is the portal to the digital world: a magic stairway that transforms the visible into a stream of pulsing electrons that a computer can chatter with and work on. A scanner literally transports your image of visible representation into another world – of digital representation. Prosaically speaking, however, what is important is that at the present state of development, film-scanners offer an unbeatable bargain: professional-quality scanning at affordable purchase prices – but only if you stick to 35mm film-scanners. If you use medium-format or larger film, you have to pay disproportionately more for the larger scanners. This is clearly a situation caused by demand and supply: as demand improves, you can expect prices to fall.

Ins and outs

Once the image is in the computer you have to make choices as to how you store the images and the software you will use to manipulate the image. While the choice of storage is a continually moving target the choice of software boils down to something simple. Either you use Photoshop or you use something else. Note that some software can be nearly as powerful as Photoshop and can do more than most users will require. But the significant word is 'nearly'. For not only is Photoshop powerful as it comes out of the box. It can be made immensely capable through adding subsidiary programs called 'plug-ins'.

Once you are satisfied with the image you create – whether it's in the darkroom or in the computer – you have still more options to consider. The print made in the darkroom could go back into the computer. Perhaps you want to show your handiwork on the World Wide Web: you'll have to scan it or take a shot with a digital camera. If you want to sell a print to, say, a newspaper or magazine they will be happier to receive it electronically – which may take a matter of minutes – than wait for the aptly called 'snail-mail' which may take an entire day. Often a portrait of an author or a small picture of a flower or location is all that is required and a small file, easily attached to an e-mail, is perfectly adequate for newspaper and even magazine reproduction. Scanning the print, attaching it to an e-mail and sending it could take all of ten minutes: within twenty minutes, your client, who, by the way, is on the other side of the continent, could have the file on their page layout.

The usual fate of a digital file is to be output on a digital printer: possibly a laser or dye-sublimation printer or most probably a desk-top ink-jet (which should be distinguished from professional laboratory-based ink-jets such as Iris or wide-format printers). Alternatively, your digital file can be output to film using a specialist piece of equipment called a film-writer. The film is processed, then it is ready to deliver another photograph. You will want to go this seemingly long-winded route when your project demands a real, silver-based photograph as the end-product: a transparency to project or a photographic print with all its attractive archival and physical qualities.

Choosing a camera

The camera is still central to
any photography and for digital
the best all-round camera
is still the 35mm SLR

There has never been a better time to buy a camera. The choice is not only wide, the quality of individual cameras ranges from the excellent to superlative. Plus you can benefit from the accumulated years of second-hand or pre-owned cameras which offer truly remarkable value for money.

Pre-owned cameras
It is worth atttending to pre-owned cameras for a moment: it is not a euphemism for a well-used camera. Rather it recognises the numerous excellent cameras which have languished almost completely unused in collector's glass cabinets for years before being sold as the collection changed. The best-known collectors' models – such as Rolleiflex, Leica, Contax and the like – are the greatest beneficiaries of this, but collectors do also prize equipment from Nikon, Pentax, Canon and so on. While there is a price premium for the more collectible cameras, it is compensated for by their often pristine condition and impeachable picture-making credentials.

To check older cameras, look at:
• The pressure-plate: this is the spring-loaded metal plate behind the camera's back which pushes the film against the film-gate. There is no problem if you find it covered with very fine marks that run across the surface – that is normal, being caused by film being dragged between the plate and the film-gate. But if it's free of scratches, even better: the camera has hardly been used.

• The shutter: try it out at every marked setting to listen to it run. A slick, positive sound is the mark of a healthy shutter. Older cameras often don't get enough exercise but will free up once the shutter's been used a several times – if they don't free up after a few tries, don't buy the camera.

There can be no excuse for not having a 35mm camera to hand whenever you need one: Some of the best are compact instruments. On a brief visit to Monte Carlo I went for a walk carrying – as usual – my Leica M6 and, on this occasion, a 90mm lens. Ideally a shot like this would be taken with a medium-format camera, but the 35mm transparency still holds excellent detail and displays good tonality. What is important is to have the image at all – to this end, nothing beats a good 35mm camera.

Leica M6 with 90mm f/2.8 lens @ f/5.6, 1/125sec on Agfa Agfachrome 100 film at EI 80

• The optics should be sparkling shiny, free of scratches and clean: dull optical surfaces may indicate an amateurish attempt to polish off scratches or fungal growths.

• All mechanical movements from lens rotation to lever wind should be smooth and not make any crunching or grating noises. If you don't like any noise it makes, don't buy.

New cameras
If you prefer a new or modern camera, you will find models to suit every budget. You will also find it easy to obtain advice from current photographic and equipment journals. Here we will concentrate on some of the finer points, which are often consigned to 'advanced' classes, but by the time you do think about them, it may be too late you've bought the camera.

• Shutter lag: whatever kind of camera you have, there is a time interval between your pressing the shutter button and the moment the shutter runs. In modern cameras, that interval or lag can run into a discernible delay of as much as a quarter of a second. For taking scenic views and architecture or still-lifes this lag will be no problem. But turn the camera to portraiture, social documentary or children and a shutter lag of even a tenth of a second may guarantee you almost never get the picture you want. For the shortest shutter lag, you need to turn to mechanically governed shutters such as on any Leica range-finder camera, older Leica, Canon and Nikon SLR cameras. The more costly modern auto-focus SLRs have a relatively short shutter lag: the more you pay, the shorter it tends to be. But most auto-focus compact cameras have terribly long response time-lags.

• Special lenses: the work you love best may call for a special lens. This is almost certain to be very expensive, but you will want to prepare for the day you can afford it, so ensure you choose a camera with that in mind. For example, at present only Nikon make a top-notch close-up lens with true zooming ability: the 70-180mm Micro-Nikkor is a unique instrument capable of first-class results, but only if you use a Nikon camera. Minolta too is strong on macro lenses: it has a range of extremely practical optics for the specialist in close-ups. On the other hand, a perfect landscape optic is the 24mm tilt-shift lens from Canon: its excellent optical quality coupled with its ability to shift the optical axis as well as tilt makes is unique – it thus gives you the possibility of the twin joys of vertical and non-converging parallels in shots of buildings as well as extensive depth of field on inclined planes – but only if you own a Canon EOS camera.

• Viewfinder type: after years of brain-washing we tend to think that anything other than the single-lens reflex is inferior. But that is not so: the direct-vision range-finder has its advantages when it's helpful to be able to see more than the field you are framing: it's sometimes as important to know what is left out of the field of view as what is in it. There are times you need to be able to continue to see while the shutter fires, particularly with long exposures. In these cases, SLR is not the preferred choice.

Digital cameras
The arrival of the LCD screen for digital cameras has changed some rules about camera construction. It has meant that manufacturers can use the optical viewfinder which is not costly to manufacture and back it up with an LCD screen which shows what the lens sees, for those occasions accurate viewfinding is needed. The body design that goes with this configuration means that short-focal length lenses are easy to mount on the camera. But it has one major disadvantage: it is difficult to permit interchangeability of lenses. In short, most digital cameras are a bag of compromises.

For fair quality work – going up to, say, half an A4 page – you can choose from the best of the smaller models from Nikon, Olympus and Minolta which offer better than million-pixel capturing. There are several models which offer more than 2 million pixels on their capture chip. All these cost more than a low-range SLR camera, but they are certainly capable of doing a lot of useful work. Their main limitation is their limited optical versatility: those of you used to zoom lenses covering ranges from 28mm to 200mm and over, those who love the super-wide angle effects of the 20mm lens or the ultra-telephoto effects of a 500mm will be disappointed: digital cameras this side of affordable cannot match such prowess. Another digital limitation is in the speed of response which (shall we be kind) is leisurely compared to conventional cameras.

At present, professional-quality digital cameras demand professional budgets and gold-lined pockets. One top camera body alone, like the Kodak DCS520 costs more than an entire top quality conventional outfit but a digital version of the Nikon F5 shows the way, being only twice the cost of a conventional body.

Choosing film

Choosing film now depends
not only on the print
you wish to make but the
scanning you need

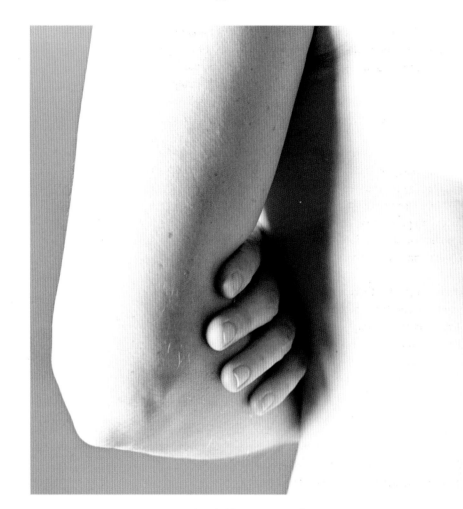

Leica M6 with 90mm
f/2 lens @ f/5.6,
1/60sec on Technical
Pan film at EI25; studio
flash lighting

A call to pregnant mothers-to-be to volunteer
for nude photography received a surprising
number of responses. The problem was that I had
not thought through exactly what I wanted to
achieve: merely that I wanted to explore the
beauty of the pregnant nude. So I used a number
of different fine-grained films and formats and
varying studio lighting set-ups – with the
inevitably variable and unconvincing results.
The project has lain abandoned for years now,
but may be rescued as silver-pixel work will help
overcome the quality problems (it may even help
with the conceptual problems).

There was a time you had an enormous range of films to choose
from, but you could not be sure what exactly you were getting.
The box might be the same, but contrast of the film inside could
have been different, the speed was likely to have shifted and, if it
was colour film, the colour balance was sure not to match. Now,
the choice is greatly contracted, but at least you know that if the
box has the same name on it, the contents are sure to be identical
for all practical purposes. There are broadly two speeds most
commonly used today: 100-speed for work where quality matters
and the lighting and circumstance allow its use. And 400-speed
where light levels are low or short shutter times are needed but not
too much loss in quality can be tolerated.

Black & white
There are modern black & white films and there are those films
which refuse to take retirement. Examples of the former are Ilford's

Delta series or Kodak's T-Max series of films. The die-hards need no introduction: Kodak's Tri-X and Ilford's HP5 are the best examples. These use a relatively thick coating of so-called 'emulsion' carrying the light-sensitive silver. They give a rich, textured image quality that many photographers cannot part with it. Modern emulsions, on the other hand, to do the job briskly with minimum fuss. They use relatively thinner emulsion coatings, relying on more efficient coverage of silver to achieve good imaging qualities. Thus they come out sharper than their older counterparts, but some photographers find their imaging lacks character. Modern emulsions are also less tolerant of poor processing control: to get the best from them you need to get the development done consistently and quite precisely.

A further type of black & white film is the chromogenic, of which the best-known example is Ilford's XP series of films. In these films, the light-sensitive layer is based on silver halides as always, but it also carries chemicals that will link up with colour dyes during processing. The process used is the standard regime – C41– for developing colour negative film. In the case of chromogenic black & white films, the final image does not reproduce colour, but it is formed from dyes (like a colour film) and not from grains of silver (which is normal for black & white).

What, you might ask, is the point of this? Apart from the fact that laboratories like being able to relieve your films of all their silver and put it in their bank – which they cannot do with normal black & white films – there is the convenience of being to get a black & white negative using a worldwide standard process available on numerous street corners around the world. There are also nuances of image formation which are favourable: over-exposure tends to produce smaller, not larger, grain (although sharpness drops just as it does in standard black & white films). In scanning too, chromogenic films can often produce better results more easily than conventional black & white. Because light is absorbed and not scattered as with films containing silver grains, the scan can be more faithful to the negative. Note that a corollary of this is that films rich in silver, such as Agfa Select, scan with more difficulty than less rich films.

Colour film

Colour films, too, have evolved along lines similar to black & white. The choice is smaller, the basic colour reproduction system is now the same for all, but the quality has gone up and with it, reliability and consistency of film characteristics. Modern ISO 100 films give a superb balance of image quality with speed. And some of today's faster films are capable of giving a image quality which would have been notable in a slow film barely twenty years ago. I personally use nothing but 100-speed films. If it's too dark for such medium-speed films and I cannot use flash, I simply sit back and reach for my drink.

Nonetheless, 400-speed films are excellent and produce results that owe no apology for their speed: the loss of sharpness and increase in graininess is acceptable. Colour reproduction quality, however, gives the game away: contrast is higher than normal and subtlety of colour discrimination there is not. To a limited extent, silver-pixel work can correct these defects.

In hybrid photography, there is little call for slower films: their grain is even finer and they record details more sharply than 100-speed, but the fact is that very few will truly need all that super-fine resolving power. And few will have the equipment and means to make use of that, e.g. when scanning: only scanners well in the stratospheric reaches of cost and sophistication can do justice to a good Ektar 25 or Kodachrome 25 original. Furthermore, such fine-grain film routinely out-resolve the lenses used: you are throwing away useful film speed with little to gain apart from perhaps smoother grain and marginally more refined colour discrimination. For a discussion of the scanning-related differences between transparency and negative film, see page 25.

'Digital film'

Manufacturers of solid-state memory are touting their products as 'digital film': certainly it does look like the once-fantastic dream of the reusable film has come true. You can pop images onto a disk, take them off and replace them with another time after time, for thousands, if not millions of occasions before the disk wears out completely. Consumer cameras regularly can carry just 4MB to 16MB of data. While these are satisfactory for the small files these cameras produce, for comparison note that for a good quality A4 image, you need some 18MB of data. That amount of information – and in fact quite a lot more – is held by any high-quality 35mm transparency or colour negative. There is another respect in which the notion of 'digital film' is a little misleading: the quality of the image depends only on the system used to capture it – the CCD and optics in the case of a digital camera – not on how or where the image's file is stored.

Choosing a computer

There is only one battleline
in personal computing:
to Mac or not to Mac.
After that, everything else is easy

The first choice you have to make is not which computer, but which operating system. However, 'Choosing an Operating System' is a much less snappy title. But it does tell you that the choice is about ways of working and, for most of us, the options boil down to just two. Either you choose to use Mac OS, the operating system for Apple Macintosh computers or you use Windows, the operating system for PC-compatible machines. These are also called Wintel machines i.e. they operate with Windows using Intel or analogous processor chips.

Should you choose Windows, you will have to select a machine from a bewildering choice. The upside to this is that prices are very keen and competitive, with many goodies thrown in for free, but the downside is that competition encourages manufacturers to cut corners, so build and component quality are very variable.

If you choose Mac OS, the ride is easier: you have only a handful of basic models to consider with various internal options plus perhaps a choice of colour scheme. Apple machines appear to be more expensive, but may actually be less expensive than equally equipped premium-priced PC computers whose premium is worth paying for the assurance of build and component quality.

Ways of operating

However, not all computer users are equal. Just as a fastidious photographer is a very different being from the holiday-snapshooter, so the silver-pixel artist places extremely high demands on the computing equipment compared to the usual home office worker. In fact, the demands are exceeded only by those working in production video. The reason for this are the extremely large files we regularly work with. A finished file of 20MB is truly enormous by the standards of those working on

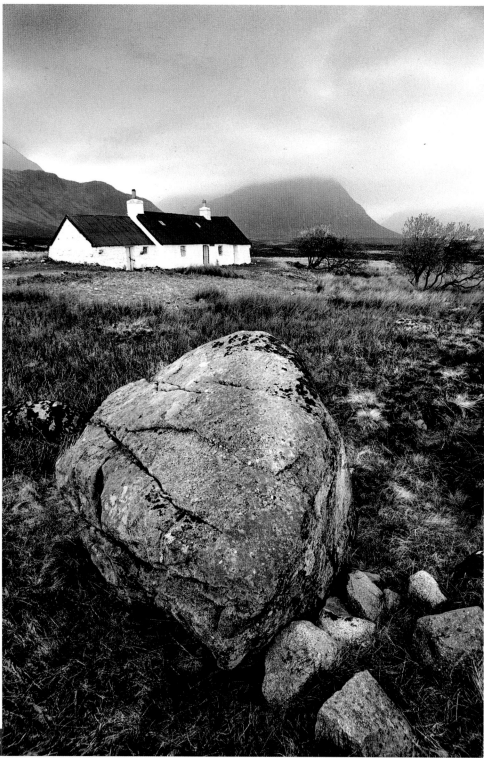

Starting from 35mm negatives, like this one taken near Glen Coe in the Highlands of Scotland, a typical modest use is to make an ink-jet print up to A3 size. A computer outfit which costs about as much as a good-quality SLR camera with a good lens or two will be more than adequate for the task. You will be able to scan to sufficient quality, make the basic tonal changes you need using inexpensive software and output the images to a useful size with little effort and a relatively small capital outlay.

Olympus OM-1 on tripod with 21mm f/3.5 lens @ f/11, 1sec on Agfapan 25 film, developed in Ultrafin 1+20

spreadsheets and databases. For the hybrid photographer, a 20MB is only the start: after a few hours' work in an image-manipulation programme, our file could easily be cluttering up over a 200MB of disc space and RAM. In short, file-handling is a big issue. In Mac OS, there is no doubt that file-handling is far easier: it is easier to name as the convention is more flexible, easier to organise, to locate files and move them around in Mac OS than in Windows. Finally, Mac icons – the little pictures representing the files – can be proper thumbnail sketches of the file itself, which is very handy when searching for an image.

Another different factor is that hybrid photographers will want to attach many things to their computer – a scanner or two, extra storage drive, a camera and of course a printer. On a Mac, adding peripheral hardware is a doddle, especially on the systems equipped with USB connectors.

And this brings us to the question of communications between Mac and PC machines, it is easy if you have a Mac: it will read PC and Mac discs with equal ease. It is also easy for a Mac to run software that makes it work like a PC – in fact modern Macs can run PC software faster than PCs can. The other way round – PCs reading Mac disks – is not so easy: the easiest way is just to stick to working on Macs.

Configurations

In as much as a keen photographer will not be satisfied with an auto-focus compact camera, the basic computer outfit will not suffice for the digital photographer. In fact, the entire chain of equipment must be enhanced above the usual outfit. We consider peripheral devices on pages 20 to 23. Here we examine the computer itself.

• Central Processor Unit: The CPU, also simply called the 'chip', is the heart of the computer and, generally speaking, the faster it works the faster you can work. The rate of beat is called the clock speed, and is measured in MHz – megahertz – or millions of cycles per second: 266MHz is regarded as entry-level and 400MHz chips are becoming commonplace. However, some chips work more efficiently than others: G3 and G4 chips in Apple Macs process the instructions differently way from Pentium or Merced chips in Wintel machines. The result is that for comparable clock-speeds, G-series chips actually do more computing in a given time. For image processing, try to get a chip running at 300MHz or more.

• RAM: Random Access Memory is very rapid in use. For image processing, you cannot have too much: not only is the software itself stored in RAM, the more the files it's working on can be stored in RAM, the faster it can work. Quantities of RAM are measured in MB or binary millions of bytes. A minimum of 256MB is what I'd recommend, although 128MB is enough if you do not try to use certain filters with large files.

• Hard disk: Like RAM you cannot have too big a hard disk nor can you have too many: you can keep one for the program files and current files while the other serves as the scratch disk – spare memory which programs use to store temporary files. Hard disk space is measured in GB or decimal thousands of millions of bytes. And if that sounds a lot, you'd be wrong: this book alone swallows up over a 1GB of space: the working files and other paraphernalia take up another 1GB. You will find that a 6GB hard disk is a good start: 8GB or more would be even better.

• Video card: If you only write letters or work on databases, a palette of 12 colours is sufficient for making your prints look nice. But the digital photographer will want access at least to thousands of colours, preferably millions. In order not to slow the main chip, you need a specialised processor just to control the image on the monitor. Macintosh computers now all come with video accelerator cards that can handle millions of colours to high resolution – at least 1024x768 pixels. You will want the fastest cards because it means less waiting around for the screen image to refresh itself. Furthermore, you will need lots of VRAM or video random access memory for the card itself: 4MB gives you enough to run to millions of colours on a 20" screen with a resolution of 1152x870. VRAM is very cheap: buy as much as the computer will accept.

• Connectors: Make sure your chosen computer has enough connectors of the right kind for the accessories you intend to use. Few PC computers come with the ability to connect with SCSI chains: although the required card is inexpensive, fitting it represents extra trouble. While all PCs use serial connectors, some will not allow you to connect to more than one accessory at a time. Fortunately USB connectors – which are easy to use – are becoming very commonplace. Even users of Apple Macs must face a choice: now you must consider whether to use SCSI, buy USB or run FireWire devices. In short, check that the accessories you wish to purchase will all use a connector system that works with your machine with the minimum of fuss.

Software and scanners

The choice is wide but
the options are narrow
– when you know
what you want

Rolleiflex SL66 with
80mm f/2.8 lens @ f/4,
1/30sec on Ilford XP-2
Super film, ISO 400

The hands of a healer and seer who was also a baker, on the island of Taveuni, Fiji. She was a lovely, gentle lady and nothing escaped her eyes. But it was her hands that really fascinated me: they were tremendously strong yet moved with great sensitivity and finesse. The close-up abilities of the Rolleiflex were a great boon for such a subject: I moved in closer and closer to try to fill the frame with the power of her hands. Image-manipulation software made it easier to bring out the dark and contrasty nature of the light than with darkroom work.

Choosing software

When it comes to image manipulation software, there is sadly no real choice – the reason why almost every serious worker uses Adobe Photoshop is simply because it can do almost every serious thing anyone can expect of it. Its faults are few (if substantial) and the few serious attempts to provide a 'better' Photoshop have dismally failed to topple it.

Fortunately, while Photoshop is expensive to buy on its own, it is often bundled with, or is much cheaper, when bought with a scanner. Alternatively, you can find you are offered a free scanner if you buy Photoshop at full price. If you're on a tight budget, don't forget that much of the most innovative work in digital imaging was created on early versions of Photoshop. While I would not recommend version 2.5, you may find earlier version 4 at bargain prices less expensive than competitors yet far more powerful.

However, there is a hidden cost to Photoshop, because of its greed for both hard disk space as well as for RAM: to make the most of it, you need to have considerable amounts of RAM – I recommend you have a minimum of 256MB. The program goes well if you have a very fast hard disk drive with heaps of room on it: at least 1GB of contiguous i.e. not broken-up disk space.

Other image-manipulation software seek to be strong where Photoshop is weak: Satori, for PC's only, works very rapidly even with extremely large files, as does Live Picture. However, files which have been worked on need to be rendered into a usable form, and that may take a long time. LivePix is a junior version of Live Picture: it has many built-in effects and templates for calendars etc, and can work to extremely high resolution without serious speed penalty. Photo Suite is also packed with many built-in effects which make it easy to use. PaintShop Pro is powerful and can replace Photoshop for many users.

Plug-in software options are programs in their own right, but are written to make use of another application's main application routines or 'engine'. Photoshop itself comes with many of its own. PhotoTools from Extensis is exceptional in adding a good range of tools such as text effects, including convenient buttons supplementing the standard menu. Another popular choice from Extensis is Intellihance, which is used to make quick overall improvements to images. There are several plug-ins dedicated to the task of removing or masking out backgrounds, making it easier

to handle tricky jobs like separating fly away wisps of hair or leaves from their background. It is relatively easy to choose which software will be most useful to you as you will easily find demo or trial versions for experimenting with before you are committed to a purchase.

With the core application in place, the purpose of most other software is to make life easier and organisation more efficient. For example, it is really useful to be able to produce catalogues of your pictures so you only have to open one file to see them all together. You can then find out where all the pictures are: some may be on a CD-ROM, others scattered on different disks. A cataloguing application such as iView, Cumulus Canto or Extensis Portfolio will save you an immense amount of time in the long run.

If you find yourself making many conversions of file format a very fast and effective program is GraphicConverter, which is inexpensive shareware. An extremely powerful, professional tool is Equilibrium DeBabelizer: this can automate many functions and is a must-have if you want to produce much work for the Internet.

I have saved a priceless application for last. This is Painter from MetaCreations. It mimics natural media such as pencil, charcoal and various paints. It is capable of producing a rich variety of effects with a level of control that no other software can match and is therefore much more appealing to the digital photographer than the comparatively unsubtle filter effects offered by plug-ins. Its abilities are discussed and demonstrated on pages 70-1, 80-1, 88-9.

Choosing a scanner

Tempting as it is to say there's only one kind of scanner worth considering – a good one – it is unfortunately more complicated than that. It is clear what one wants from a scanner: that it translates faithfully, with no loss of information and in as much detail as required, the image on the original into a digital equivalent. But the machine that delivers this perfection is very expensive, difficult to maintain and finicky to use: it is a drum scanner and, not surprisingly, it is found only in professional laboratories. We are left with two alternatives, both of which are compromises: the film-scanner and the flat-bed scanner.

For the silver-pixel worker, a film-scanner represents the best balance of features and quality. The reason is in the optics: firstly, they are made to scan only a very small area – that of the film

format – so the sensors can be dedicated to pick up over 2000 points per inch, and secondly, because one scans only by transmitted light, the light source can be optimised for that job. As a result, modern film-scanners can give excellent results at modest cost – reproduction-ready results for the cost of a basic SLR body.

The main manufacturers such as Minolta, Canon, Polaroid, Olympus, Microtek and Nikon all offer good film scanners. For 35mm, it is hard to beat the Nikon Coolscan: their 2700dpi performance have put much of publishing industry on the desk-top. But Polaroid's 4000dpi offering is a threat to Nikon's supremacy. Minolta, Polaroid and Nikon also make sound machines for larger formats. In selecting a model, prefer one that offers an optical resolution of at least 2500 ppi (points per inch), giving you create files around 18MB in size – enough for fair-quality A3 ink-jet prints.

Flat-bed scanners are a must if you need to scan prints such as old prints whose negatives have been lost or prints whose negatives are too large for your film-scanner. If your print is large enough and good enough, even inexpensive scanners are capable of producing results which can, with a little work, be turned to publication. Scanners come slow and they come fast: for the same cost, faster scanners do not necessarily produce lower-quality scans. When making purchase decisions, try to see the scanner in action and have it scan an original you supply.

Flat-bed scanners can be adapted to scan transparent originals: the 'transparency adapter' is usually another light source that resides in the lid above the scanner bed and is hooked up to move in step with the scanner head under the original. Check that the adapter is supplied with the scanner: separate ones can add considerably to the total cost.

If you will scan flat artwork like prints of around 10x8" in size, a scanner offering resolutions of the region of 600ppi (points per inch: often quoted as 600dpi) will be fine. Should you require to scan medium or large-format films, you need a much more capable scanner, with resolutions of at least 1000ppi: so-called 'repro-quality' desk-top scanners offer resolutions of some 1200ppi to 2400ppi. If your artwork is bigger than A4 size but smaller than A3, you'll need an A3-size scanner which are much more expensive than A4 scanners. It is possible to scan parts of a larger whole, then sew the bits together, but that's not a recommended procedure: you often find that edges do not match well.

Printers and accessories

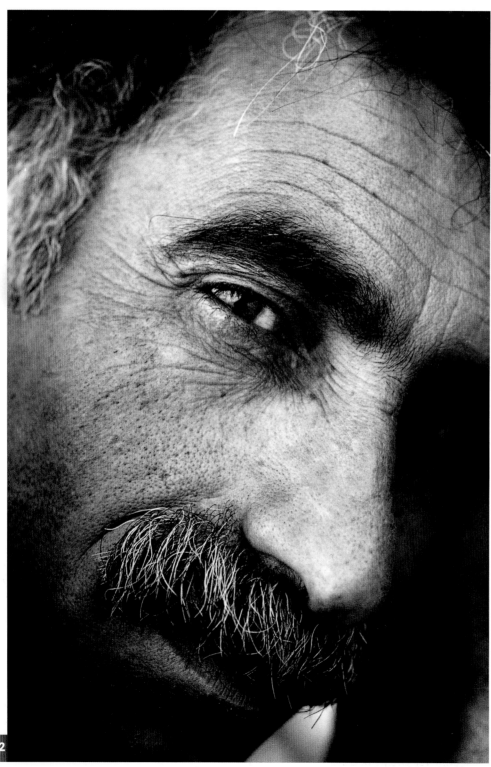

It has not been greatly remarked, but while the desk-top revolution miniaturised the computer, it has transformed just about everything else in the office: the modern printer is faster and better than earlier printers, but it is a fraction of the cost, quieter and a fraction of the size. The filing cabinet has been replaced by a tiny disk of magnetic material and where one used to have to send out to a specialist supplier, one can now simply turn on a small machine at one's elbow and get the job done is less time, less effort and far less cost. The silver-pixel worker has greatly benefited from these improvements.

Printers

Today's printers are just about the best-value equipment you can buy. You can thank one manufacturer for this: its products are so dominant and such great value that they have forced the entire industry to rewrite its gameplan. That manufacturer is Epson and its printers are without doubt the business if you want excellent quality combined with excellent pricing. Other printers, such as those from Hewlett Packard, Canon and Lexmark, are very capable and entirely suitable for silver pixellers but none to date actually excel the capabilities of their arch-rival. Epson's software control leaves many things to be desired – stability being high on the list – nonetheless, it is a model of flexibility and is easy to use. So Epson cannot be complacent: Canon is catching up and, with printers using up to seven inks compared to Epson's six, has gained some ground.

In general, you will find printers that use six (or more) coloured inks, including black, are the best for photographic work: the two colours in addition to cyan, magenta, yellow and key (black) are either lighter versions of cyan and magenta or different colours altogether, such as orange and green. The use of two or more extra

In the north-eastern Anatolia region of Turkey, a boatman joins us for a beer. In a short time, he consents to having his portrait taken: thanks to the beer, I can use a macro lens almost in his face. This lens is so sharp it seemingly picks up every pore and hair in the face: the resulting richness of texture calls for the tonal depth that is better even with PE-coated papers than any ink-jet print. The image was reproduced from a scan of an excellent print rather than from the negative – a procedure which often gives improved results.

Leica R-6 with 60mm f/2.8 lens @ f/4, 1/30sec sec on Ilford XP-1 ISO 400 film

inks greatly expands the range or gamut of colours which can be printed out: that is of little significance for colour used in business documents but makes all the difference to us photographers.

You should not assume that ink-jet printers are the only way: struggling against the tide are the dye-sublimation printers from ALPS: their micro-dry system achieves staggeringly good results which can be very similar to the photographic print, with the promise of good keeping qualities. Furthermore, their inks, being dry cannot dry out. However, colour fidelity and brilliance is a few notches below the best that ink-jet can produce and its restriction to special papers and to a maximum of A4 size are also handicaps, but it is well worth considering.

A common complaint of these printers is that they take too long to produce a print: more than a quarter of an hour for an A3-sized output is not uncommon. But consider that the set-up time is minimal: no darkening of the room, no mixing up of chemicals, no checking their temperature while warming them up, no set-up of the enlarger and so forth. However, once a darkroom is set up it can indeed steam ahead and produce prints far more quickly than an ink-jet printer can.

Accessories

• Graphics tablet: These input devices are an evolutionary step up from the mouse: comprising a flat tablet like a solid mousemat and a pen-like stylus, graphics tablets give you excellent control over hand-drawn lines. They also give you a chance to vary the pressure of a stroke so that it increases line width or depth of colour – something that's impossible to do with a mouse. The tablet part can be small, around A6 in size, or as large as you like – over A2 size is possible. I find the A5 size is the best compromise between adequate size and something that would otherwise take over the desk. Also note that the larger sizes need their own serial port, rather than sharing the same chain as the keyboard and mouse. Competition has determined there is effectively just one choice: the Wacom range of tablets which are expensive but well designed and reliable.

• Removable media: Digital photography is one of the biggest users of data the world has ever seen: we think nothing of copying over and backing up heaps of files which actually represent more information than in the whole Encyclopædia Britannica – yet they represent only a few tens of images. Removable media give us the storage space we need. In general, the bigger the capacity, the cheaper the medium per megabyte of data. The smallest you should work with is the 100MB Zip disk: this is cheap and very widely available but for image use it is limited by its capacity. Far better are the Jaz disks which are of two types: the 1GB is widespread but is superseded by the disk with double that capacity: 2GB. The 2GB disks are much less expensive per unit of data, and the 2GB drives are faster than the 1GB drives. 2GB drives will also read 1GB disks.

• CD-ROM writers are the best option for exchanging files with other workers or laboratories. The best system is the most wide-spread system, and it is the recordable CD or CD-R. It holds up to 650MB if you fill the disk up in one go and once written it cannot be changed – which is both its strong and weak point. Rewritable CDs (CD-RW) are available: they can be written and erased then rewritten very many times but they cost some five or more times more than normal CD-R and there remain compatibility problems which mean that a CD-RW can often only be read by the machine that originally burnt it. Also note that sequence: to re-write you must first erase the disk, which can take almost as long as writing it in the first place. And this points to the main problem with CDs: they take a long time to write, even with writers working at, say, four times the standard rate, it can take nearly half an hour to write a full CD-ROM. Even so, CD-ROM writing can fail at the last hurdle, a minute before the end, which will cause the total failure of the disk: you may have to write a new disk all over again.

• UPS: An Uninterruptible Power Supply is essentially a clever battery that senses if the mains electrical power supply cuts: if so, it instantly switches the computer over to the UPS battery and sounds a warning. If you have one, your computer and its screen will continue working long enough for you to shut it down gracefully and in due order until the mains power supply returns to normal. Compare with no UPS: you have blind panic when your screen goes blank and you realise that not only have you just lost the selection you took 30 minutes to draw, the actions you spent half a day defining are also gone. A UPS goes further: it is the best protection against power surges and spikes (more or less sudden rises in power) that can damage your computer as well as other electrical faults such as brown-outs. Inexplicable, erratic behaviour of equipment can often be laid at the door of irregular power supply: even with steady electrical supplies, a UPS helps to make my computing relatively trouble-free.

Improved scanning

Scanning is the gateway
to the digital domain:
do it well and it will
serve you well

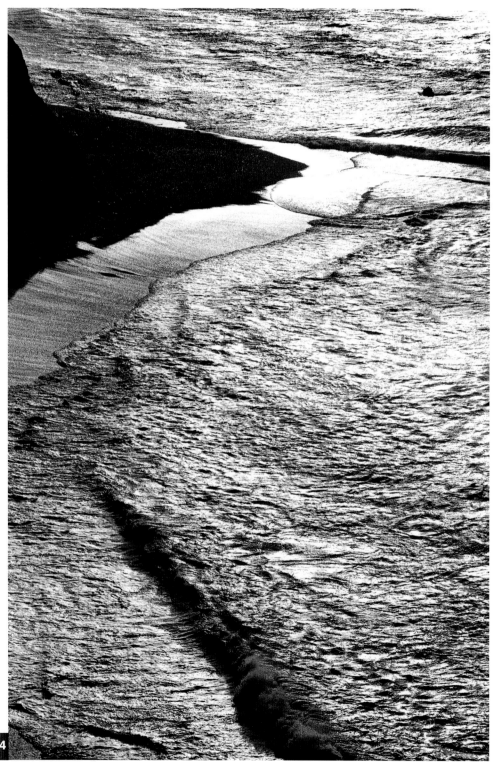

You can make it easy for the scanner to produce the best results it knows how ... or you can make it difficult. This is not to re-state that dreary cliché 'garbage in, garbage out' because even with an image that is superlative in every way, if you ask the wrong kind of scanner to read it, you will not be happy with the results.

We need to revisit some fundamentals. Input devices must first sense or measure some change, then translate that into some other change which can be registered. The first stage involves the same things as a camera lens: you want good contrast and a good ability to separate out bits of detail – both being closely interrelated. Unfortunately, the commonest scanners – flat-bed and film scanners – use lighting arrangements which are inherently low-contrast: the light-paths for illuminating the object and the light from the object are very close together. Thus where the film is very dense it is difficult to push enough light through it for the sensor to pick up. Conversely, where the film is very thin, light penetrates easily in all directions, so making it difficult for the scanner to pick up any details.

A related issue is what photographers know as the Callier effect: this is the official name for the phenomenon that you can see specks of dust in a beam of sunlight but not on a cloudy day, even when the light is equally bright. This leads to that old problem of which kind of light-source is best for an enlarger. A condenser type (giving 'sunbeam' type light) gives higher contrast but picks up all the dust specks on a negative. The diffuser type gives lower contrast but most of the dust specks disappear. It's ironic that even with cutting-edge digital hi-tech, this problem remains for scanner manufacturers: the scanners giving the snappiest results also give the snappiest dust – every last speck on your original. A significant exception to this is the ICE system used in the Nikon Coolscan: it

When the sun shines in Dorset, southern England, everything seems beautiful. A late afternoon is reflected in the sea: a distant shot from a high viewpoint using a long focal length lens renders the scene into an almost two-dimensional abstract of panels, lines and forms. The varied, random textures make this an easy image to scan but the high density of silver from the high-resolution film can tax many scanners: it is difficult for the light to penetrate solid areas of silver. Here, the tiny details effectively mask scanner problems.

Canon F-1n with 200mm f/2.8 lens @ f/5.6, 1/30sec on Agfapan 25 film in Ultrafin 1+30

24

identifies dust and hairs to remove them automatically. The downside is that the process softens image detail somewhat, so corrective sharpening is needed.

As for separating out detail, note that one of the problems of flat-bed scanners is that the CCD sensors seldom run the full width of the bed: this means that if you have a full-size original, the sensors have to read the outer quarter or so of the original at an angle, which reduces resolution. Film scanners are superior in that the optics usually run the full width of the scan area, so resolution is even right from one side to the other.

If you like being rebellious, you're out of luck: to get the best out of a film-scanner, you must provide very average originals. Not too dark, not too light, not too contrasty, not too flat. In short, your original cannot be too average. A colour slide taken on, say, a slightly cloudy day with lots of middle tones like flesh and grass with neither deep shadows nor highlights is ideal. If, however, your transparency shows a black cat glowering on a dark sofa, every bit of information will be vital.

Conversely, that high-key nude shot with light streaming in through the windows is also hard for the scanner: the transparency is letting in so much light it's like pointing a lens at the sun. It is difficult for the scanner to pick up the dark details in the model's hair. Even an average transparency can be a trial if you want any details in the shadows: films like Fujichrome Velvia have a high density with precious little shadow detail, but we can see it because we blast light through the transparency by holding it up to a lamp. Most scanners can't do that, so all it sees in the shadows is a continuous wall of black. For this reason, the drumscanner will continue to have a future as it is designed to penetrate shadows.

How to make scanning more efficient:
• Collect all your originals together and plan ahead.
• Use a naming convention that someone else can understand: for example more people will be more likely to find an image called 'beach, girl & grass' than 'Jan, Greece'.
• Scan all the landscape-oriented pictures separately from the portrait-oriented pictures; this saves you rotating the scans. And it will help if you classify originals by the final file size or resolution you want so as to minimise visits to dialogue boxes.
• Scan to the lowest resolution that you need. This gives you the

What about other kinds of film? One would expect colour negative film to do better on scanners: there's no silver to scatter light and the contrast is much lower than with transparencies. It is indeed generally easier to get scans with a good range of detail right through a colour negative, but this has as much to do with the film's vastly superior exposure latitude as anything else. The problems come when trying to translate the negative colour information into a positive: some software are better than others in dealing with the overall orange cast (technically it is actually a mask) of a colour negative film. Of course there's also the perennial problem working with colour negative film of you yourself knowing exactly what is the right colour when you cannot see for yourself what it is.

Black & white films scan well, provided they are, again, very average. Trying to get details out of heavily exposed sky areas when scanning is just as hard as doing the same in the darkroom. Similarly, trying to get details out of thin shadow regions is very difficult: the low-contrast details are swamped by light. I find that modern black & white films can produce better results than older types: the difference is probably in the make-up of the emulsion. Modern films such as Kodak T-Max and Ilford Delta are thinner than classics like Tri-X and HP5, therefore scatter less light. At any rate, modern films are also sharper and less grainy.

The best results come from Ilford XP2 film: this uses dyes to create the image – just like a colour film – but the image is actually a black & white negative. An advantage of using XP2 is that, like colour negative films, as exposure increases the grain size gets smaller (thanks to developer inhibitor release couplers): greater density comes from more grains being developed. This is reflected in deliciously smooth tones in the scan.

smallest practicable file size, which makes image manipulation faster, takes up less storage space and will be quicker to move around.
• When you scan, crop as much extraneous image as is sensible to keep the file size small but still allow yourself room for manoeuvre if you need to crop further.
• You may need make your output image very slightly larger (say 5mm all around) than the final size. Sometimes this is essential, e.g. when you want your image to extend to the very edge of the paper, i.e. to bleed.

Resolution

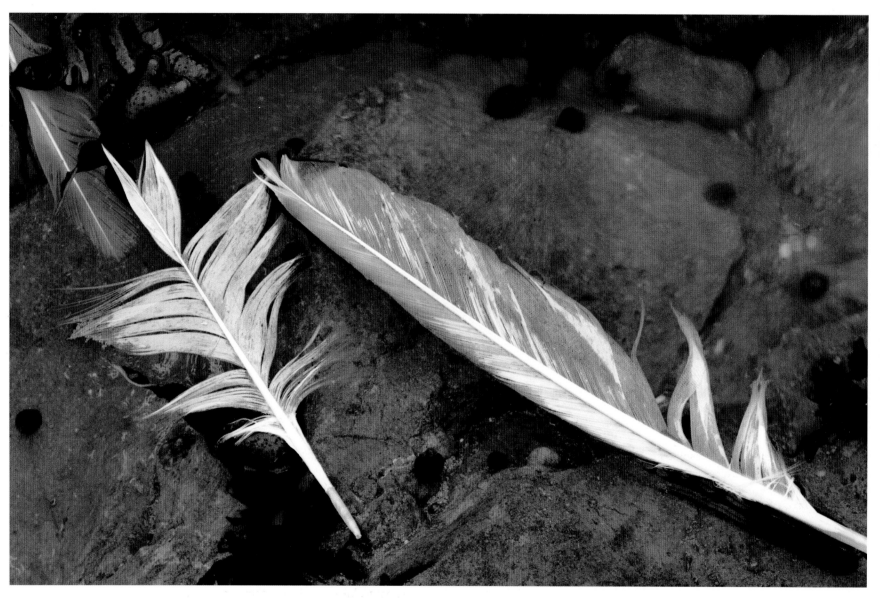

Wista 45 Technical with Nikon 150mm f/5.6 lens @ f/11, 1sec on Ilford FP4 film EI 100 devloped in ID-11, 1+1

The problem with location stilllife is they are often anything but still. I waited many minutes for a lull in the light breeze and had to shoot several times to be sure I had one sharp image. Although very light, the breeze was enough to move the feathers which would rock gently for a few minutes afterwards. Using a field camera with lens movements enabled me to take a position that minimised reflections and use movements to maximise depth of field.

Some things would be clearer if only we would use more words or a more carefully defined and determined lexicon. However, the more we use different words, the more difficult it is to learn the language. So as an uncomfortable compromise we are stuck with one word used in several ways, with only context or a helpful indicator to tell us which. Thus it is with 'resolution'.

In abstract terms, resolution in its various guises is in fact a measure of density or linear density: how much of something you can cram into a given distance or space. In practical terms,

resolution is a measure that specifies what is needed for a particular job to be done to a given level of quality. Put the two together and the result is like ordering cloth: if you're okay about using a roughly woven cloth, you order one with only a dozen or so threads per inch. As you ask for finer and finer cloth, you want to see more and more threads per inch, until the finest silks may, for example, have thousands of threads per inch. Clearly, as you try to squeeze more threads into each unit length of material, they must become finer and finer in order to fit. With resolution, too, the more you have, the finer the quality.

Input resolution

When we scan a film or print, we are turning points or small areas of our image into an array of pixels: input resolution, measured as points per inch, tells us how much detail we are extracting from our image and therefore how many pixels we will have when scanning's complete. Suppose we scan to a resolution of 2000 ppi (points per inch): then over an image that measures one inch by one and a half inches, we will build up a total of 2000 times 3000 points, making a total of six million points. The scanner has looked at each of those points and assigned a value to each one: when this is placed in the array of points, we have a pixel taking up its place with other pixels on the regular array that now is the digital representation of the image.

It is important to reiterate: resolution is a density, so it is relative to a set unit and therefore cannot tell us about anything concrete like an actual size apart from the amount of data in the digital file itself. That data is essentially the number of pixels we have. Now, as far as the computer is concerned, it does not matter whether you output the file on the side of the Golden Bridge or onto the corner of a letter. Until you change the actual number of pixels in the file, its size remains exactly the same.

In fact, you can see from the above that from a resolution figure and the figure for the size of the object, we obtained a figure for the total number of pixels. When we come to replay the pixels back into the real world, we will need the opposite process – from the total number of pixels, given a size we want to a achieve, we can work out the new kind of resolution – output resolution.

Output resolution

When it is time to output the image, you will need to decide on the size of the printed or otherwise output image. This leads to a simple calculation which will give us a different kind of resolution figure, the output resolution. Suppose you have a thousand pixels down the side of your image that you want to be 10 inches long: it is obvious that if you lay 100 pixels an inch, you will indeed obtain an image that is 10 inches long. Notice that this makes no reference whatever to the printer: at this point what the printer can or cannot do is of no relevance to the output resolution.

However, you do want to know what output resolution is needed for good-quality print-out at average viewing distances. The figure is in fact similar across the board from photo-mechanical methods to the photographic print: for the digital image, we want to see at least 200 pixels per inch of output for this to appear smooth and even-toned. This is somewhat higher than the 133 lines per inch that is satisfactory for printed material because we cannot vary the size of the individual pixels as it appears on the page. Working with print, we can lay anything from the tiniest dot to a large dot although the number of dots per inch is fixed.

Device resolution

We can ask for an output resolution of 1000 pixels per inch but if the printer can only manage 600 dots per inch, how can it deliver the required resolution? In fact, the main source of confusion starts right here. The device resolution does not actually tell us directly what the output resolution will be: it sounds like it should, but in reality it does not and cannot. A more descriptive term is 'addressable point': this is the number of points that a printer can point to and decide whether to lay a dot of ink or not – for ink-jet and similar printers, the addressable point figures gives the same result as device resolution. Thus if an ink-jet printer can print 1500 dots per inch, it can address 1500 points per inch.

A few moments' thought will show that not all of these dots can be used to deliver detail. Ink can only be either laid on the paper or not: you cannot change the brightness of the ink colour as you lay it, although some printers can change the size of the dot within small limits. Therefore a number of dots must be used together – in groups called half-tone cells – in order to simulate the impression of differing densities of colour or of varying greys. This process is called dithering: that is, using patterns of dots in order to represent changes in tone. Therefore, if sets of, say, 10 dots are used to create a half-tone cell, given a printer with 1400 addressable points, we can expect to be able to make use of, at most, 140 dpi of output resolution. For further discussion, see pages 96-7.

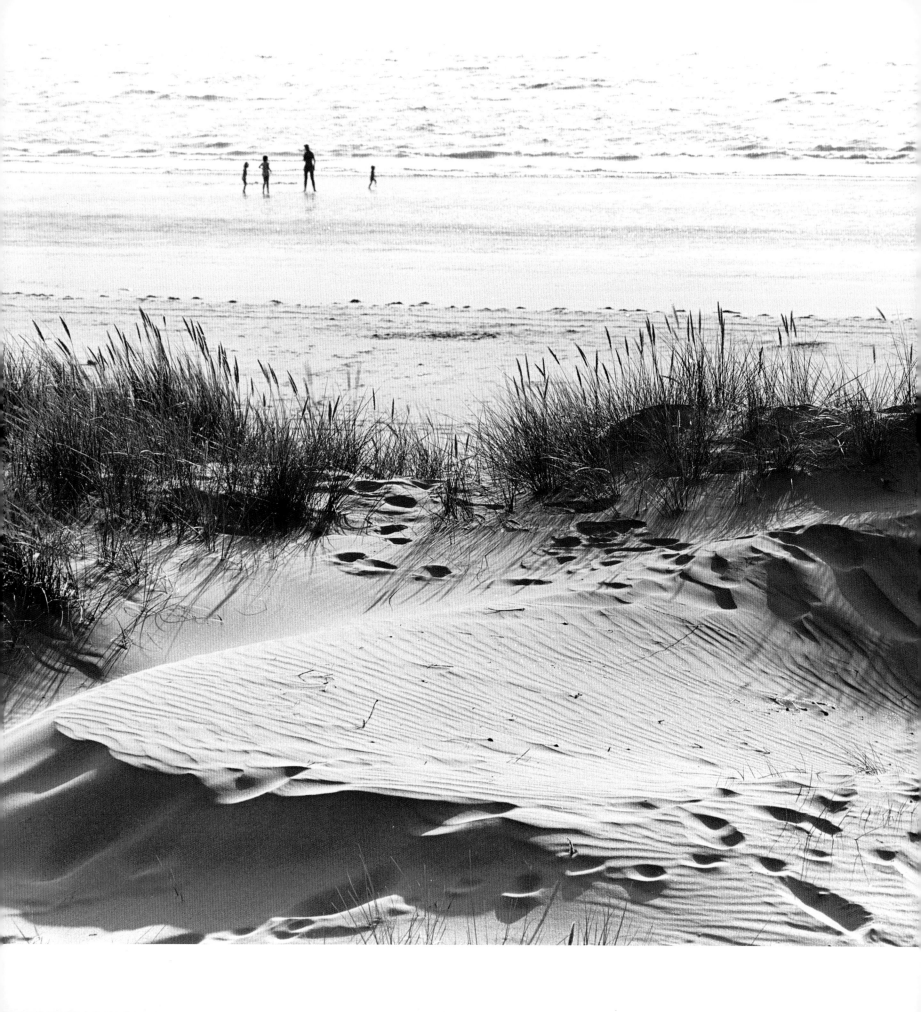

ROUNDED CURVES

Digital imaging has added a dynamic dimension to the concept of tone reproduction. In classical photography, tones were limited by the sensitive materials themselves. But in digital imaging, tones are toys to be tossed around with abandon – yet you can also work with all the restraint of tradition.

Contrast and levels

Statistics comes to the aid
of photography:
histograms are surveys
of pixel tonalities

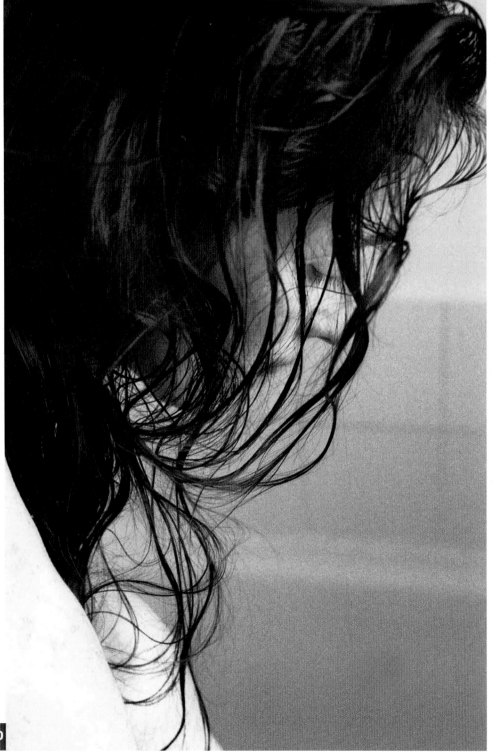

The most obvious counterpart in digital photography to the contrast grade of sensitive materials is levels. The concept of levels comes straight out of statistics: it is a representation of the distribution of tone values as a histogram. This means that the more pixels have a certain value, the higher will be the column in the histogram. From this, you can get a quick assessment of the image. But it will be pretty obvious anyway, just by looking at the image. So there must be more to it. The Levels control offers several easy and powerful ways into changing the global tone distribution: but there is a price to pay which is less than precise control. Software like Photoshop allow you to change settings both by altering slider controls or by directly inputting numbers – which is more precise.

Note that 'global' may apply not only to working on the whole of one image, it can mean applying the same changes to a whole bunch of files at one time. On such occasions you need to be able to reuse a setting that you have found correct, e.g. for improving scans produced from a certain kind of negative or for tweaking images captured on a digital camera. In applications such as Adobe Photoshop you can save the settings and load them in at a later date; these can in turn be applied automatically using the 'actions' feature. Equilibrium DeBabelizer uses a slightly different technique: you can save the settings as 'scripts' which can be replayed on any image.

The easiest thing to do is to click on the 'auto' button (in most applications), I find, however, that this works effectively in fewer than 5% of cases. What 'auto' does is to make your darkest pixel become black, the brightest pixel is made white and everything else in between is spread out evenly – which often also change the overall density of the image. Adobe Photoshop actually applies a type of 'Olympic' filter (i.e. extreme values are discounted) when applying the auto levels, just in case the darkest and lightest pixels are not in fact representative of the whole image.

Alternatively, many photographers twiddle the Levels control as if they were working a television set: see what happens when you turn one knob and if it looks promising, keep turning. For much work, this method is as good as any other. A little experience shows that moving the left and right pointer (in MetaCreations Painter, Adobe Photoshop, etc.) closer together increases contrast while moving the middle pointer (which represents the average value) affects the overall density.

In fact, the middle pointer, misleadingly called 'gamma' (not to be confused with photographic gamma), represents the adjusted brightness of the mid-tone grey in the image. It is somewhat confusing because you might think that if you made the mid-tone darker (i.e. set a 'gamma' lower than 1), the whole image gets darker: in fact the opposite happens because you are effectively compressing the range between the black and the mid-tone: this leaves more pixels to be lighter than mid-tone, so the image gets brighter. The output level is an important control because it sets the black and white points: i.e. how they are translated in your printer. You should make a practice of setting the white point at least 5 less than the maximum and you can often set the black point to at least 5 more than minimum without any visible loss of density: both help improve results when printing.

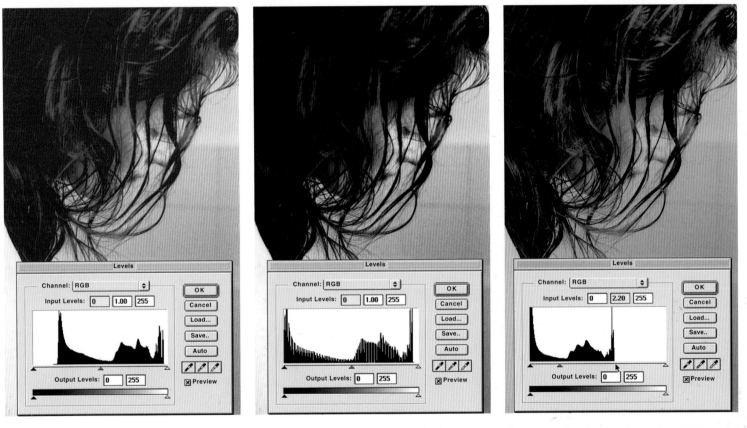

Pentax MZ-3 with 43mm f/1.9 lens @ f/1.9, 1/30sec on ILFORD XP-2 film rated at EI 320

The original negative is thin, and the resulting scan shows big gaps at both ends: poor highlights (right side of the histogram) and even poorer low densities (see gap to the left of the histogram).

Hit the 'auto' button and you get a livelier image – the histogram is better spread out – but tones are uneven, shown here by the comb-like profile showing complete absence of some pixel values.

If you make the mistake of using the Brightness/ Contrast control, you will truncate pixel values even further than evidenced in the original scan – shown here by the huge gap in high values.

How to read Levels
• If all values are filled, with one or more gentle peaks, you have a well exposed or well scanned image (see e.g. p.37).
• If the histogram is heaped up with most values low, e.g. to the left, the image is overall low key or dark; if values are heaped up with most values high, the image is high key or bright.

• If you have a very sharp peak towards one or other extreme with few other values, you probably have an image that is over- or under-exposed.
• If the histogram is comb-like, it is a poor image which many missing values and too many pixels the same value: such an image looks posterised, with sudden changes of tone or colour.

Curves and variable contrast

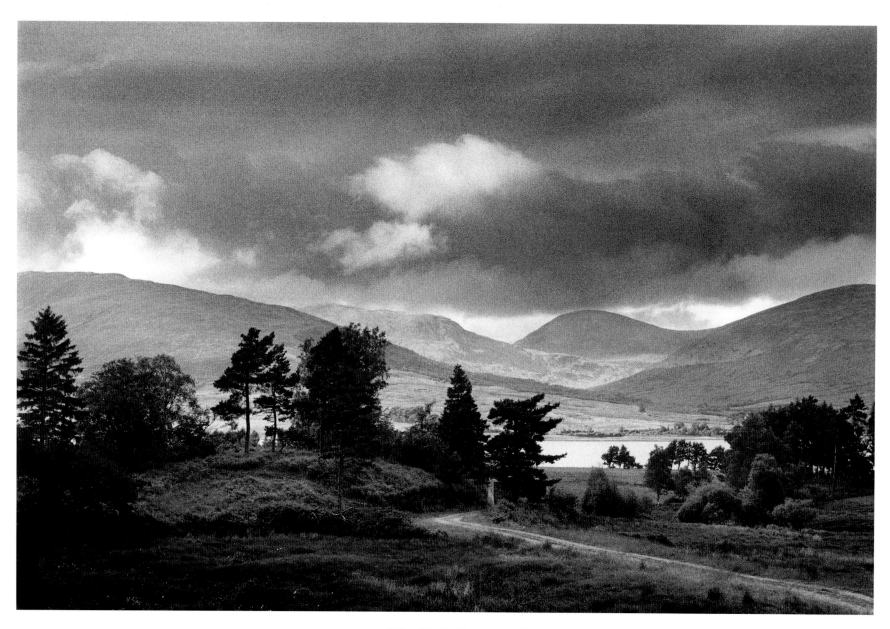

Nikon F2 with 50mm
f/1.4 lens @ f/8,
1/60sec on Kodak Tri-X
film at EI 400
developed in Ultrafin
1+30

This image, taken in Scotland, shows the best of silver-pixel work: no amount
of digital work could produce it. Nor could days in the darkroom equal the
subtleties and clean imaging of this image. In fact it is a carefully made
conventional print that was scanned and then subjected to further
manipulations, largely to clean up some uneven grain, a long surface mark on
the emulsion (very difficult to remove with darkroom techniques) and to
improve the light on the trees and path.

If contrast grade, with its broad-brushstroke control of tonality, is represented by the Levels control, then variable contrast grades has its natural counterpart in the Curves control. This takes the Levels control significantly forward. Not only can you adjust contrast with good subtlety, you can limit the alterations to a small part of the tone curve. It is rather like being able to draw your own H&D or characteristic curve. You should not, however, confuse the Curves control with a film's characteristic curve itself as each is derived and defined in quite different ways (see box).

Good programs will take Curves further: you can click on a point in your image and the point's value will be located for you on the curve. Some software allow you to sample from the image for the shadows, mid-tones or highlights and have those values used for automatically setting the key points on a curve. This provides a means of making extremely rapid adjustments or assessments of the image.

Practically speaking, the value of the Curves control is being able to extend the apparent tonal range of an image. Typically, film records at low contrast at two main regions – in the shadows (the so-called 'toe' region) and in the highlights (beyond the so-called 'shoulder' region). Here the curves run close to horizontal, so there minimal gradient of contrast. This means that changes in the brightness values in the scene (variations of scene luminance) are little reflected in changes in density in the negative – so there is no record of the luminance variations i.e. no details. With the Curves control, you can lift up the curve at the shadow end to make it a little more steep in the shadow region as well as in the highlight region while leaving the mid-tone 'gamma' the same. This creates a characteristic 'bow' shaped curve (see right).

This is similar, but not identical, to using variable contrast grades to improve contrast rendering within a certain tonal range. Working digitally, just as in the darkroom, we can limit any changes we make to a selected area of the image. Simply select an area, e.g. all the dark shadows, using one of several techniques and then call up Curves: in most manipulation programs, once a selection is made, changes to a control affect only pixels selected while others are left alone. Take care that selections are well feathered i.e. there is a wide region of transition between selected and non-selected areas – that the change from is not sharp or sudden. If feathering is insufficient, you will be greeted with very artificial-looking shadows and boundaries.

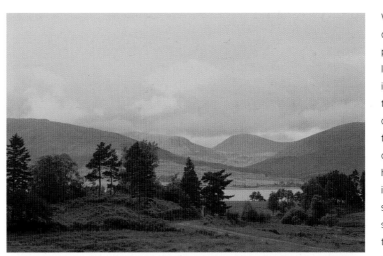

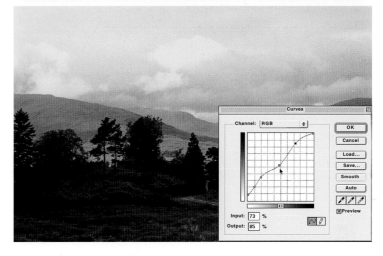

While the Curves control is versatile and powerful, it has its limits, which are well illustrated here. The typical bow-shaped curve (below left) has the effect of darkening the highlights while improving contrast and similarly giving strength and contrast to the low values as well. This helps to give life and sparkle to the dull original (left). But even the improvements are a long way short of what can be achieved with the careful burning-in and dodging used to create the main image.

H&D and characteristic curves ... and Curves

The curve that describes the way film responds to light for a given development regime is often called the H&D curve because it was the partnership of Hurter and Driffield who first investigated the sensitometry of film, i.e. they measured how film responded to light and development.

It is easy to confuse the H&D curve with the Curves control in software like Photoshop: after all they are similar-looking graphs. Although both graphs plot the relationship between an input and a result, the characteristic curve uses a completely different measurement scale (it is a semi-log graph) and the two values related are physically different. In contrast, the Curves graph uses the same units on both axes to display the relationship between the pixel values of the current image file with the pixel values after you have made your adjustments; i.e. it displays the input (the values as they stand) and the relative output values (as they will be once you hit the 'OK' button).

Local contrast control

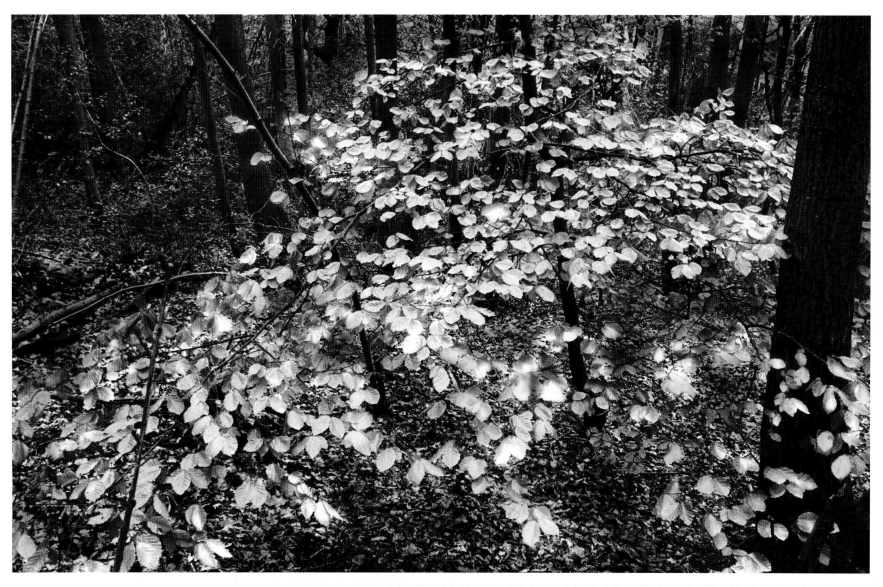

Nikon F60 with AF-Zoom Nikor 20-35mm, f/2.8 @ 20mm, f/5.6, 1/30sec on Ilford Delta 400 in ID-11 @1+1

This image, taken in Igtham, Kent, needs either 20 minutes' work on the computer or endless messing about in the darkroom firstly to burn down the numerous small patches of pale sunlight showing through on the ground - these patches distract the eye from the leaves. Then it would takes hours of careful work with Farmer's Reducer to try to make each leaf lighten up, as if it had caught the sun. The computer-based work was to use a soft-edge brush – just large enough to cover the leaf being worked on – set to 10% pressure i.e. very low, to dodge mid-tones. This final image is close to what I had in mind when I took the photograph: for at the time, the light, spring-time green of the beech leaves stood out brilliantly in the dark forest.

What exactly is achieved when you burnin or dodge? The effect of both controls is to distort tonal reproduction as originally recorded by the film. You may be correcting for the non-linear recording of tones by the film, or you may be wishing to create a visual effect. When you burn in, you add density, reducing the overall dynamic range of the image. However, the visual effect may be the opposite, depending on whether the adjacent areas are light, in which case you increase local contrast. If the adjacent area is dark, you decrease local contrast. The opposite effects apply, when you dodge, which reduces the local density.

Thus far, there is no difference between analogue and digital working. In fact, the pros and cons of working in either medium are rather evenly balanced. In the digital domain, you can work with as much precision as the image will give you: right down to the exact pixel, and you can adjust densities with absolute precision if you wish. However, try to burn in a great expanse of sky in a computer and you soon discover the limitations: if you set a large brush, you usually obtain uneven effects full of gaps. This is partly because the processing of a large brushstroke can make heavy demands on computing (depending on the software), making your strokes run ahead of the feedback on screen. Unevenness may also be set deliberately in the brush options: to remove this, uncheck the 'spacing' option.

On the other hand, burningin small areas with precision in the darkroom is a nightmare. Normally, we take pains to cast a fuzzy shadow with our burning-in or dodging tool in order to avoid unsightly effects. The optics of the enlarger will always mean that there is spilling of light: that any burning-in or dodging tools will always be unsharp. Working with chemicals to intensify (rare) or reduce, with agents like Farmer's (potassium ferricyanide in acid solution) is little better for precision.

The beauty of hybrid photography is, of course, that you can benefit from the best of both worlds. For example, you make a print with skies subtly burnt in as it's only possible by working under an enlarger on a paper you know. You can then scan it so that you have a digital version on which you can do all the precision manipulations you need, say the miniscule burning and dodging on details that are far too complicated or fine to work on using the old tools of masks cut from card. Finally, you will need to output the result: either you return to film by writing the file onto a film recorder (to produce a negative) or straight onto paper.

Above: Thanks the combination of a dull day and a much less than ideal film development, the negative was rather flat as well as low in density. Furthermore, the green of the leaves appears less bright to the film than to the human eye: the eye has a peak sensitivity in green, whereas film does not. To improve tonal rendering, I could (or should) have used a yellow-green filter: this would have held back the browns of the rest of the forest and allowed the greens to look much brighter. Below: Select a brush size to suit the area being worked on: here it is just large enough to cover each leaf.

Toning

Endless experimentation with not a drop of chemical in sight: that is the great promise delivered by digital toning

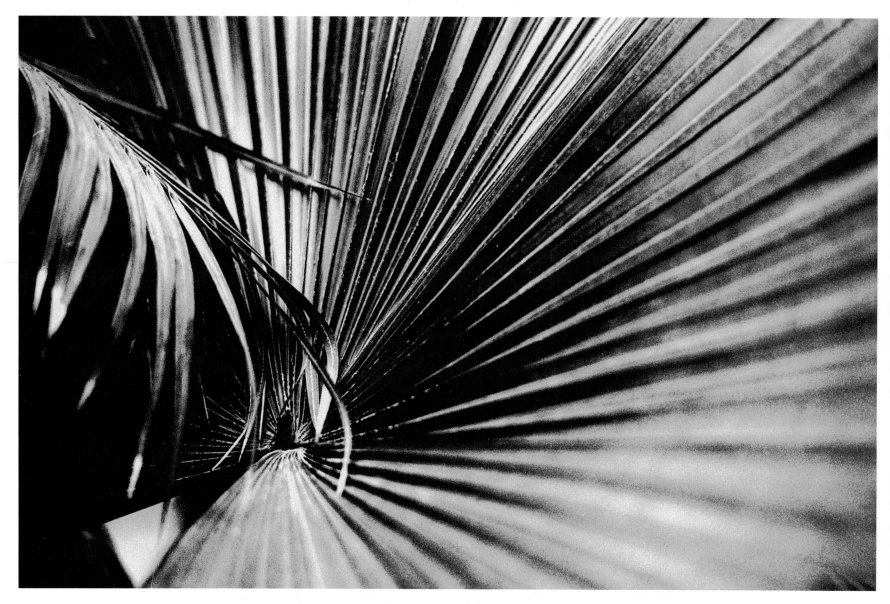

A simple geometric or abstract pattern is often the most effective for bright toning effects: the abstraction helps render the artificial colours acceptable, while the colours may direct the viewers' attention towards the pattern. Here I used Deke McClelland's 'Color Creep' filter from his Tormentia set: this filter multiplies one colour channel into another, so lightening and increasing the contrast of the image in step as the effect is increased – exactly what a toning chemical does. I applied the green channel, then adjusted the result in Levels because the filter gave me blacks which I found too heavy, so I reduced them in the Levels control, adjusting the black output levels to about 10.

Working with chemicals, toning is a somewhat hit-or-miss affair. Even with good knowledge of the chemistry and careful print-making, toning gives results which are at best more 'hit' than 'miss'. In truth, the situation with digital is little better: often one is striving for a certain effect but the many different ways to achieve toning-like results all behave slightly differently and even with experience it is hard to predict exactly what you will get until you actually hit the 'OK' button. But there is one big difference: in the computer, if you don't like a result, you simply reach for the undo button command and you immediately have a fresh image to start with. Furthermore, as you work, you need not worry about the chemicals going off or oxidising which adds a further, usually unwelcome, element of variation into the process.

With chemical toning, you are replacing the silver atoms of your print (or, in rare instances, your negative) with atoms of another kind – another metal or metallic complex. Naturally, this changes the colour or tone of the image – that is the effect you are after, but at the same time, it also changes the overall tonal character of the print. Many toning processes increase the overall contrast of the print: so to compensate, you make your print softer if you intend to tone it than you would if leaving it untoned. This introduces yet another variable into the equation.

With digital toning, you are also replacing one thing with another: in this case, you are selecting a range of pixel values and altering them with more or less subtlety. The possibilities are actually endless because there are so many different ways to select a range of values and change them. They also range from the subtlest hue change as you might see in selenium toning to violent changes, of the kind that some chemicals such as the Colorvir range can give you.

When working digitally, remember you will have to turn a black & white negative into a colour image to apply toning effects. This means that the greyscale image (i.e. there is no colour information) must be turned into, for example, a RGB image (i.e. with colour information held in the red, green and blue channels). It looks the same but the computer thinks it is different. The simplest toning effect is to apply changes to Levels to only one of the colour channels. You can experiment with colour space: applying changes can give markedly different effects. You can also start with a colour image: turn it into a greyscale image, then return it into a colour space to apply effects (but see pages 40-41 on channel mixing).

The quickest way to tone an image is to alter one of the colour channels from Levels (above) or Curves to see if the effect is what you want: if the colour is not quite right, you can adjust it by changes in another colour channel. Specialist filters are also effective (e.g. below, which shows the image before application of the Color Creep set to an extreme red).

Nikon F2 with 50mm f/1.4 lens @ f/4, 1/15sec on Kodak Tri-X film at ISO 400 in Ultrafin 1+20

Duotones

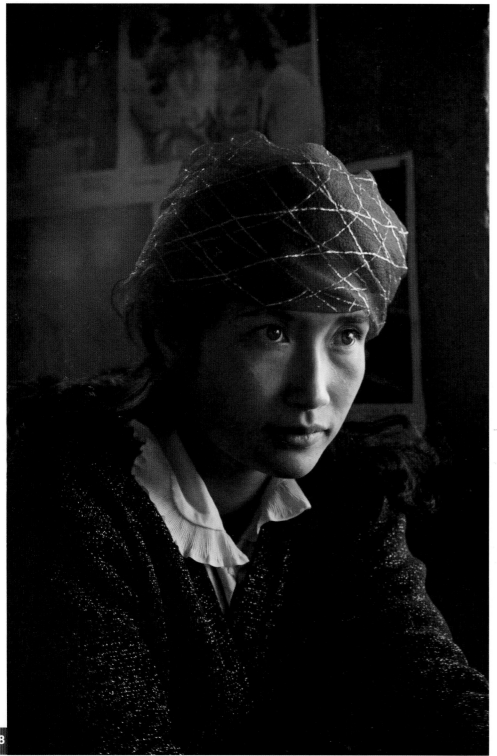

If you think about it, you'll realise that we had nothing like a true black in a photographic print until the invention of integral tri-pack subtractive colour print papers - i.e. the modern type of colour-sensitive photographic material - and that was in 1939, a full century after the invention of photography. Before that time, we had admittedly gorgeously deep and dark silvery tones - but not black. This is largely because the silver grains in a print do not adsorb light so much as disperse it - that is, spread it around. As we all know, that limits the dynamic range of a print: the difference between the brightest part of the print - nominally the white baryta coating - and the darkest part - where there is most silver - is not as great as if the darkest part were to be a pigmented black - as it would if you applied black oil paint.

Much of the art of black & white printing is working out how to make the most of the limited tonal range inherent in the print material. The commonest, nay, standard tactic, is to suggest a wider tonal range than there is: we make the psychologically mid-tone range contrasty to imply that when you get to the shadows they'll be really deep and the highlights will be really bright. They aren't, of course, because the paper flattens out the reproduction curve for the shadows and highlights. But it's a good little botch and works because we've trained ourselves and a lot of suckers, I mean, our viewers, to accept it as a fair representation of real life.

And the fact is, we have never been entirely happy with this bit of sleight of hand, which is why every photographer has, at one time in their career, dreamt about toning their prints. Toning transforms the silvery pseudo-black into anything from blue through coffee stains to rusty reds. It is as if to say, 'If it's not really black then why pretend? Let's make it blue (or brown, or red).' Unfortunately every toning process I've ever seen, apart from feather-light selenium work, actually makes the dynamic range even smaller than before. Having kicked out the silver grains that disperse most light of most wavelengths, the toner metals simply

Taken by the window of a street-side eating place near Karshi, Xinjiang Province, China: as I expected the girl to be shy, I spoke to and photographed her male companion first, before asking if I could photograph her. I exposed fully for the mid-tones, in order to bring the shadows in: as a result, the high-values are hard to burn in. I turned this into a blue-tone after much experimenting.

reflect quite a lot of light in a selective way. Toners that work by bonding with silver are even worse in that respect.

Modern digital printers - such as ink-jet, dye-sublimation or laser - have opened up the possibilities in thrilling ways. The range of colours for toning is virtually unlimited because we are simulating the toning colours by using any colour that can be created using the four or more colour processes. And of course the control we can exercise over the effect is very exciting in its possibilities. The discipline that is now needed is not of darkroom practice but of

ensuring the effect is appropriate to the image. For this, just as in the darkroom, there is no substitute for making numerous prints and looking at a print in the flesh.

And further, we will continue to need to call on those craft skills that served us so well in the darkroom: the judicious choice of materials to match your image to the printing-paper characteristics, the economical use of costly resources such as inks plus that steady, consistent way of working that comes only with lots of practice.

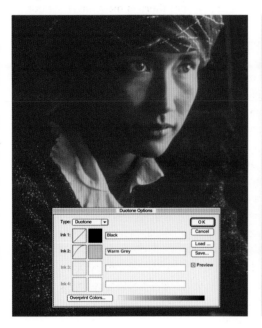
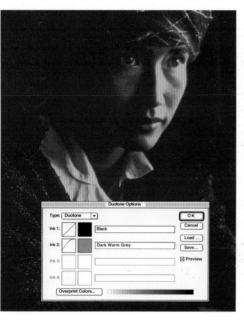
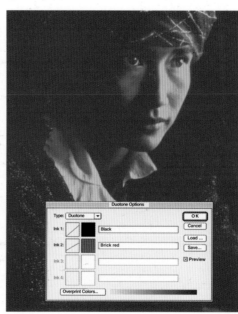

Leica R-4 with 60mm f/2.8 Macro Elamarit-R, @ f/2.8, 1/60sec on Ilford XP-1 exposed at EI 320

One of the most powerful, yet under-used, features of Photoshop is its duotone mode – found under Image > Mode > Duotone. This image mode is well implemented in version 4 of Photoshop, but in version 5, it is quite perfect because you can change colours and tone curves while instantly observing the effect of your changes. The only difference between this image and the one on the opposite page is the direct substitution of colour, a very warm grey for the blue, as the second ink. Being able to make the changes on screen is a convenience that cannot be matched in the darkroom. Equally important, whenever you find a combination of colours and curves effective, you can save it for reuse later.

This image uses a warmer ink than that on the left and the curve has been slightly adjusted to increase the heaviness of the ink in the shadow and lower mid-tones. Note that such heavy tones can drench a paper when printed with an ink-jet printer: for the best results you should ensure you use a heavy-gauge photo-quality paper (of at least 180 gsm (grams per square metre) which feel like photographic paper and whose thickness can absorb the ink without unattractively buckling under the strain. Heavy ink can cause another problem: that of failure of ink to dry: some ink-jet papers are fine for the light inking typical of business use but are tacky for days, even hours after a heavy inking given to a photograph..

In this sample, I have substituted a red second ink for the blue used in the main portrait opposite and also added a purple over-printing ink. In order to compensate for that extra ink, the values of the second ink have been substantially reduced - note the low gradient of the curve, seen in the box to the left of the red-brick-coloured square. The effect of the over-printing is to replace all black ink with the over-print colour, thus flattening the overall tones – this is useful when you want to avoid the rather modern feel of contrasty tonality.

Channel mixing

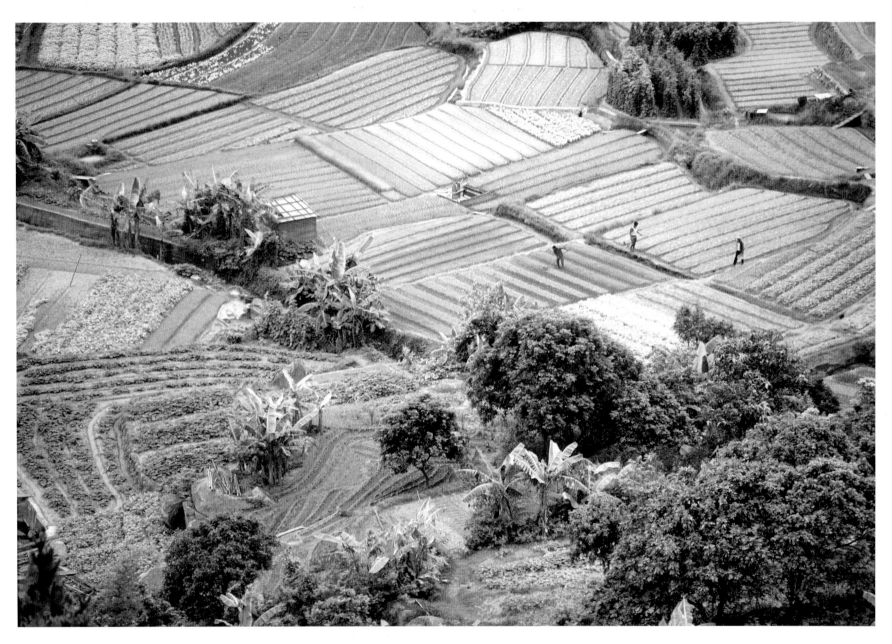

Nikon F2 with 135mm f/2.8 lens @ f/5.6, 1/60sec on Kodachrome ISO 64 film

This image results from adjustments of the Channel Mixing control in which reds were greatly reduced and blues also reduced but by a lesser amount, while in contrast, greens were considerably increased. This brings the foliage to sparkling life (compare with the greyscale image opposite), with the kind of brightness that obtains from using a strong green or yellow-green filter. In fact, one can work out that a channel mixing that favours green and reduces red and blue must have the same effect as a filter that passes yellow-green while blocking reds and blues.

One technique that often mystifies the beginner in black & white photography is how colour filters can be useful. If the film's black & white, what is the need for colour filters? The easiest way to understand their working is to recall that a colour filter appears a certain colour by stopping other colours from coming through. So a red filter is red because it stops non-red colours such as greens and blues from passing through it. Now, a picture taken without a filter would show reds, blues and greens of similar brightness at around the same density. Place a red filter on the lens and compensate for the fact that it is removing a fair amount of light. You will then find that reds in the image are recorded brightly while blues are recorded dark.

Using coloured filters in black & white photography is the classic technique for turning blue skies to dark greys: yellow, orange or red filters produce progressively more marked effects. My favourite all-rounder is the yellow-green filter as it works well on landscapes to brighten leaves and grass as well as being able to darken skies without the over-dramatised effects of orange or red filters. However, you can see that using filters is a relatively unsubtle method: you are limited to the specific filter values built into each piece of glass and, indeed, how the film responds to the filter. There is also the drawback of looking through coloured glass.

The digital equivalent is channel mixing. There are a number of ways to turn a colour image into black and white. If you want a greyscale file, the easiest method is just to change the mode from colour to greyscale. If you want a greyscale image but to stay in working in colour, it is easier to desaturate the image i.e. remove all the colour. This has exactly the same effect as turning the image into greyscale then returning it to colour. However these are crude conversions, that leave it up to your software to decide how to turn colour into grey. With channel mixing you can decide for yourself how to convert a colour image to greyscale: e.g. to make the greens brighter in preference to reds.

Incidentally, this gives you a clue about how to improve results when converting to greyscale even if you are using software that does not offer channel mixing. You can change the colour balance or individual ranges of colour prior to the greyscale conversion. For example, if you want blues to be darker, you select blues and make them darker before you convert. Of course this is rather hit-and-miss compared to a proper channel mixing control, but it is rather better than nothing – which is the sad darkroom option.

The intensively cultivated fields in Hong Kong are always full of activity: from a hill-top vantage point, the pattern of tiny fields, activity and intricate relationships can be seen. A straight conversion to greyscale from colour leaves the greens too dark and lifeless (below), even after working with the Levels control in an attempt to bring some sparkle into the image.

Above: a standard conversion to black & white is dull, dull, dull – similar to the response of monochrome film – the various greens of grass and trees come out too alike and also run into the tones from the brown colours.

Sun prints

Old processes revelled in rich
tonalities: with digital techniques
you can now recreate them
all with minimum fuss and expense

Wista Technical 45
with Nikkor ED 300mm
f/5.6 lens, on Ilford
FP4 rollfilm developed
in Ultrafin 1+30

Ancient tracks of the North Downs Way in southern England gave rise to the
original image: its richness of texture and subtlety of tone can only be
captured successfully with medium-format or larger film. A long focal length
lens helps visually to compress the space between the trees and their
surroundings. The original colouring for this image was created with an
orange layer set to colour-burn mode over the black & white image, which
was subsequently turned to purple (typical of sunprints) using the Hue and
Saturation while the Curves control set an appropriate tone curve.

Ingenious and (just as fundamentally) lazy as humankind is, it was not long after the invention of photography that people looked for ways of making a print without having to go through the business of developing it. As the original discovery of the light-sensitivity of silver salts was precisely that they got dark, it was but a few steps to the invention of sun prints, popularised by Ilford as POP or printing-out-papers. You placed a negative in contact with the paper in a wooden frame and left it out in the sun – hence the original name – until the image looked dark enough. The image was then fixed or, in later versions, the paper incorporated toning salts within the emulsion so the image toned as it was exposed. The typical tonalities were rich and vibrant golden browns and yellows, even orange and purple colours.

Nowadays, you cannot do this easily with modern papers because using standard fixes almost entirely wipes off the image. And, at any rate, the exposure to ambient light is unpredictable (as differences levels of brightness cause marked changes in contrast as well as image colour) and exposures are long – stretching into hours, even days. Furthermore, the technique was feasible only with larger negatives – 5x4" is really the smallest practical size – as it is impractical to enlarge. From time to time since their demise in the 1950s, printing-out papers are reintroduced: in the early 1990s a batch reached the market that was excess to an order for photographic materials that could be used to record explosions: these produce so much light that a really, really slow exposure was needed, and POP filled this need.

Needless to say, in the computer, you can recreate the luscious tonalities of sunprints with ease and convenience. Better still, you are not limited to using large-format negatives or even black & white film. The basic technique is to turn to any greyscale image or to desaturate a coloured image to grey. Then you can play around with colour balance until you obtain a rich warm tonality. However, the highlights and shadows will still be generally neutral in colour and it is important that they take on the colour cast.

The easiest method is to create a layer above the image and fill it with colour. Set the layer modes to colour burn (which intensifies colours) or colour mode (which adds colour values to underlying layer without changing brightness) or else the top layer masks the lower one. Be aware that as you do this, the images easily fall out of the printer's gamut i.e. the colours seen on a monitor screen cannot be matched by the printer's more limited range of colours.

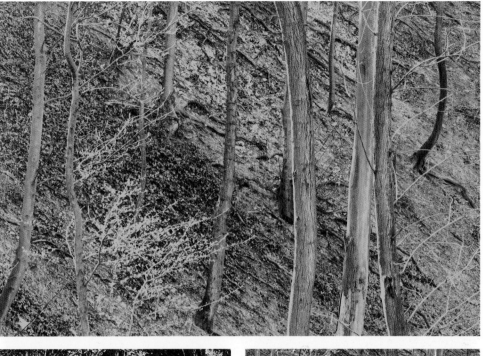

Above: an alternative approach to the simple layer-effects manipulation to is use the layer blending options. Using the same colour layer as for the image on the opposite page, I opened Layer options (in the Layers Palette of Photoshop) to lower the setting for the 'blend if grey' slider: this has the effect of increasing the effect of the upper layer but limited to the setting you specify. As a result, the image takes on a split-toned appearance, which occurs in toned sunprints.

Top: another example of sun-print tonality: this time created with two coloured layers, one orange (set to colour burn), the other yellow (set to colour). Notice how the blacks appear to become richer although they are exactly the same values as in the other images: this may have to do with our atavistic preference for warm or fiery tones. Above: the original black & white image, as first scanned.

Posterisation

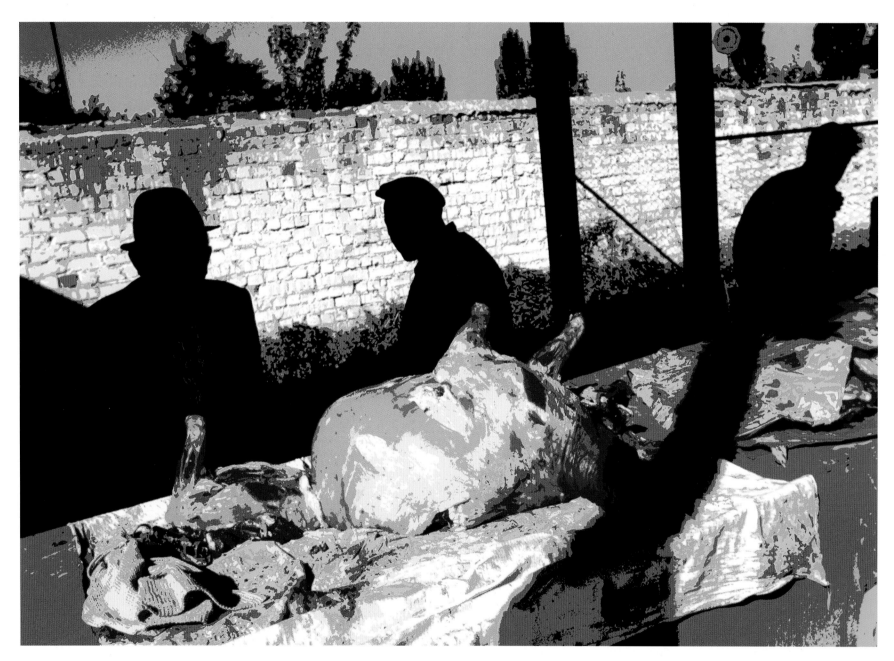

Canon EOS-1n with 20-35mm f/2.8L zoom @ 20mm, f/8, 1/125sec on Kodak Ektachrome ISO 100 film

A meat stall does not make the most likely subject, but the repeating elements of the carcass feet with the girders of the shelter as well as the shadows with the distant trees all attracted my attention. Exposure was tricky thanks to the bright light and dark shadows, but I knew the key was keeping the sky blue: it was the most important mid-tone, so I exposed for that. Note how the posterisation makes the image more palatable by abstracting the life-like elements.

Long before photography joined forces with printing to produce the photo-mechanical printing technologies that dominate our print media, there were posters. The forefather of posterprinting was the wood-cut, which was brought to consummate heights by the master engraver Ho Ye Cong, working in the so-called 'Ten Bamboo Studio' in the early 1600s. What makes the studio's work so remarkable is the subtlety with which Ho reproduced tonal transitions and light colour. To succeed in this, however, he had to cheat: he used varying strengths of ink to create tonal gradation.

The idea remains the same, nonetheless: that the image is made up of a limited number of blocks of colour arranged in non-contiguous areas, that is, there are areas not in contact with each other. Working digitally we have several ways of approaching the posterised image. A black & white image can be coloured by painting in software using a brush: this is slow and labour-intensive but is obviously able to give the most controlled results.

Another method is to use Replace Color in Adobe Photoshop (under Image > Adjust): you can achieve rapid results using this to change systematically one range of colour into another. Even quicker to use is the Posterize adjustment, also under Image > Adjust. The effects range from largely indistinguishable from the original (when you choose too many levels) and grossly over-posterised (when you choose too few), with little in between. Note that the number of levels refers to each channel: thus 3 means three levels in each colour channel.

How to make a step wedge
1. In Adobe Photoshop create a new image with a white background to the size you want and set a low resolution of e.g. 100 dpi.
2. Pick the Gradient tool (or type 'G' on the keyboard).
3. Ensure that the gradient option (see the Options palette) is set to 'Foreground to Transparent...'
4. Click the tiny overlapping black and white square at the bottom of the tool box to bring the foreground colour to black.
5. Drag the gradient tool right across your empty image: it fills with a gradient from black to clear.
6. Go to Image > Adjust > Posterize: as the dialogue comes up, the image instantly turns into bands of black leading to grey: change the Levels setting as required and save the image
7. Finally, you print off the step wedge to the size you need.

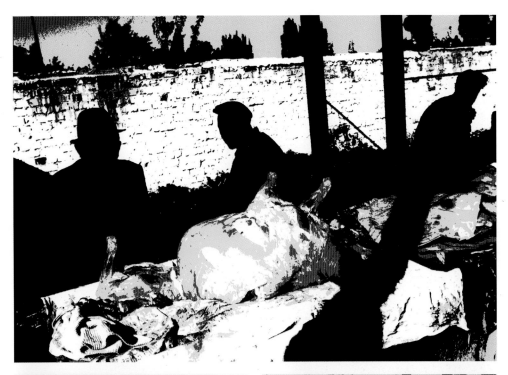

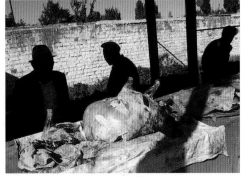

Top: this image results from reducing the number of colour or greyscale steps to just two per channel: it is markedly different from the main image, that has four steps. Above: you can very easily make step wedges of any size your printer can handle (see left) – and even circular ones if you wish. These will be accurate enough for basic sensitometric tests e.g. for the Zone System evaluations of films and developers. You can of course also make coloured step wedges too (but you may discover the bugs in Photoshop that prevent smooth colour gradations).

The combination of brilliant sun in a perfectly clear atmosphere plus deep shadows, here in the bazaar in Pokrovka, Issyk-Kul region of Kyrgyzstan, raises the range of scene luminance way beyond the capacity of any colour film to record (but some scanning digital cameras could cope). Exposing for the blue sky ensured that the shopkeepers were well underexposed, so that they create silhouettes.

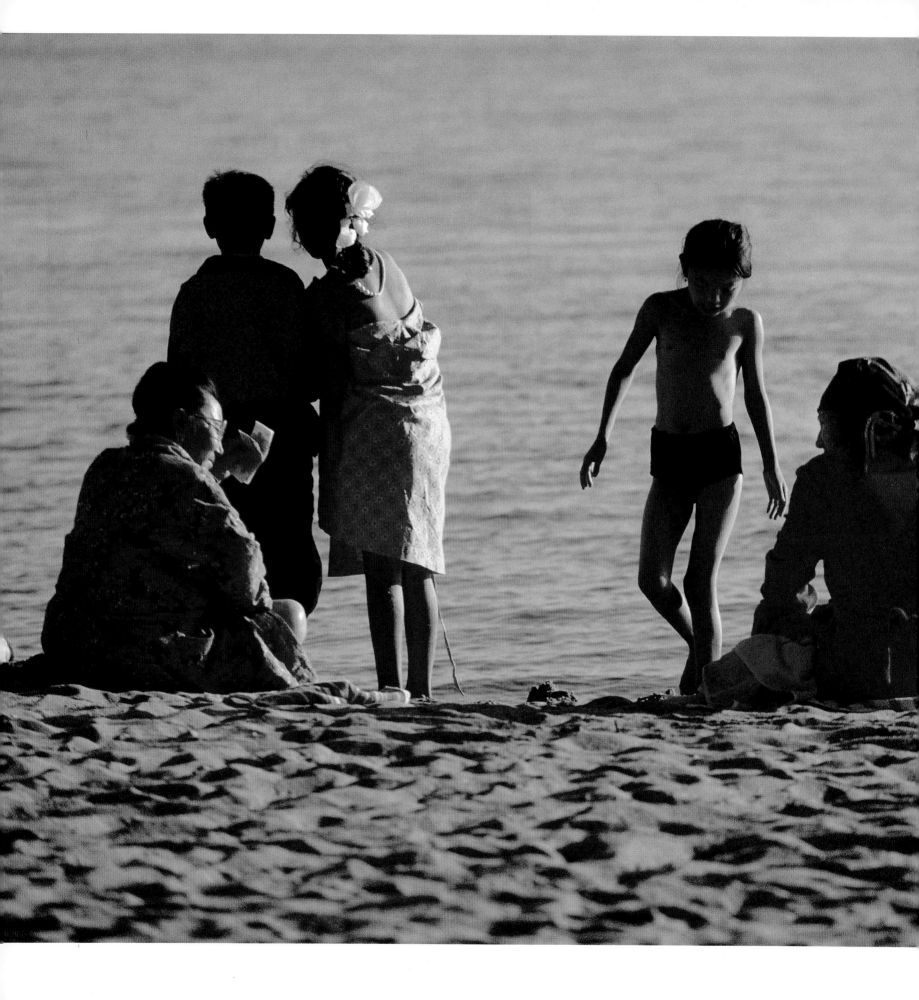

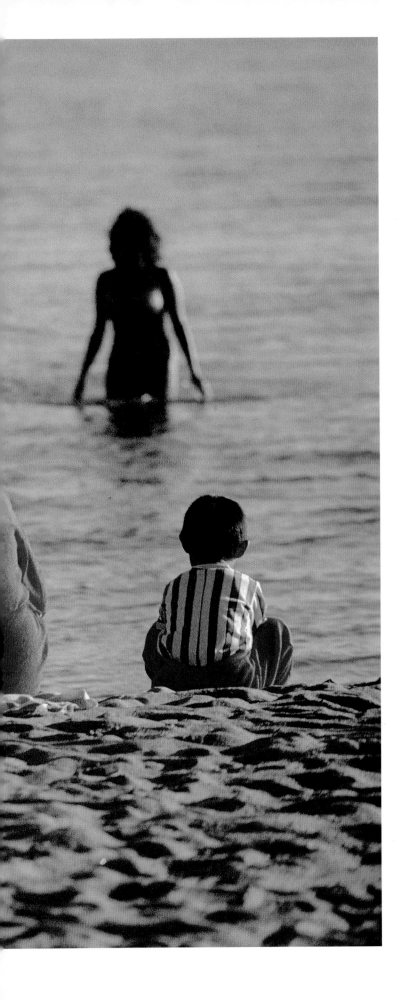

HUE AND CRY

If you think tonal control is powerful in digital photography, wait till you learn what you can do with colour. It is easily one of the most exciting things to happen to photography in its short but eventful history. You can achieve effects with ease, experiment as long as you like – all without using a drop of chemical or a scrap of paper.

Colour control: Levels

The interior of Gur-Emir, or Mausoleum of the Emir, in Samarkand, Uzbekistan. This heavily renovated masterpiece was lit by a mix of tungsten light and halogen spots. A simple automatic correction of the digital file removed the yellow-orange cast (visible in the un-retouched original below) and enabled the blues in the window and blue details in the cupola mosaics to be seen more clearly.

Canon EOS-1n on tripod with EF 20mm f/2.8 @ f/8, 3sec on KODAK Elite ISO 100

Better than anything else ever invented, computers can count: in imaging this gives us the power to analyse every single pixel and produce any kind of statistic that we care to programme. Colour balance then becomes a simple statistical exercise, not the exercise of trained eyes or carefully calibrated meters.

It is straightforward for software to discover that every pixel has a high component of yellow. A simple removal of yellow can transform the image from a heavily colour-imbalanced – caused by exposing a daylight film with tungsten light – one to one recording true colours. There are limits of course: if an image is so heavily colour-cast that there is little or no information for a certain colour, it will be impossible to correct without introducing artefacts or by manually reintroducing some colour information. Of course the same effects can be achieved in the darkroom, with, indeed, the same limitations. Experienced darkroom workers know that the best results come from using light or low values of filtration: the colours produced when heavy filtration is used are never very subtle or satisfying. The obverse of this is that one tries to produce colour correction in the darkroom by reducing a filter setting. In the computer, there are no such bounds.

As a result, you can colour correct by letting the software do the work or by correcting manually. Theoretically, the best way to colour correct an image in the computer is to use the readily available information on each pixel. You select a highlight pixel and read off the values for each separation: you know a neutral colour means you will have roughly equal values for each separation. Similarly, you check a neutral mid-tone and of course a deep black. A simple sum comparing the values enables you to work out how much to change the global values for a given colour channel. This procedure followed rigorously means you should be able to make colour corrections even on a black and white monitor screen. Few, however, are the photographers willing to work this way.

In practice, the colour calibration technique is the 'suck and see' method: change the image and watch the results of each change or manipulation onscreen. This is effective for most purposes, but you must remember the eye's great abilities to adapt to any overall colour. But be very aware that the nearer you approach to the neutral colour balance, the harder it is to see what effects your changes are having on the image. At least, your calibration should ensure that at least your monitor and printer are well matched.

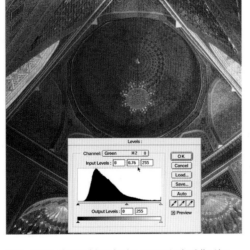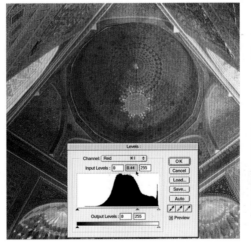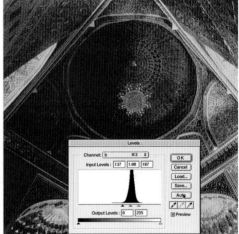

The green channel has been corrected while the red channel is left as it was in the orinigal scan image (left). The combination gives us a more natural rendering which is close to the result produced by the software on 'auto-correct' in the main image opposite. Note the shape of the histogram for the green is radically different from that of the red, next image, right.

The red channel has been selected and over-corrected, leading to the overall green colour cast. Notice that colour casts usually show up in the mid-tones first, as in the original scan image. Note the shape of the histogram indicates reds dominate the middle and some high tones, as we would expect from the appearance of the original scan (first image in this row).

Auto-levels do not produce the same effects with different image modes or colour spaces: here the image has been changed to L*a*b mode and each channel has been separately 'auto-levelled'..The result is unexpected (possibly due to programming errors): you obtain an extreme colour 'correction' which shows you cannot safely leave everything to the software.

Colour control: Curves

Extraordinary results from an
ordinary-looking control:
Curves is a powerhouse
of effects

Canon EOS-1n with 28-
70mm f/2.8L zoom
lens @ 50mm, f/5.6,
1/60sec on Kodak
Panther ISO 100 film

This wild-looking image, originally of an old motorcycle in a market in
Kyrgyzstan, is the result solely of manipulation of the image's curves. It
results from forcing a curve that is controlling all colours at once (the
master curve) into a shape similar to that shown in the smaller image on the
opposite page where the curve is applied to the green channel only. Although
you can save curves and load them onto any other image, I find it more
rewarding to apply new curves to each image as tiny changes in curve shape
can make a large difference to an image.

Curves offer you great (possibly too much) power over, and endless resources for, radical alteration of image colour reproduction. The secret to this power is realising that while the Curves control looks superficially like a photographic H&D or characteristic curve, it is little of the sort. In this context, what is important is that we can manipulate the response of each colour channel or separation totally independent of the other. Note that the channels can be changed totally without affecting another. You can invert one channel while putting another through several contortions and leave the remaining channels untouched. It will look weird, but then maybe that's what you were after.

Most photographers adjust the curves using only the master or all-in-one curve, that changes every colour channel by the same amount. Manipulation of a single channel is certainly more complicated: you can easily chase your own tail as you adjust one channel, then adjust another and have to return to the first to compensate for some untoward effect of the second change. But not only is it entertaining, if at any time you like the result, you can save the file as a variant, and continue playing away – it is all without a whiff of chemical.

For best results, you will want to work with the best possible scan which has not been compressed in any lossy regime such as JPEG. When you pull the curves about into extreme configurations, defects at boundaries or edges of the image are exaggerated and can intrude into your image. The square, quilt-like pattern left by heavy JPEG compression can, in particular, become very intrusive. Another issue is the bit-depth: if you have a choice – users of Photoshop and Satori do – work to the highest bit-depth you can. The file will be bigger and slower to operate on, but for these extreme curve settings, you will find that images with 12 bits per channel will give smoother transitions and fewer artefacts than images opening at 8 bits per channel.

Note that you can work in any colour space that your software permits: as we saw in the previous spread, working in L*a*b space can give unexpected results. Some software allows you to manipulate in HSB space as well. Or you can try converting your image into CMYK space and manipulating the curves there: as you are working with the secondary colours, the results – being based on cyan, magenta or yellow – are softer and not as violent as results from RGB space, where the effects are blasted at you with vivid reds, blues and greens.

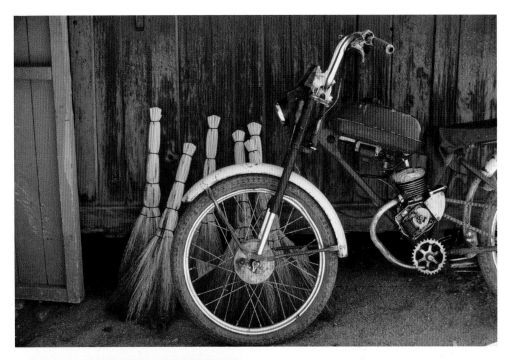

While the original image, top, is quite attractive enough, its strong and simple shapes makes it a good candidate for Curve manipulations. Note that in contrast, objects such as faces and other organic body shapes produce unattractive effects with Curves as the sharp colour contrasts overly distort the form. To produce this image, the green channel curve was heavily manipulated as shown, plus small changes in the red channel.

In the shade under a bright sun and clear sky, this photograph carries a strong blue cast because the illumination reaching the areas in shadow must come not from the sun but from the blue sky. As a result the illuminant is rich in blue and weak in reds. This kind of cast is often a problem when you have a mix of directly lit areas with shadows because it is difficult to correct the shadows without spoiling the bright areas. In this image, the cast is even – there is nothing in the the sunlight – and it is not too objectionable because of the strong and contrasting colours in the brushes and bike. A simple adjustment in Levels corrects the overall colour cast.

Hue and saturation

Trial images prior the final image. Top: the original global hue was changed to -90° (i.e. reds turn to purples and blues to green) and above: the hue was changed by –180° i.e. the colours were turned into their complementaries. These controls are very powerful: more subtle control comes from selecting colour ranges instead of changing all colours simultaneously.

Actually, the name is incomplete: in Photoshop for example, the controls are actually three in number: hue, saturation and lightness. This corresponds to the old colour-space model of hue, saturation and value (or brightness) which is now largely superseded by other models. But it does have the merit of being so easy to understand it is almost self-explanatory: hue controls colour name, e.g. changing from blue to blue-violet, saturation measures how rich or intense the colour is, while value or lightness measures how bright or dark it is.

This control is rather underused, perhaps because it is not well understood, but I reach for it whenever I am balancing and adjusting a set of images, especially those from a scanning session. I use it because often no amount of adjustment of the Curves or Levels controls will brighten up the image satisfactorily – what is needed is a slight upwards tweak of the saturation levels. Alternatively, if overall colour balance needs adjusting, it is often easiest to change the Hue setting for the entire image than to tinker with the Curves or Levels for separate colour channels: this method is not as scientific or precise, but then few of us are here to learn the pre-press disciplines. Our real interest here is how this, and other controls, can enable us to create images which we could not otherwise have made.

In version 5 of Photoshop the Hue and Saturation control is particularly powerfully implemented, because you can select a range of colours whose hue you want to change. For example, suppose you select the red channel: changes you make will affect a range of red colours only, but you can extend or restrict the range manually – either by dragging the slider controls or by using the eye-dropper tool to add or subtract colours.

As a result you can produce effects similar to powerful chemical toning or colouring agents, the best known of which is Colorvir. The main technical issue to watch is colour gamut: as you raise colour saturation to high levels you will see your image turn into patches of even tone with no gradations: what has happened is that you have exceeded the colour gamut of your monitor screen and, indeed, that of your colour space – between them, they are unable to show variations in colour. Now as your monitor can show a larger gamut of colour than any printer (i.e. a wider range of colours), you must be prepared to be disappointed that the brilliant effects you see on screen are impossible to reproduce on paper, especially the pure, bright hues.

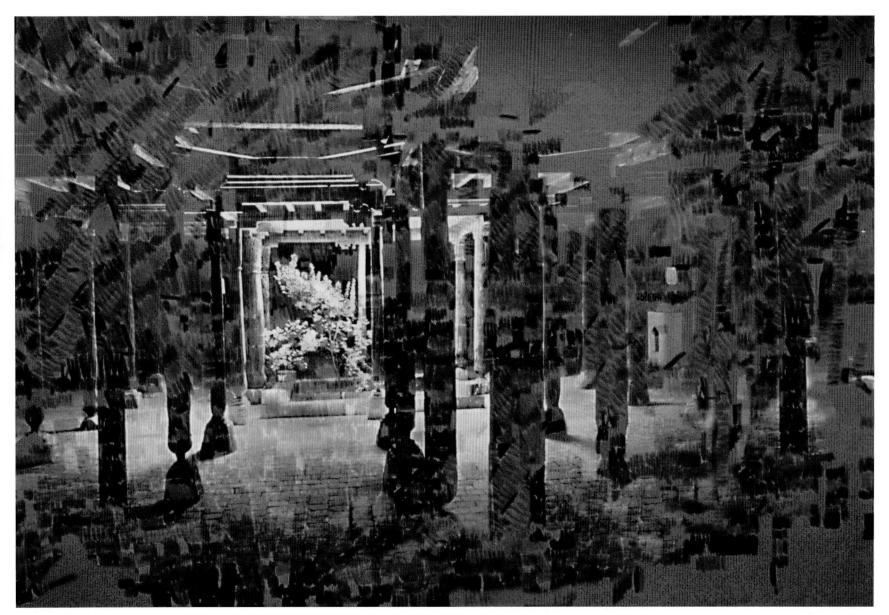

Working in the other direction, you can reduce the saturation and richness of colour – this is useful if you want to create a background image for your web-site (and incidentally, you may be able to benefit from having a smaller file) or desk-top picture. Now, if you desaturate all the way, you are effectively discarding all the colour information while your image remains in a colour space. This is a neater approach to creating a monochrome image than going through the rigmarole of changing image mode to greyscale and then having to return the image to colour.

The base image was taken within the great Djumah Mosque of Khiva, in Uzbekistan, and then combined by double-exposure in a conventional SLR camera with a pencil drawing. The resulting image on transparency was put through the Hue and Saturation wringer, with many global and local changes of both hue (in the lighter areas of the mosque) and saturation (in the drawing) as well as local burning, dodging and saturation plus cloning here and there to tidy up the image.

Canon EOS-1n with 24mm f/3.5L TS lens @ f/8, 1/4sec on Kodak Elite ISO 100 film

Changing the colours

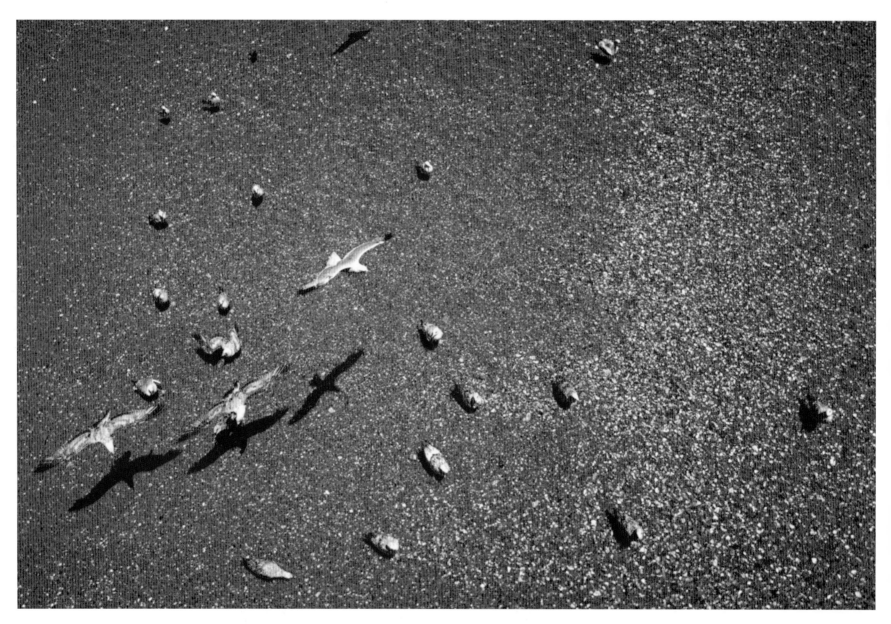

Contax RTS with 50mm f/1.4 lens @ f/5.6, 1/250sec with Fuji RDP ISO 100 film

A group of gulls riding the breeze under Brighton Pier were photographed from above in brilliant sunlight. The golden colours of the pebbles seemed rather predictable and I wanted a return to the blues of the sea while keeping the textures of the beach. The final image is the result of multiple passes of the Replace Color adjustment: this was necessary because it was not possible to select all the different colours of the pebbles in one move. Notice how the resulting simplification of the colour scheme brings out the shapes of the shadows and individual gulls.

One of the lesser-known methods of colour control is Replace Color, available in Photoshop under the menu: Image > Adjust > Replace Color. (Strictly speaking, it is not a selection method as you do not create a selection as such, but for it to work, Photoshop must first make a selection.) With this control activated, you click on a colour and the control selects every pixel in the image with the same colour. You can set the 'fuzziness', i.e. how tight a selection is made: low fuzziness selects pixels of very similar colour, high fuzziness selects a wider range. Once you've made your first selection, you can finesse it by adding colours or subtracting them from the selection. You will see that the controls are very similar to that of the Hue and Saturation command, and indeed Replace Color is essentially a version of Hue and Saturation applied to selected colours.

Now, one of the great strengths of Photoshop is that nearly every control's settings can be saved, and Replace Color is no exception. You can therefore save a setting you find particularly effective and then load it onto another image altogether. The results can be unexpected and therefore well worth experimenting with. Furthermore, you can repeatedly load the same setting onto an image, which can give effects which are not easy or possible to achieve with one setting applied only once.

A related control is Selective Color: this is essentially a variant of the hue control in Hue and Saturation: the colour range is selected for you, but you have a greater control over the colour changes you can make. You find it under Image > Adjust > Selective Color: it is worth visiting if you are finding it difficult to adjust the colour balance or overall tone colour.

You can take the concept of selecting colours a step further by turning your choice of colours into a selection proper i.e. it can be saved as an alpha channel, meaning it is a greyscale record that behaves as a mask or, in other words, it is an channel whose job is to control the opacity of the rest of the image. It is found in Photoshop under: Select > Color Range. This dialog looks like a cross between Replace Color and Selective Color and allows you to save the selection. With the selection loaded, you can then turn to other adjustments such as Levels or even Curves to make the adjustments you need. Note that one option is for Color Range to find out-of-gamut colours. This is much more useful than the old 'out-of-gamut' display as it allows you quickly and easily to make the requisite changes to bring the colours back into line.

The original image (above) looks like an easy candidate for the Replace Color adjustment but in fact the broken-up structure of the image due to the pebbles meant that three passes of the adjustment were needed to catch the range of sandy colours.

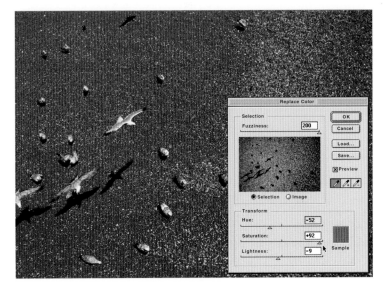

One of the early attempts, showing the selected colour replaced with red whose saturation is raised nearly to maximum as is the fuzziness control – to catch as many pixels in one pass as possible.

Colour of infra-red

Pictorially useful but inconvenient to implement conventionally, the 'infra-red' look is easily simulated digitally

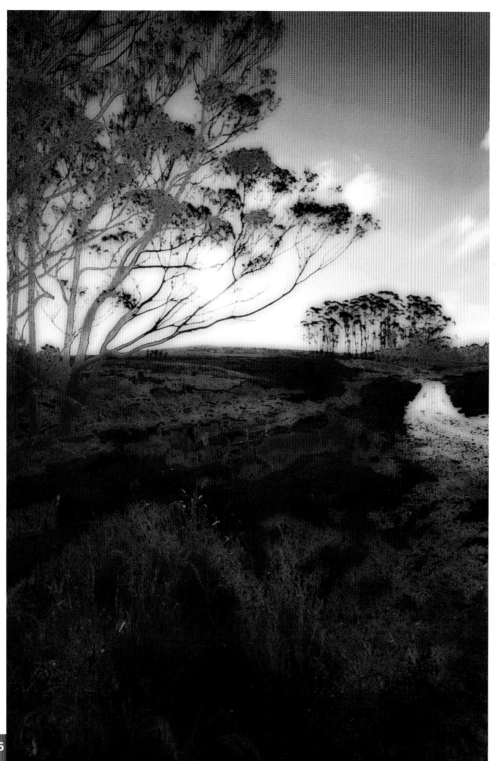

When you see an image taken on infra-red film, you see the rare sight of scientists at play. The fact is that infra-red is invisible to us: its wavelength is over 700nm, longer than the eye's higher limit of 680nm. So the question is not 'what colour is it?' but rather, 'what colour could it possibly be?' Nonetheless we have no problem making our films or sensors sensitive to infra-red. For a long time, we have had infra-red sensitive colour films. So the problem of what colour to make infra-red was solved in playful fashion – the various bands of wavelengths were allocated arbitrarily to various colours. With many infra-red films green objects (absorbing high amounts of infra-red) are shown as blue, red objects are green and infra-red light from objects is shown as red. The result typically looked weird and wonderful.

By similar tokens, a black & white infra-red film reversed usual tonal values, such as producing brooding dark skies (because it eschews sensitivity to blues to make room for the infra-red) or gave unexpectedly light renditions of subjects like trees.

The point is not that such effects are easy to produce digitally, but that the effect can help direct or inspire our image manipulation. You can use either the Replace Color control or by manipulating the ever-versatile Curves control. Closer to the original notion of matching waveband to colour separation, you can change colour values using the Hue and Saturation control. Digital simulation avoids the limiting characteristics of infra-red photography: the need for heavy filters that make it nearly impossible to see what you are doing if using a single-lens reflex camera (apart from Ilford SFX film, which responds to near infra-red and can be used like normal black & white film), the limited film choice and non-standard processing for colour films.

However, there is another characteristic of infra-red photography which was part of its charm although it was actually the symptom of an optical defect. Most infra-red photographs are unsharp: highlights were surrounded by a diffused blur. The reason for this is

A landscape in New Zealand with blue sky and foreground grass mostly in shadow was transformed to 'infra-red' colours using the Hue and Saturation controls to select a range of colour and changing them one at a time e.g. blues to purple. The shadow areas were selected with the Magic Wand tool in order to lighten them.

Canon EOS-1n with 17-35mm f/2.8L lens @ 17mm, f/8, 1/125sec on Kodak Ektachrome ISO 100 film

that no commonly available camera lens can focus infra-red light as tightly as it does visible light: as a result, infra-red rays create a blurry halo around the focal point – a classic example of longitudinal chromatic aberration, in which focal length varies with the colour of light. (This is why many lenses have a little red mark next to the main focusing pointer: this red mark is the focusing reference when using infra-red film.) In the images on this spread, the aberrational blur was simulated using a digital filter.

A dramatic mountain valley in Tajikistan was photographed early in the morning, when the sun lit up one side but had not reached the rest of the valley. The colour scan was turned into greys using the Hue and Saturation control. Then, Using the Curves control, I made the sky very dark while the areas in the sun became bleached out. The softness in the image was created in KPT Gaussian Glow: left to itself, the filter creates too marked a blur, so it was reduced by using the Fade control, to reduce the filter effect to some 60%, which leaves the softness without losing too much detail.

Canon EOS-1n with 28-70mm f/2.8L lens @ 35mm, f/8, 1/60sec on Kodak Ektachrome ISO 100 film

Hand-colouring

The image above shows the colours as applied to the Color Mode layer lying on top of the background layer (the grey squares indicate transparency in the layer): the airbrush strokes could obviously be cleaner, but as the Color Mode only adds colour where there is density, colour does not spread into highlight areas. In addition, when the two layers were combined, the upper layer was set to only 24% of opacity i.e. the colours were very weak. The top image shows the result of setting the opacity to 100%, with an increase in saturation, which mimics the effect of deliberately over-colouring a print.

Even as people gazed in wonder at the first photographs the world had ever seen and as they were marvelling at the fine detail, they simultaneously noticed the lack of colour – and complained of it. The force to get a brush in their hand and find some paints must have been irresistible: some of the earliest daguerreotypes are tinted with light, hesitant strokes of colour. In time, hand-colouring prints became something of a form of art in its own right, with its own little vocabulary of 'permitted' tones, its language of what should or could not be tinted. And because it required skill and steady application, hand-colouring tends to be the preserve of the artistically capable, to those unchallenged by having to hold their hand steady and stroke with finesse. For the fact is that the slightest slip could cost you the entire print or – as with any handicraft, the stern test is being able to get to the end of the job without mishap. The more you invest, the more you lose should a lapse in concentration come late in the process.

For better or worse, hand-colouring in the digital domain eliminates all such risks. It allows you plenty of virtual experimentation without any commitment and, of course, it is as clean and unencumbered by pots of dried-out paint as any process could be.

However, there are some points to watch. Many photographers make the mistake of painting directly onto their image with the brush tool set to normal: this never works well because you are switching the pixel values of your image directly into the brush colour. You may then try painting into a layer: this does not help much, even if you change the opacity in an attempt to make the effect more subtle: it still appears as if the colour has replaced the image. What you need is to add the colour values in your brush to the greyscale values of your image without changing the luminance. That is the job of the Color mode.

There are two ways of doing this. The most direct, and most like actual painting, is to set your brush mode to Color (by default it is at Normal) and then paint away: this is satisfying and direct, but it tests your skills: can you back-track if you don't like a result? Actually you can, but it's not the obvious erase or use of the History palette: you can simply use the Desaturate setting of the Saturation or Sponge tool. But I prefer the other way, which is to create a new layer above the image and paint directly into that once I have set the layer mode to Color. This makes it possible to erase any errors without any damage to the image itself.

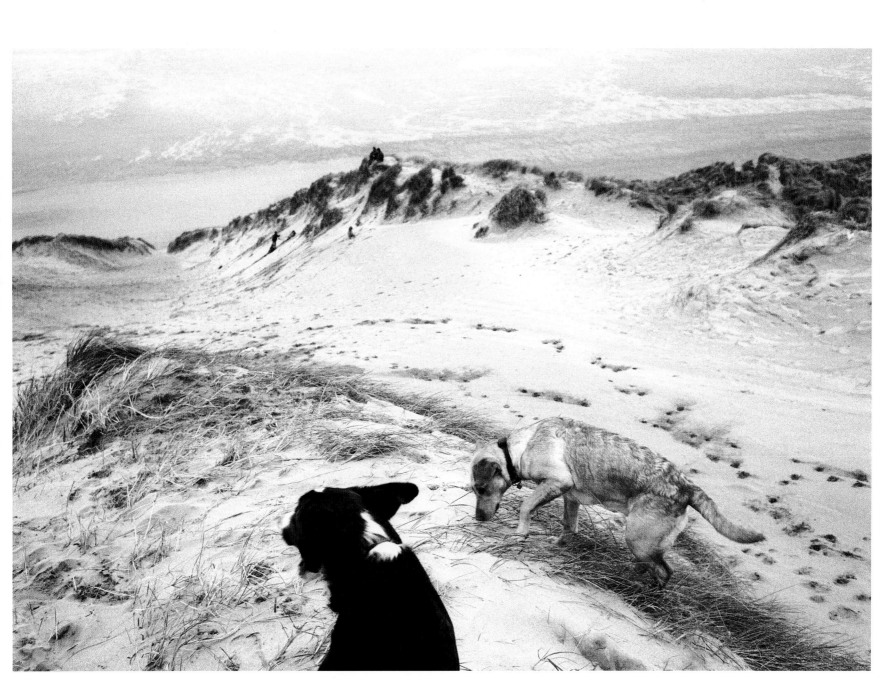

Note that pastel shades are often out-of-gamut with ink-jet and colour monitor screens. You may need to work with barely visible subtleties for the printed result to look soft enough. As yet, the truly fine, porcelain-textured finish of a good hand-coloured print is still beyond the reach of ink-jet printers. Careful use of papers with tinted bases can help, as the tints will narrow the dynamic range and soften up all results.

Taken on a wind-swept beach in Cornwall, walking the dogs: this image depicts a wide expanse of space and openness largely through its composition. The lens is only moderately wide-angle, but the sparseness of the main part of the image and the sweeping lines of the sand-dunes and footsteps in the sand work to suggest a wider view. As a straight black & white image, I felt it lacked warmth, that it was too bleak: a touch of colour here and there gives the image more fluidity.

Leica M6 with 35mm f/2 lens @ f/8, 1/60sec on Ilford Delta 400 film developed in T-Max developer

IMITATING ART

If art imitates life and life
art, technologies like to
imitate both art and life.
Visual technologies are
usually driven by artistic
ideals, often determined
by parameters set
a long time ago by
classical theorists and
encouraged by the
thought that advances
should at least mean
that it will be easier to
achieve a given goal
than before.

Blur/sharpen

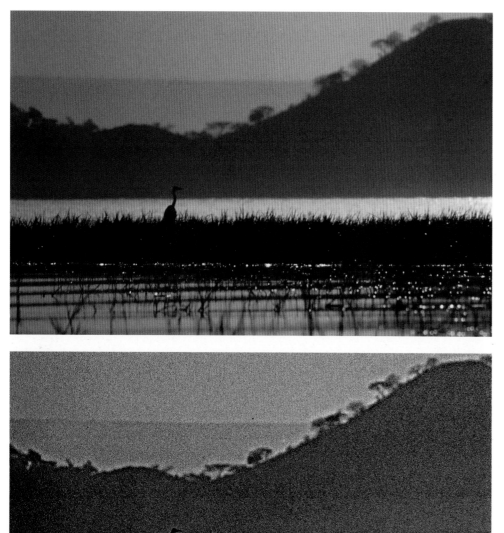

Top is the original scan which, although excellent, is soft because the original image itself is soft. The result of too much unsharp masking is shown above: note the film 'grain' itself has been emphasised and even the tone distorted.

To those of us who have struggled all our working lives with getting the sharpest possible results from our lenses, there is something alarming about the way in which an image on screen can appear improved with the simple click of a mouse. Of course, it is something of a chimera: there is no real increase in the amount of information in the image. But what information is there is indeed put to better use. In fact, edges are defined with more clarity through improvements in local contrast. Blur effects do the opposite: they make an image less sharp i.e. boundaries are less distinct, lower in contrast and there is loss of detail visible after the blur has been applied. Note that blur can paradoxically be used to make an image appear more sharp: sometimes if you make a background much blurred it causes the foreground image to look sharper than it really is.

Digitally, the blur or sharpen effects are true filters in the sense that filters hold back a certain thing but selectively let something else through. In this case, a sharpen filter is a high-pass filter, meaning it passes high-frequency or detailed information, but holds back low-frequency or less detailed information. Blur filters work the opposite way.

Sharpening effects can be implemented in different ways. Some look at edge data and simply increase contrast. Others, like Unsharp Mask, take a whole grid of pixels at once and performs a calculation designed to increase edge definition without introducing artefacts.

Like any other effect, it is possible to overdo sharpening. An over-sharpened image takes on halos which are not unlike Mackie lines or edge effects in conventional photography caused by processing in high-energy developers at very low dilutions. In digital imaging, you can avoid the worse effects of a halo by sharpening in one colour channel only. So which channel do you choose? Of all the channels to use, the best one for our purposes should be the one that carries the most detail information, that is the one that best defines boundaries and transitions. Such data is more likely to be found in the green channel than in the other two. This is deliberate: green is the colour to which our eye has its highest sensitivity and yet finds most restful: green is the channel in our own eyes that carries most of the high-frequency data. Try sharpening an image only in its green channel, rather than in all channels. Not only will the sharpening be cleaner than with three channels and sometimes more realistic, it will also go much faster.

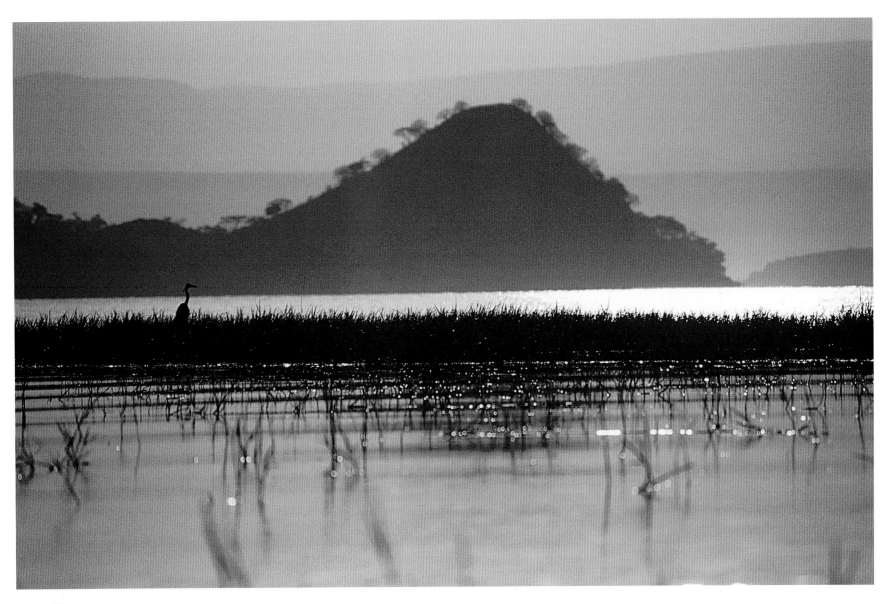

How to make better blurs

The Blur filter makes details blurry or fuzzy – appropriately enough – but this seldom looks good when applied to the whole image. An alternative method is to increase the size of the image by, say, 200% to 300%, with resampling ticked and bicubic or bilinear interpolation also ticked. Next you reduce the image back to its original size and check its appearance. Repeat this as necessary. This method gives a softer image yet with more subject detailed retained than that given by the Blur filter.

A Great Heron looking for breakfast on Lake Baringo, Kenya, is caught as a silhouette. A modest amount of sharpening improves considerably on the original image which was taken at the extreme end of a zoom lens from a gently rocking boat (it is quite amazing the image is at all sharp). Note how the sharpening has given a very slight fringe, or pseudo-Mackie line, to some of the higher-contrast boundaries such as the heron itself.

Canon F-1n with 100-300mm f/5.6L zoom lens @ f/5.6, 1/125sec on Fuji RDP ISO 100 film

Pixellation

If all light is good light,
as the great Ernst Haas once declared,
does it follow that
all defects are good defects?

Close-up views of two examples of Pixelate filters. The effect of the Pixelate > Crystallize filter on the main image (opposite) is shown top: the size of the crystal 'faces' can be altered. The Pixelate > Mosaic filter is very often used to introduce the deliberately pixelated look. The size of the 'pixels' can also be set as desired.

Usually treated like some kind of disease you should avoid, pixellation is actually a visual characteristic which has its uses and value ... in the right place and right time. In the narrowest sense, pixellation occurs when the individual pixels of an image have been enlarged to the point they become visible. This means that where we expect to see transitions of tone we see sudden and stepped changes or only solid patches of colour and, of course, the patches are shaped as regular squares, not as irregular in shape or random in size corresponding to what you would expect from the stochastic variations of a silver-based image.

With pixellation effects, we take the notion of regular patches of colour and exploit it for graphic ends. Essentially, each filter defines an area: it can be regular, like a square, or irregular in size and shape – like a crystal face – within each these areas, everything is the same colour, usually derived from the modal (i.e. most frequent) or average value of colour. In some applications, that area can be of a size you can set, others limit you to a fixed, standard size. The filter then looks at all the colour values within the area it is working on, then calculates a value that applies to the area. Next it looks at the adjacent area and works out the new value and so on.

Within the Filter > Pixelate menu of Photoshop, there are a couple of effects that usefully mimic printing processes: the colour half-tone and the mezzotint. These are very handy for the quick simulation of photo-mechanical processes and are much loved by fine-art workers for their controllability, ease of use and reliability. Remember that these effects need not be ends in themselves, but can be the basis of more complicated images using, for example, the mezzotint texture as a background for the final image.

Note that as pixellation effects break up the outlines of an image, they are best applied to subjects with very clear and easily recognised shapes such as sailing boats, flowers, still lifes with pottery and so on. The effects also tend to work best when the image has strong colours.

As with most filter effects, applying the filter is just the start of the process: to turn the result into a working image, you are likely to need to adjust the tonality of the image both overall (adjust Levels or Curves) as well as locally. Most of the time you will want a viewer to respond to the image, not to the filter: care with tonalities is, as always, a key element of image construction.

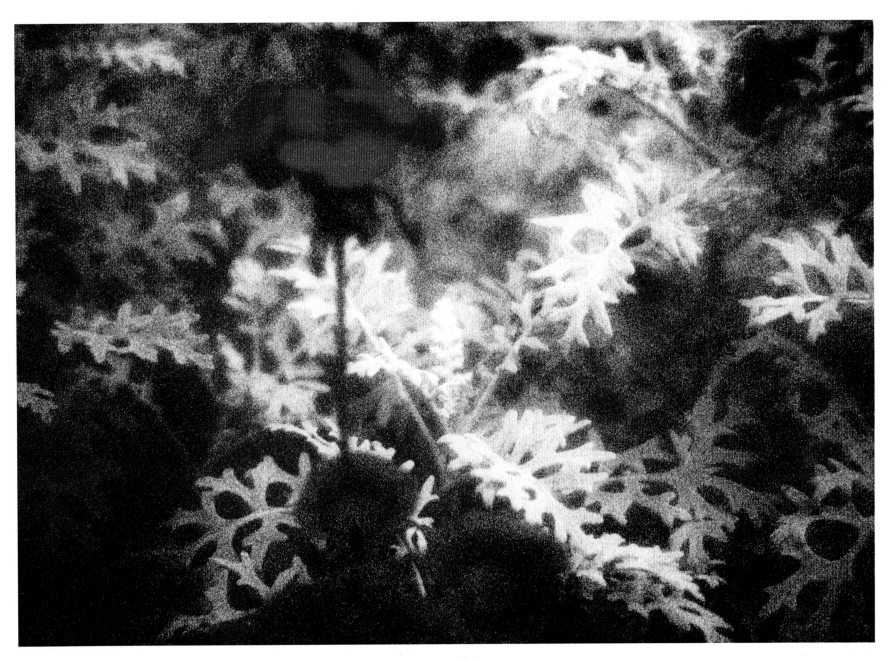

A deceptively simple-looking image, at least as far as its technical history is concerned. Originally shot on Polachrome, it was then duplicated onto normal ISO 100 transparency stock. After scanning, the image received several passes of the sharpening filter, then contrast was heightened using Levels. Next the Pixelate > Facet filter was applied (which runs pixels of similar values together together – all with the view to increasing the graininess of the image. Finally, I could not resist giving it a last tonal adjustment, using Levels.

Canon F-1n with Sigma 70-210mm zoom lens @ 210mm, f/4.5, 1/2sec with softening filter on Polachrome ISO 32 film

Distorting transformations

Distortion is
useful for correcting
defects in the
image's geometry

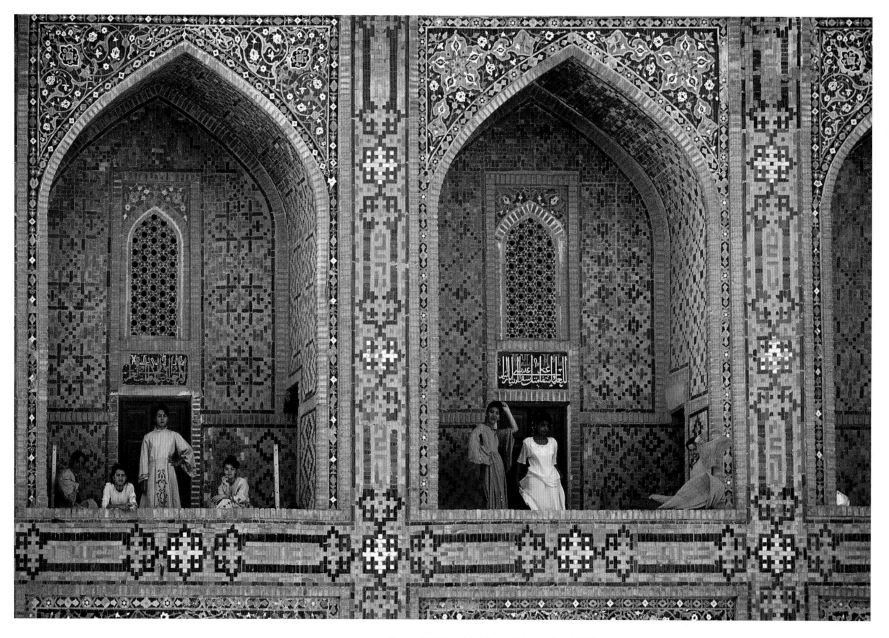

Canon EOS-1n with 80-
200mm f/2.8L zoom
lens @ 180mm, f/4,
1/125sec on Kodak
Elite ISO 100 film

High on the third level of the great Tillakari Madrassah of Samarkand were
several belles of Uzbekistan waiting for their turn to perform at a concert.
While the angled shot may appear more lively and 'real', when I was making
the picture I was wishing I could correct the distortion. This is due to
projection geometry: objects further away from the film appear smaller than
those near the film, so if a regular object like the front of a building is not
exactly square onto the camera, you will find the projected image is
distorted. Note that this is not a defect of perspective.

One of the joys of digital photography is that it offers tools and effects which you would otherwise not have thought of. There are teams of numerous clever programmers and others more or less mad whose life is centred round their computer, dreaming up effects and ways to achieve them. Most of the effects need never trouble your life. But now and then you will see something that resonates in your mind and you think: 'I should try that some day.' Many filter effects are like those camera functions that take such a long time to describe and even longer to understand, you can only wonder what is the point. Then one day a problem turns up and you will be glad someone provided just the solution you need.

Most people treat the 'transform' tool only for resizing or the occasional distortion of an object before it's placed in a montage or composition. But it has a use that neatly solves one of the problems we all have to suffer in silence in photography: namely the projection distortion caused by not having the camera square to a geometrically definite subject such as a building or painting. If the camera is not square to the subject, the plane of the film is not parallel to the main surface of the subject which means that one side of the film is closer to the subject than the other. In this set-up, the part of the film nearer the subject receives a somewhat larger image of the subject than does the part of the film further away: this is the source of the distortion, which causes regular shapes to look skewed or distorted.

In the darkroom, you may try to compensate for the distortion by tilting the baseboard. The usual method is to prop one corner of the board it on books and magazines or else tilting the negative stage (if your enlarger allows it) – or both. This is awkward, as it is very difficult to workout which part of the image to focus on, the limited depth of field greatly hampers the range you can work in and it looks plain embarrassing to be caught in the darkroom with baseboard balanced on old books. In short, in this case, darkroom manipulations are not the right answer and have only ever been a last desperate resort – which is why there is a still a good trade in cameras offering lens movements.

Digitally, the technique is as clean and simple as you could wish: it is a combination of careful cropping, allowing for losses at the corners if you have to rotate the image, followed by distortion of the entire image. It is simple to do and effective on any size of image or resolution, provided your computer has the requisite fire-power should you work with very large files.

The angle of the shot – upwards and to the side – caused the converging verticals and horizontals. The distortion gives the image a certain liveliness. However, compare with the main image to judge which is preferable: the correction took less than a minute to complete in the computer.

The image was selected using the Marquee tool, then transformed using distortion or transformation tools: the above image shows the effect of taking a distortion the 'wrong' way.

Sabattier effect

A misunderstood and obscure darkroom
effect lay dormant for seventy years
until an artist of genius
saw its potential

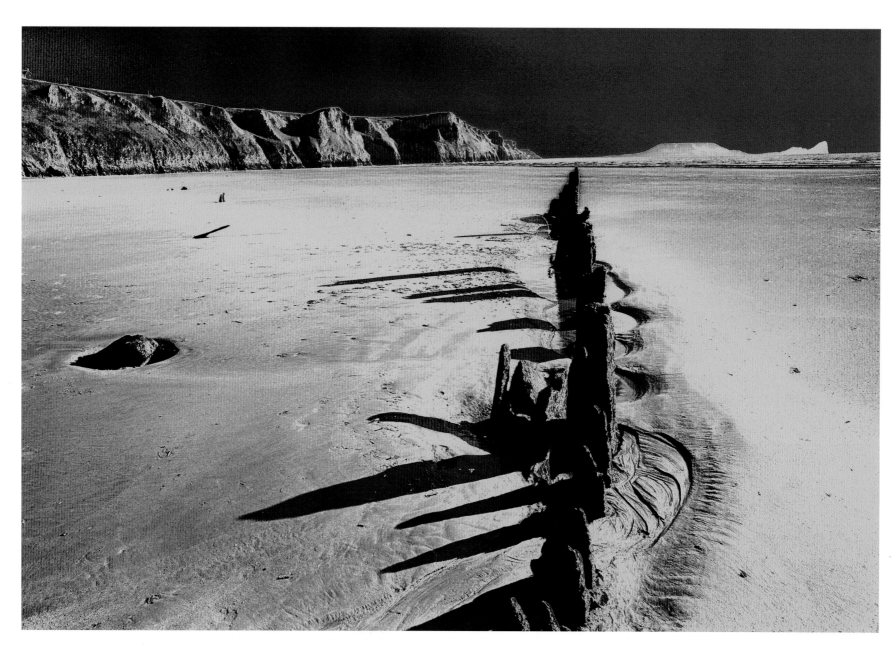

Canon F-1n with 20mm
f/2.8 lens @ f/11,
1/30sec on Kodak
Technical Pan ISO 25
developed in
Technidol

The ribs of a shipwreck stick out like the bones of an uncovered dinosaur at low tide in southern Wales. Many shots taken on this roll were spoiled by uneven development as the extremely fine-grained film was very sensitive to processing conditions, aggravated by the large expanses of even tone in this image. The digital 'Sabattier' effect here turns the mood of the landscape from the sunny, open scene into one with literally darker overtones. As typical of Sabattier effects, some of the tones (and hence the corresponding colours) have been reversed while others have gained in contrast.

The great mystery is why the effect is not known as the Man Ray Effect, as his technique and models are by far better known than anyone else's. The effect was in fact discovered over 70 years before, by one Armand Sabattier. He found that when a partially developed print is exposed to light, the tonalities reverse because the developed areas are desensitised but the relatively undeveloped areas can be further developed. Because Sabattier described the effect, correctly, as pseudo-solarisation, less precise writers have called the 'solarisation' (the reversal of image tone due to extreme overexposure). On the other hand, a technical pedant would also insist that the Eberhard Effect (variation of density related to size of the area being developed) also occurs. What Man Ray did was a variation of the Sabattier Effect: when his beautiful girlfriend opened his darkroom door without warning, he shut the door and continued to develop the print, resulting in a combination of negative and positive image.

For the darkroom worker, the Sabattier effect is notoriously difficult to control. That may be part of the charm, but it is difficult to feel charmed when faced with two dozen prints, none of which look remotely like the first one you made and are trying to copy.

There are several techniques for simulating the Sabattier effect. One way, using Adobe Photoshop, is to work with two layers: the bottom layer is your original image, the upper layer is a duplicate of it. You can then play around with layer modes: the most dramatic is Difference layer or, for a softer effect, you can try using Exclusion. You can adjust tonality by altering Curves or Levels for either layer. Another method is to create an Invert Adjustment Layer above the image: you can than erase the parts you want to appear positive. The easiest method is to go to the Curves control and draw a meniscus, i.e. the profile of a saucer, with a more or less pronounced dip in the middle. Small irregularities in the curve make interesting effects (see right).

Thus image-manipulation software give you predictability. The question is exactly what kind of predictability do you need: if you need to produce multiple prints that look exactly the same, then digital effects will deliver – with the usual provisos about keeping qualities. But is it appropriate to look for predictability in the effect itself? With a little experimenting you will learn no two images require exactly the same effect. You need to experiment and here you will find the greatest benefit of digital working: you can experiment without limit and without using a drop of chemical.

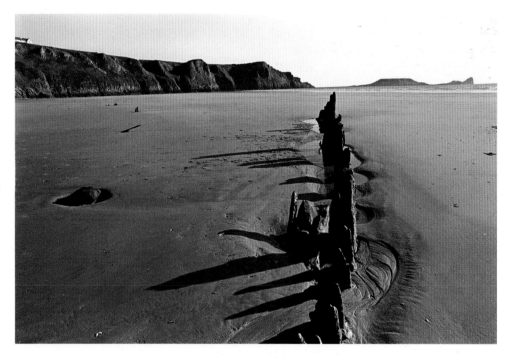

The original image was a black and white negative: after scanning, the image was turned into a duotone using an orange for the 'second' ink to produce the very warm image (above), then converted to RGB colour. This was the basis for the image opposite, which used a curve like one shown below.

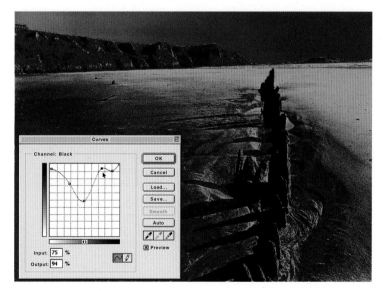

This shows the result of applying a 'Sabattier' curve to a black and white image: note the white fringe to some of the edges – the 'Mackie' lines characteristic of the Sabattier effect.

Paint textures

A picture's meaning is borne on several inter-relating layers: literally under the image itself is the texture. This is the contribution from the supporting material whose role is to provoke a sense of the physical nature of the image. And with each kind of material comes an implied history of the image's genesis: if a canvas, then it suggests that the image has been painted, probably in oils. If the paper is a heavily grained laid surface, it suggests drawing was the creative medium, and so on. Creating a sense of the support texture is relatively straightforward in digital manipulation: at it simplest, you superimpose an image of a texture unto your image. The way to control this is to use different Layer modes (see pages 84-5). You may also want to make more of the surface effects by using lighting effects – as if there is light shining on your image and casting shadows (see pages 88-9).

An image's texture is not, however, gained solely from the support material itself. The texture can also come from the way the image is constructed: on top of the canvas surface, the oil brush provides its own texture as each stroke builds up the image. In the nature of silver-pixel work, one can imitate textures build up of repeated elements more easily than large single ones: thus you can take a fair stab at the tiny strokes of a pointillist effect or the bristles from an oil brush, but the large washes of watercolour are altogether much more difficult to simulate. The Art History Brush in Photoshop v5.5 offers an attempt to match the power of software such as Painter and is useful for quickly producing paint-like effects.

If you want to imitate natural media, the most effective way is to rebuild the image using the digital equivalent of such media (as described on pages 80-1) using natural media cloning. Here we apply textures to an entire image at one time: all that one can do is to suggest the paint textures: this is useful when you need images that will be used in the background, not to stand by themselves.

The brush and artistic filters in Photoshop are cumbersome compared to those available in plug-in software: Paint Alchemy from Xaos Tools, which produced this image, is simple and effective. The brushstroke is a gradient whose colour is taken from the image - thus each 'stroke' fades like a typical brushstroke. The size and orientation of each stroke as well as colour was randomised. Version 5.5 of Photoshop offers the Art History Brush for creating paint-like effects.

Often textures are more easily controlled when applied to a layer above the main image: this can be a duplicate of the main image or a plain coloured layer. The easiest way to create such a layer is to make an empty layer, then fill it with colour using the Bucket tool (in Photoshop) or other fill command. Note that some texture effects are surprisingly demanding on RAM: the entire image may need to be loaded into RAM or virtual memory before the texture can be applied, if you are only experimenting, work with small files until you know what you want.

Finally, don't forget that the application of an effect is often only the start of an image's transformation. You can usually enhance or exaggerate any the effect by applying sharpening filters or blurs or other texture filters. Note that applying a filter with relatively low settings repeatedly can give quite different and more marked results than applying a filter once but with high settings. I find that after all the manipulation, I almost always have to return to either the Curves or Levels control in order to fine-tune the tonal balance, usually to adjust the black output level.

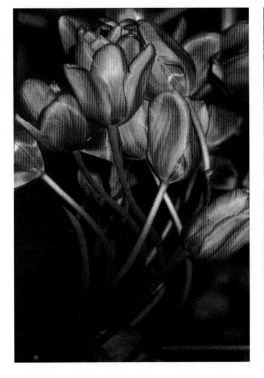

Canon F-1n with 80-200mm f/2.8 Tokina lens @ 120mm, f/5.6 with flash on Polachrome film

A bunch of tulips, bursting with good health at the Chelsea Flower Show, were photographed by electronic flash on Polaroid Polachrome film. After processing (which takes place in a portable box), the 'instant' slide was duplicated onto normal transparency film using the Beseler Dia-Duplicator. As the Polachrome is extremely dense by the usual standards of transparency film, this requires multiple flash exposures in the duplicator. The result is an image with bright contrast and high colour saturation over a limited palette that is characteristic of the Polachrome's additive method of colour synthesis.

The textures in this image are not particularly painterly in the sense of being imitative of what an artist might do, but the individual treatments are derived from paint textures. To achieve this, I created a layer over the base image, then filled this upper layer with black. Next, I applied a large level of noise so that the Artistic filters had something to 'bite' on and set the layer mode to Color dodge at a low opacity of 20%. This complicated sequence altered the image tonality and texture all at once, while giving me a level of control through the opacity setting and the Levels of both layers.

More convincingly 'artistic' than the image above left is this (above), the result of applying the Watercolor filter. But that was not all: to enhance the filter's effect, I applied the Sharpen Edges filter five times. This naturally caused the edges to look pixellated (i.e. individual pixels stood out), so a Blur filter was then applied to make them disappear. I then repeated more applications of the Sharpen Edges filter and once more applied the Blur filter. Even this seemed not enough, so I applied this sequence once more. The net result was to accentuate the 'brushstroke' impression – from watercolour but still paint-like.

Give us more grain

Grain in images –
like pixellation – seems like something best
avoided. But it has its uses and
even artistic value

Canon F-1n with
350mm f/5.6 mirror
lens @ f/5.6, 1/30sec
on Polaroid Polachrome
EI 40

The image of poppies bursting with colour in the afternoon sun is in fact too
bright, too brilliantly red in the version opposite (top image) as the
duplication step has increased image contrast while the film is over-
saturated. The image above used a great increase in grain in order to reduce
the strength of the reds while at the same time promoting texture into the
light wall to the left and the deep shadows to the right. A mix of
monochromatic and random grain was applied, together with slight tonal
controls to improve the contrast which appears to fall with increased noise.

In photography, grain is understood in two more or less contradictory senses. In developed black & white film, grain consists of the individual specks of silver particles that make up the image: typically, there is a range of sizes, the distribution and the limits of which depend on the particular film and the processing regime used. This sense is closely related to the notion of grain in colour film: here the individual specks of silver are replaced by clouds of dye, more or less spherical in shape with a darker core that 'float' in the volume of the film gelatine. The dye-clouds also vary in size within limits set by the film and process.

In the print, grain looks like the same thing: individual specks that make up the image. But of course that grain is actually a representation of the gaps between the grain of the film, for it is through the gaps that light passes largely unaltered to reach the print material. Furthermore, in most prints, the visible 'grain' is actually far larger than the individual elements of light-sensitive halides in the print's emulsion.

Digitally, it is tricky to simulate the exact 'look' of grain because one has to match the randomness of the distribution of grain sizes. There are various methods of adding grain, digitally referred to as 'noise'. This is appropriate because, like noise, grain provides data but it is the kind of data that does not contribute to the information content of the image – to the contrary, noise or grain reduces information by interfering with or obscuring fine detail as well as distorting local tonal relationships.

In image-manipulation software the effect of film grain is simulated by adding random values to the pixels. There are different approaches which produce somewhat different-looking results. As software operates on images using the model of colour channels, the variation in effects depends on how the randomness is distributed through the channels. A monochromatic noise will distribute equally through the colour channels, so the noise is in the form of specks varying in greyness. In contrast, a uniform noise will affect colours as well as brightness values. As darkroom workers, we tend to prefer the look of monochromatic noise.

A little experience with the noise filters shows that their ability to change the appearance of a fine-grained image is limited and the result looks unconvincing. Fortunately, there are alternatives. In Photoshop you can experiment with the Pixelate filters (see also pages 64-65) such as Pointillize and Mezzotint.

Originally exposed onto Polachrome, this still life was then copied in a slide duplicator onto Fuji transparency film. This step opened up the image tonally while at the same time greatly increasing contrast thanks to the photometry of duplication, which increase reproduction contrast unless corrected.

Polachrome duplicated in Beseler Dia-Duplicator with 50mm Componon-S lens, no contrast correction, using multiple flash exposures on Fuji RDP ISO 100 film

Scanning the original Polachrome gives poor results in this: because the image is made of large particles of silver, it is very difficult for the scanner to penetrate them and resolve the image. The coloured bands are due to Moiré interference between the scanner and the Polachrome's image structure.

Gum dichromate

Coming and going with changes
in fashion, it actually predates
photography and
still has its attractions

Gum dichromate is the modern term for gum bichromate following changes in chemical nomenclature. It is a technique that has been popular for most of the history of photography because it is relatively inexpensive to do, is tolerant of processing variations and is a rapid route to effects that look painterly. And, of course, it is an accessible way to add colour to black & white photographs. However, it is also rather messy and unpredictable and most workers tire of it after a few experiments. Fortunately for us silver-pixel workers, once we know the typical look of a gum dichromate, we can reproduce it rapidly and easily, but without having to paddle in the sink with dyes and sticky substances.

Gum bichromate printing was invented in 1855 by Poitevin but not fully exploited until 1894. It is based on the light-sensitive qualities of a dichromated gelatin which hardens on exposure to light, leaving the unexposed parts susceptible to being washed away by hot water. To create gum dichromates, you make up gum arabic and treat it with dichromate salts to which is added the pigment. You then cover paper with the dyed and sensitised gum. The paper is not sensitised until it is dry. You then contact-print negatives for several minutes with a bright lamp. Development consists of soaking the exposed print in hot water, possibly for hours.

The beauty of the process is that after drying you may coat the print with new colours, contact print and develop again to add additional colour layers of four or, if you're skilful, more layers. Another attraction of the process is that the texture of paper – which has to be pretty tough to take all this coating and hot washing – adds to the image's visual impression.

Digitally, the main point to watch is keeping the colours fairly muted – it is easy to create too many brilliant colours: this is easy through control of the opacity setting which can mute the strongest of colours. The gum dichromate effect in photography is essentially the colourisation of a greyscale image. In the process, tonality

This negative image, from a Polapan original, was coloured in three steps by using the Colour Range control from the Select menu: selections were made of the shadow, the highlight as well as the deep shadows: each was separately coloured magenta, purple and red – exactly as one could do when creating a gum bichromate.

Canon EOS-1n with 28-70mm f/2.8L lens @ 35mm, f/4, 1/125sec on Polapan film, with flash

tends to be compressed – the sensitised gum does not offer a subtle reproduction regime. Such effects are easily mimicked by image manipulation – or better, improved because the digital approach is so easily controlled. The easiest method is to work in layers, experimenting with a top layer of colour, with the mode set to Color and applying colours by filling a selection using the Bucket or fill tool, or, for a painterly effect, using the Brush tool.

A simple nude study was colourised with three separate colours applied to three different selections – of the bed-covers, bed and upper background. Each selection was given its own layer set to Color mode (i.e. colour is applied only to those pixels which have a value (i.e. non-empty pixels, and further, coloured in inverse proportion to that value, so that there is more colour the darker the pixel). The selection, heavily feathered to 22 pixels in width, was then filled with colour using the Bucket or fill tool.

Mamiya 645 ProTL with 75mm f/2.8 lens @ f/2.8, 1/30sec on Ilford XP2 Super ISO 400 film at EI 400

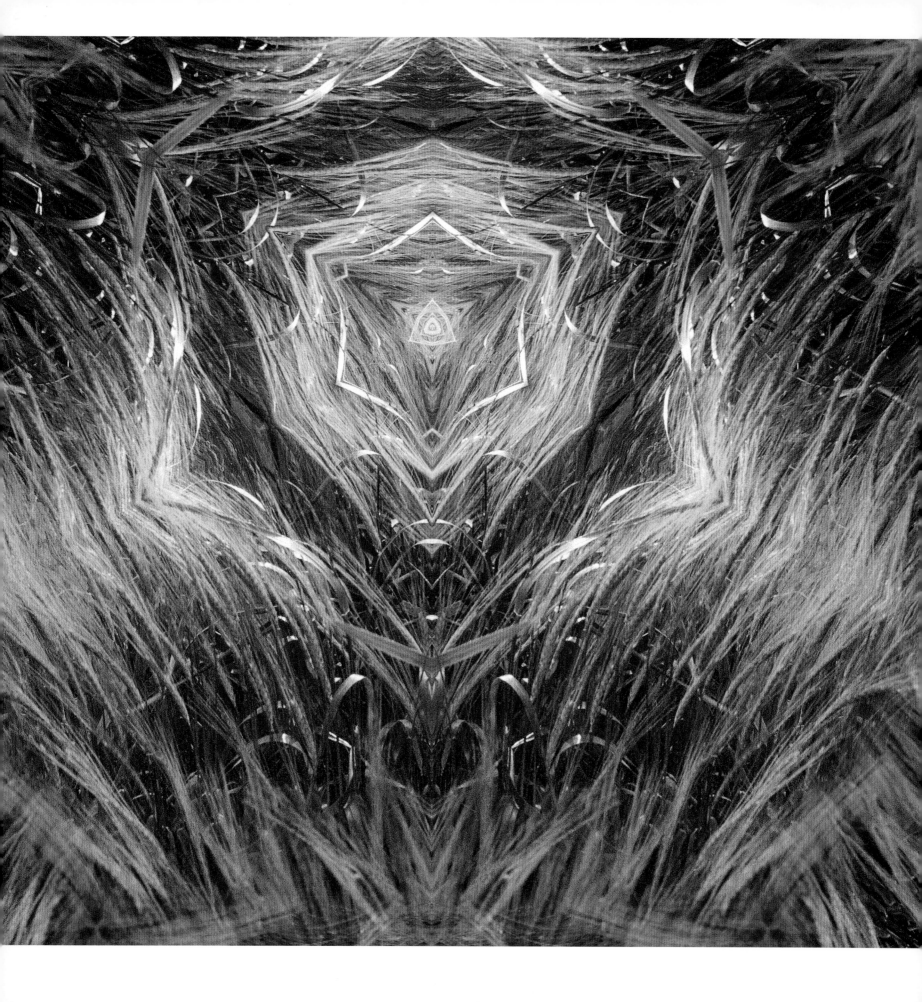

FRONTIERS ANEW

Digital techniques deliver more than new ways to do old things. They give altogether new techniques, they add to our gallery of effects, open up possibilities that we may have only dreamt of. And throughout are digital's hallmarks: effects are widely scaleable and you can experiment without limit and with the minimal use of resources.

Cloning techniques

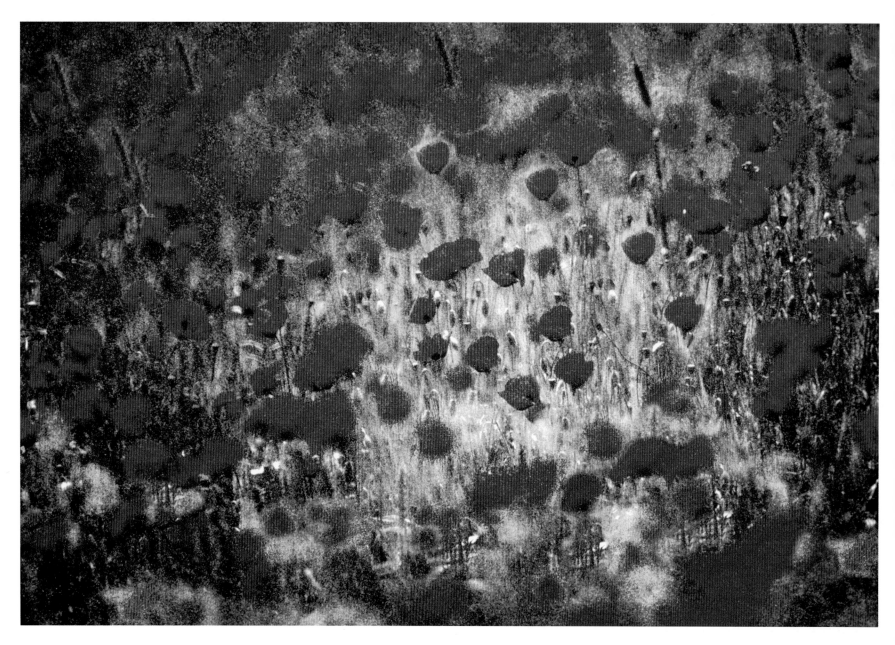

Canon F-1n with
Tamron 350mm f/5.6
catadioptric (mirror)
lens @ f/5.6 on
Polachrome instant
transparency film

The original Polachrome image had first been duplicated onto normal colour transparency film: this is essential as it is next to impossible to scan a Polachrome transparency properly because of its very heavy deposits of silver. The duplicate transparency lacked strength of colour, so that was the first thing to improve – using Levels and the Hue and Saturation controls. Then the cloning could begin: I was careful to clone so as not to distort any distance or tone relationships and also to avoid making the image too perfect, too full of flowers.

Cloning copies the pixels from one part of an image (the source) to another (the target): in some software, you can copy pixels from one layer into another and even from one image to a totally different image. The copying process is not like copy and paste – in which data is stored temporarily in a buffer – but is more direct; more a replication or duplication of pixels – because cloning allows you to paint or draw directly from the source to your target area. Incidentally, in Adobe Photoshop, cloning is done using the confusingly so-called 'rubber-stamp' tool. The way the tool works bears no resemblance to any understanding I have of a rubber-stamp, so I recommend you stick to calling it the cloning tool.

Cloning is the best way of cleaning up scans which have picked up dust specks, hairs and fingerprints along with your deathless pixels. However full of dust and defects your scan, there will surely be parts of the image that are clean and larger than the largest dust spots. To clean up the specks, you replace it with a bit of clean image: in most software, you choose the clone tool, then you Option (Alt) + click on the part of the image that will be your source. Then you click or draw over the dust speck, your target: hey presto, the speck disappears, replaced by the source pixels. You need to experiment with hard-edged and soft-edged brushes for different kinds of specks and different types of image. For fast working, I usually use large, soft-edged brushes working at full, 100% pressure or coverage. But there are times – when working to highest quality levels and at high magnification – when one has to be more subtle and slower working: use a fine brush with a hard edge and softer pressure.

Most, but not all, software gives you a further option, namely a choice between using aligned or non-aligned cloning. With aligned cloning, the distance and relation between the source and target is fixed: it is most useful for replicating a larger area over to another part of the image. With non-aligned cloning, the source remains fixed once you have clicked on it: this is best for duplicating a part of your image repeatedly to other parts, e.g. when repairing dust specks in dark areas.

Note that after extensive cleaning up, the image may take on a smoothed-out appearance because the individual silver grains or dye-clouds have been merged together by the cloning. This smoothed-out appearance is a dead giveaway to your retouching work and at any rate it looks artificial and mechanical. You may return the image to its former grainy look by selecting the smooth

A fabulous field of poppies glowing in the North-Eastern Anatolia region of Turkey: it was tempting to try to photograph them all, but in fact a tightly composed close-up view proved to be more effective at giving a sense of encompassing colour. The mirror lens I used gave the characteristic halo-shaped highlight: fortunately in this image there is only one. Cloning removed that highlight and put flowers where there were none as well as improving textures: the graininess of the film makes it easy to work seamlessly.

areas then applying some noise: this creates a random pattern of dots that replicates the film grain. Try using different amounts and types of noise to achieve the most convincing effect. You may also find it is better to apply small amounts of noise repeatedly rather than a lot of noise all at once.

I also find cloning is useful for patching up larger areas of complicated or busy images where there are portions that have, say, too much of a highlight or an empty patch that fits uneasily with the rest of the image. In the above image, there were highlights that I did not like, and there were the bulrushes which I did like. I therefore cloned suitable poppies onto the highlights, and I cloned the bulrushes so there are now a half-dozen instead of the original two. Do not use cloning to replicate large, distinct elements with definite shapes like petals or silhouettes of birds: this kind of task is better done using the selection tools.

Natural-media cloning

To imitate the most natural of
artistic endeavours
– copying from life –
is digital's sincerest flattery

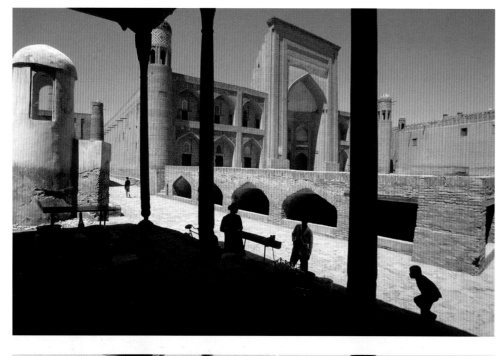

The top image is the original scan of a Madrassah in Khiva, Uzbekistan. The above image is the result of applying a curve which inverted the upper middle values which gave the painterly range of tones suitable for the image I had in mind.

Cloning usually implies a direct and faithful copy: a cloned sheep that looks and sounds like a cow will impress no one (but it would worry everyone). The digital equivalent is in fact something artists do all the time but we do not realise we are doing it: cloning in natural media is a jargon-loaded way of saying that we use normal artists' materials to draw from life.

The key to this application is MetaCreation Painter software: this is a uniquely powerful, deep and rich application which is the most complete attempt to recreate all the visual effects of natural media for the computer. With it you paint as if with water loaded sable brush or applying oils with a stubby bristle.

It is a program that more than any other graphics software relies on your abilities as a draughtsman or draughtswoman. If you can draw, you will have many a happy, very long session using Painter. But even for those who cannot draw, there is help. This is Painter's own implementation of cloning. A cloned image in Painter's parlance is a file with a one-to-one correspondence with the original but with no image as such. The first step to creating a natural media clone is to duplicate or clone the entire image. The next step is entirely counter-intuitive: you must select the entire image, then delete it. However, because the now empty canvas is derived from a clone of the original, it has retains a one-to-one correspondence with it.

This means that you can now recreate the image using any of the brushes and in numerous styles. Each stroke you make will use the original image as the source data, and apply the clone image – but not directly: the data will be changed by whatever brush effect you choose. Thus you can choose to have the data spattered in a random dot pattern, you can have some hues randomly change in colour or smeared as if applied in oil paints. The clone source can also be randomly varied within limits that you set: this mimics artistic practice of deliberately changing viewpoints or composition as a drawing or painting progresses. You can also apply the image over a paper or other texture which interacts with the image; and of course the texture can be defined or modified at will.

In short, Painter can turn many an artistically challenged person into one who can make a stab at representational painting. You need to choose your image with care: it should have strong shapes and clear lines, and you may need to alter the colours to compensate for the changes that the natural-media cloning will

cause. But what you have in store for you which, incidentally no darkroom could even begin to offer is hours of fun without any commitment or exhaustion of materials. In fact, it takes not a great deal of work to produce results which look pretty close to the real thing. All your work will lack are those final sensuous qualities – like smell of drying linseed oil and the dry, crumbling texture of a good watercolour paper – and those sensuous qualities no digital technique can yet, unfortunately, reproduce.

A laid-paper grain was chosen as the background for this image, intended to give a sense of it being sketched with soft coloured pencils (my favourite medium). After initial scanning and application of a curve which half inverted colour and tonal values, the colour was strengthened in Photoshop's Hue and Saturation control. I then built up the image with numerous 'pencil' strokes of varying strengths and two thicknesses. For this work, a graphics tablet (using a pen-like tool on a flat electrostatic sensing tablet) was essential: using a mouse would cause repetitive strain injury in no time.

Canon EOS-1n with 24mm f/3.5L TS lens at full shift @ f/8, 1/125sec on Kodak Ektrachrome ISO 100 film

Compositing

The top image is the original scan of a view of a park in north London: I experimented with various adjustments to levels and curves before settling on one which gave strong reds and contrast, with its obvious symbolism. The image above shows that the process of selecting the green chestnut leaves from their original black background made for an unnatural fringe.

Exposing different negatives onto printing paper is a practice that has been long recognised – almost as soon as the paper negative was invented – yet it has never taken hold as a mainstream practice. Technically, multiple exposures is a multiplexing: the combination of two or more channels of information. And, like all other multiplexed systems, the fundamental problem is noise from cross-talk i.e. there is unwanted or obstructive information caused by interference or overlapping of the different channels. As every darkroom worker knows, the trick to making good multiple prints is in the masks – how you separate one image from another. Technically, that can be a tremendous challenge.

Digitally, the need for masks is ever present. The difference is that, because the mask is digital (in fact, it is a greyscale image in its own right) it can be manipulated like any other digital file: you can erase bits, you can increase or decrease borders and even add gradients.

Alternatively, it is equally easy to separate an image off its background. The new magic eraser and background eraser tools in Adobe Photoshop 5.5 as well as many masking plug-ins such as Extensis Mask Pro all do the same thing: they select and keep certain pixels and they reject the rest. But they do it quickly and painlessly and, most importantly, if you if make a mistake you can redo. The analogue alternative is to cut bits of paper or the print itself: you do not want to be making any errors. Once the image is selected from the background, it can be dropped into the composition. The main error to watch for is the fringe that is often left by selection tools: it is often too sharp, too sudden to be natural-looking. The boundary of a subject is a very seldom perfectly sharp; there is always an area of slight softness. This boundary is often taken off by digital selection and the resulting fringe, often a dark or a bright line is a giveaway of sloppy compositing.

Fundamental to the practice of compositing is the metaphor of layers or floaters: that each element occupies a different space above that of the background image. In most applications, composited elements are left 'floating' or in a layer until the final composition is settled. Then the elements are fixed down or 'flattened'. In some software, the floating composited elements are the full-sized images, in others they are only proxies, or low-resolution stand-ins. The latter way of working is much easier for the computer to handle (it is working with small files), so that the

on-screen response is more rapid than normal – however, you subsequently have to substitute full-size image files: this can introduce errors of placement and take a long time to process.

It is tempting to throw in as many elements as you can. If you can orchestrate all the elements and keep them under control to ensure a balance between the planes and subjects competing for attention, complicated composites can work. Otherwise, the strategy for successful composites is: keep it as simple as possible.

A simple image, contrasting regeneration and new growth with the debris of a fallen year, was one that required just two elements to be composited. Firstly, a landscape taken in autumn and, second, a young tree photographed in early summer. The young chestnut tree was back-lit in a forest: removing the predominantly black background was easy, apart from the need to prevent unnaturally bright fringes being left on the leaves: these were removed by a combination of erasing and blurring. Other significant details that were needed included the tinting of the green leaves and the highlights in the stem of the chestnut tree with a little red to suggest it was picking up the colour from the red landscape.

Canon F-1n with 20mm f/2.8 lens @ f/8, 1/30sec on Kodak Kodachrome ISO 64 transparency film

Layers and modes

The desk-top publishing revolution
enters the darkroom with the
metaphor of layers –
giving programmers a lot of fun

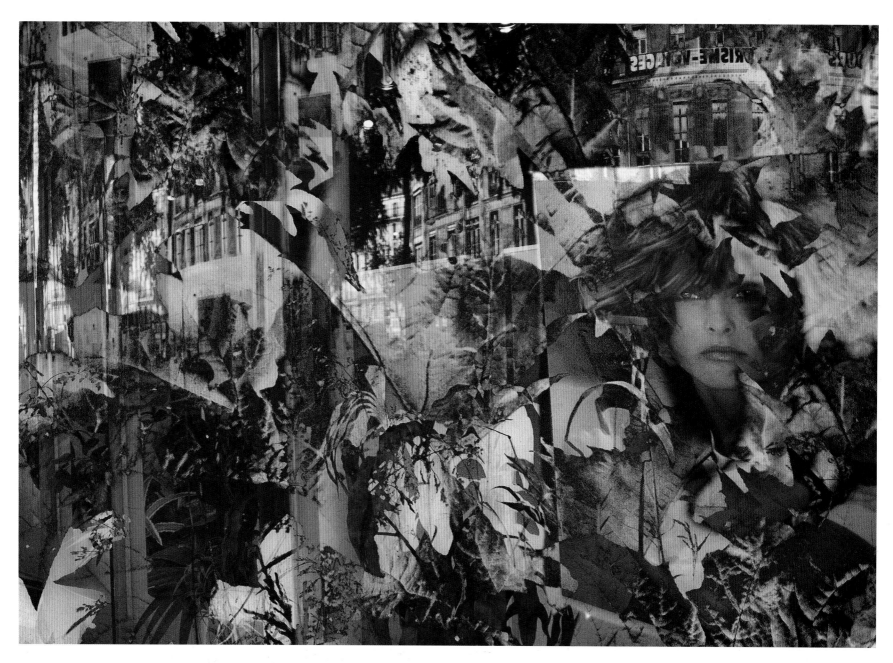

The rhubarb shot was placed on a layer above the Paris picture with its layer mode set to Difference. Careful examination of the image that resulted will show that I erased some rhubarb to reveal the model, cloned various parts to fill in detail and empty spaces and adjusted colour saturation here and there (for example on the model's lips and eyes), added colour to her eyes. I also adjusted the contrast and colour of the rhubarb to a dark blue to brighten the tonal and colour balance of the image.

The key to the first truly successful page-layout application was that it introduced a leap forward in thinking about the way we handle digital information: it gave us the metaphor of layers. Once objects were treated as floating above the paper, it was easy to understand how you can move them around and change the order in which they floated above the paper. Now, once upon a time, Photoshop did not have layers – anything and everything you did to an image, you did directly. Note that Photoshop layers were exactly the same extent as the underlying image, whereas floating objects were generally smaller than the page.

In practice, the most important point is that layers interact with each other in ways we can control and determine. This interaction is unique to digital imaging and cannot be reproduced in the darkroom: in fact, if the effect can be mimicked in the darkroom, you can be sure it was actually modelled on the chemical-based technique. The interactions are many and powerful – all are based on the fact that when one is working with a digital image, one can play around with the digits without let or hindrance. For example, you can invert a range of values, you can multiply values from one layer with values from the other or change them according to the values of the lower layer – you can use any mathematical manipulation you care to program.

The result is that superimposing one image over another leads to a bewildering range of possibilities - usually illustrated with gleeful abandon in manuals. For the silver-pixel worker, only a handful are used at all frequently: you will likely find yourself reaching most often for Color (for adding colour without changing greyscale value, as demonstrated on pages 58-9), for Difference (for violent reversals of colour and value, as on this spread), for Hard or Soft light (for blends) and for Color burn (for dramatic increase in contrast and hue saturation). You can always try the others, but I suggest you start with just these and learn what you can do with them before attempting to exploit others.

Note that you can soften the effects of any layer by changing its opacity setting. Another level of experiment is to change round the order of the layers: some combinations give markedly different results according to the order of the layers. This should alert you to another dimension of fun (or frustration): if you erase parts of one of the layers, the results are not entirely predictable, e.g. erasing to transparency in Difference mode makes black marks – in this, knowledge will come only from systematic experiment.

Above: Olympus OM-1n with 21mm f/3.5 lens @ f/5.6, 1/60sec on Kodak Kodachrome ISO 64 film

Left: Canon F-1n with 135mm f/2 lens @ f/5.6, 1/30sec on Polaroid Polapan ISO 125 film

The shot (top) of a shop-window in Paris has always intrigued me and in my mind it always seemed linked in some way to the picture of ornamental rhubarb (above). After scanning, I selected the poster of the model (which was distorted because it had been taken sideways on) and used the Distort and Transform tools to correct the distortion.

Multiple images

Above and right:
Canon EOS-1n with 28-70mm f/2.8L lens @ 70mm, f/4, 1/60sec on Kodak Ektachrome ISO 100 film

From several rolls of film I took of a fish-tank in Paris, I selected three images. Once scanned, I set the Marquee tool to pick up squares of 118x118 pixels as these would fit on the 10mm grid of my new document. I copied and dragged the selections onto the document. The image was built up by repeatedly copy/dragging the squares onto the grid, experimenting with different arrangements. Some selections were rotated to try to suggest a flow and movement. Clearly, any number of versions could be made – which could well be visually more coherent that the attempt above.

One of my projects is the making of multiple images using a restricted number of basic building blocks of photographs. Theoretically, it is a kind of deconstruction of an image, from which a reconstruction must then take place. In practice, what matters it is that the process is a whole lot of fun, from which I have managed to produce images which I find very satisfying to work on and which viewers find intriguing to experience. However, the technique using silver-based prints is extremely long-winded and hard work; it takes me years to complete a single image.

First, I select a number of prints, say of cloud formations or the swirls in water. I then cut the prints up precisely into squares, usually 10mm x 10mm: by precise, I mean that the variation in size is under 0.1mm – any more than that, and the assembly is very difficult to make. Next, the tiny little prints are laid out and moved around: after some months of experimenting with different arrangements, an order starts to assert itself and the prints then start to arrange themselves. At this point, it may become evident that more prints may need to be made. The size of the final assembly becomes clearer too: usually in the region of 1m x 0.7m – from which you can calculate how many component prints 10mm square are needed.

Once the arrangement and distribution of elements is finalised, the prints have to be stuck down: I do this one by one, reconstructing the assembly on another board. This is when the precision of the original cutting is vital.

The digital technique is delightfully and vastly simpler. You set a marquee size of, say, 100 pixels square and just copy parts of the component images onto a new document. In Photoshop, each element drops into its own layer. You can then multiply each element by option + command dragging on each selection. If you set up a grid and snap to grid, the elements will line up nicely. However, I like to leave a few elements slightly out of alignment as that prevents the image taking on an overly mechanical look.

Software such as ArcSoft's photoMontage will do much of the work for you as it selects from a library of images which you set up but then it is applied to recreating an existing image using these other images. Using the technique described here, you will be completely free to create any kind of image you like – whether totally free in form or directly inspired by the tones and lines of a pre-existing image.

This image is created from actual cut prints laid out and stuck down: it is clear that it would be improved with neater, more regular squares. It is a portrait of an expert in Chinese calligraphy of the Far East Asian Museum in Cologne, Germany. The intertwining of parts of the handsome face with the 'strokes' of bamboo leaves offers obvious associations.

'Deepening delights rivule
'Thus are you memorialis
Lake of astonished warmt

my heart ~
in a loving
four years deep.

INSIDER INSIGHTS

Despite the promises,
digital technologies actually
make it more difficult to
understand the photographic
process than ever.
Where chemicals would give
up their secrets if you
experimented long enough
and optics is an open
book to a good
mathematician,
much of digital technology
is impenetrable.

Colour symphony

The frustrations of colour management
are nothing new to photographers –
but new technology
does add new complications

For many years after the invention of colour photography everyone had to struggle with what was euphemistically referred to as 'batch variations' – this translates into 'unreliable colour reproduction, varying contrast, differences in speed'. Worse, when it came to making a print from a transparency or negative, the variations in both the film and the paper would compound (not to mention the chemicals) and make it impossible to get colour-correct results first time. With improvements in the production technology of films, the variations have steadily narrowed, with the result that colour films now are very reliable and predictable from batch to batch, while paper variation can be controlled by simple filter calculations. However, with digital technologies, life – if anything – has become more complicated, with new sources of error being introduced.

It is relevant to keep this historical background in mind because it is often said that colour-management problems arise from the transfer of images from one colour space – say, film – to another space – say, the monitor screen or paper print (see page 91 for more on colour space). In fact, what is new is the demand for automation and the insistence on first-time correct results: it seems paradoxical to pay thousands for computing equipment and printers to find that the colours in the print do not match the colours seen on screen. Unfortunately, even with the most sophisticated colour-management system in place, you still have to check that the system is consistent whenever you recharge the ink or change paper – or alter any other element. Printing-press managers will tell you that colour reproduction can even depend on the weather: cold, damp days can make paper take up inks more slowly than on hot days. For the silver-pixel worker, it pays to beware that changing your paper stock for your ink-jet printer will probably cause a colour shift – just like the good old days.

The transition from colour transparency to printed page is perhaps the most painful for photographers: much of the brilliance and depth of colour is inevitably lost. This is most apparent in images such as this, of a brightly painted metal box made in Uzbekistan: metallic highlights, garish colours as well as very deep tones from the dark reflections are a challenge for every instrument and technique in image reproduction. It is an excellent image to use for calibrating the performance of scanner and monitor as well as printer.

Canon EOS-1n with 28-70mm f/2.8L lens @ 70mm, f/5.6, 1/60sec on Kodak Ektachrome ISO 100 film

In practice, colour management needs constant vigilance because each change from one instrument to another introduces a source of error. For example, from your original transparency, you make a scan. The scanner may introduce its own colour characteristics e.g. one scanner may give slight over emphasis to blues. Unfortunately, you cannot assess the scanner's work, except on a monitor, and that introduces another source of error: if the monitor downplays blues, the image from the scan may look fine. But that is no help when the print comes out too blue. Systems such as ColorSync chase this unruly gang of performers into the same theatre so at least they sing from the same song-sheet. If you work on Apple Macs you're in luck: if you load the colour profiles for the monitor you use and the printer so your system can work out how to translate one to the other, the likelihood is that you will obtain a pretty good match between your screen image and those you print.

A colour profile of a device is a matrix of values that indicates how that device reproduces certain standard colours. These values allow software to compensate for individual colour reproduction characteristics. For example, suppose a certain monitor tends to over emphasise reds. When software such as Photoshop sees the profile, it will use the quoted values to change the reds so that the image will look the same on this monitor as on another monitor.

For the solo worker the procedure for colour calibration is relatively straightforward. Decide on a standard lighting for the room. I pull the curtains to darken the room and turn on a desk-lamp but ensure that lamplight does not shine its light onto the screen. Next, the monitor screen should be turned on for at least 30 minutes to warm up before calibration. Set it to its normal settings and to as bright as is comfortable: if the system or software allows you (all modern Apple Macs allow you), set the

monitor to a Gamma of 1.8 and a white point of D6500. (Note that gamma for a monitor does not mean the same as gamma in photography. Gamma in electronics is a measure of the correction voltage on the electron gun of the cathode ray tube: a higher gamma gives a less bright, higher contrast image). Set your monitor ColorSync profile if you have one: for Mac users in the Monitors and Sound or the ColorSync control panel, depending on version of Mac OS or in the monitors settings for Windows users. Users of modern monitors and latest Mac OS should go through the calibration steps offered by either the operating system and by Photoshop.

Next you open up a good-quality RGB file (say 10MB at least, from a good scanner) showing a wide range of colours and print out that file with your standard printer using best-quality settings and preferred paper. Compare the printed image with the screen image. Now you need to adjust the monitor's settings. Owners of Photoshop can go to the Gamma control panel or setting and make changes via software (in versions 5 and later, ensuring that 'view single gamma only' is checked for controlling overall contrast. Uncheck it to control colour balance: you should then see three coloured panels with sliders for each of the RGB channels). Many monitors allow changes to be made directly with on-screen controls, and this is preferable although settings are less repeatable. Try first to match the contrast, then the colour. You will not be able to match every colour. Don't despair when you find that changing colours will also change the contrast. Just take your time, and try all the controls to see what effect they have. This procedure is not strictly technically correct, but it works if you don't have to work with different printers. Professional users will need to calibrate their monitor and printers using with colour meters to produce custom colour profiles.

Deep bits

Monitors have them and so do scanners: the bit-depth tells you how finely a piece of equipment can recognise (in the case of scanners) or reproduce (in the case of monitors) colours. All modern film-scanners work to at least 24-bit RGB depth, meaning that they can code the sensor information to 8 bits per colour channel (8 bits times three channels equals 24). This means, in theory, each channel is divided up into 256 equally-spaced steps, the minimum for good-quality reproduction. However, the industry is increasingly finding 24-bit is not up to our demands: the tones

are not smooth enough and there is not enough data to allow for any dramatic changes in tones or colours. The better modern scanners can work in 36-bit or more – even when down-sampled back to 24-bit the results are better than if the scanner works straight into 24-bit. Some scanners even provide 48-bit RGB files: these are bigger than normal and very few image-manipulation programs can use them. Even Photoshop is very limited in its ability to manipulate 48-bit files. But the results are worth it: much smoother tones and fewer problems when Levels or Curves commands are used.

Files in the ointment

Unfortunately for the beginner in silver-pixel work, the basic currency of digital deals is the file. Worse than working with international money, one can never be sure of the precise quantity or quality of a file until you have used it for some time. While, like currency, digital files come in many flavours, unlike currency they also come with different compressions. Thus a big file does not necessarily hold a better-quality image than a smaller file. And what claims to be a small file appears four times bigger when you open it up. As a result, after its name, there are three things you need to know about a file. Firstly, you need to know the format – whether it is a TIFF or a GIF or a PNG-24, and so on. You need to know the colour space it is saved in. You need to know the level of compression, if any. And after that, it can be useful to know its size.

File types

For the silver pixel worker, the most important file type is the TIFF (Tag Image File Format). The tag refers to the fact that in addition to the basic image data, you can attach other information as tags to the basic image data. This makes TIFF a most versatile format, but is also the root of some of its problems: there are many different varieties of TIFF – which can cause unexpected incompatibilities. An important aspect of TIFF is the Mac and PC byte order, so-called because the data is stored backwards in one variant compared to the other: ensure that you choose the right one for the environment you work in. Nonetheless, TIFF is by far the most widely used for publication and print-media work.

However, TIFF is of no use on the Internet; in this realm, JPEG is the key format for the photographer. It is a data-compression technique that can reduce file sizes to as little as 10% of original with only a slight loss of image quality and to less than 1% by sacrificing a bit more quality (see the box opposite for details). You

These images of a corner of Prague are printed at 13x enlargement – approximately equivalent to making a 20x16 inch print. Can you tell which one is the uncompressed file of 3MB in size, which one is just 119KB in size and which one takes up a mere 30KB? Even with a mix of even tone with fine detail, it is not easy to tell the difference between them. The top image is best quality, the middle one is JPEG compressed to middle quality and the bottom is compressed to lowest quality. Even on-screen, differences are not obvious.

Canon EOS-1n with 28-70mm f/2.8L lens @ 28mm, f/8, 1/125sec on Kodak Ektachrome ISO 100 film

can save enormous amounts of file space by saving your files to JPEG, even with maximum quality and minimum compression. Note that different ways of implementing the JPEG standard give better or worse results in terms of colour and maintaining detail. The choices in Photoshop are rudimentary, even in version 5. In version 5.5, the controls offered by the ImageReady component are far superior. You can use other software to control JPEG compression: the most versatile of these is the shareware GraphicConverter or ProJPEG – obtained from the Web (see page 114). The key fact to remember is that once your image has been compressed through a JPEG regime, the data you lose will be gone forever. Furthermore, each time you save as JPEG, you can lose data – so ensure you leave the 'save as JPEG' step as the very last one.

Compression

It is important to realise that compression does not involve any physical squeezing of the data in any sense: the only physical change is that data takes up less space on the disk. It is easy to understand compression when you take a look at a typical desk: papers which are being used are strewn on separate piles. This takes up lots of space, but it's easier to work that way. Papers not in use are stacked up – compressed – because they do not need to be arranged for working with. And papers put away into files take up even less space, but are not at all convenient for working with.

Broadly speaking there are two kinds of compression: those which are effective at saving space but which drop unwanted data, examples of which are JPEG and GIF: these are called 'lossy' compression algorithms. Lossless algorithms do not lose data but compact less effectively: examples are LZW for TIFF files or PNG formats: these half the size of files at best. All compressed files take

JPEG in detail

The technique - "jay-pegging" - consists of three steps: (i) The Discrete Cosine Transform (DCT): an algorithm similar to that of the Fourier Transform that takes data in blocks measuring 8 pixels x 8 pixels and converts them from the spatial domain to the frequency domain – somewhat similar to presenting a graph of a continuous curve as histograms that plot the frequency of occurrence of each value. This step compresses data, loses no detail and identifies data that may be removed. (ii) Secondly, matrix multiplication: the data is re-ordered for quantisation. It is here that variable amounts of the data can be discarded through

longer to open than uncompressed files. As a result of the different compression ratios you can apply, you may find that a small file is actually perfectly capable of producing perfectly usable, high-quality results. In fact, almost all the images offered on royalty-free CD-ROMs have been JPEG-compressed – and they are selling in their millions. You might think that a large file is obviously superior to a smaller one. Clearly there is more data, but does quantity of data guarantee quality of image? To answer that, you need to ask about colour space.

Colour space

Colour space is an abstract model of the relationship between the colours that can be reproduced by a given colour system. RGB space, the commonest and used for monitors, defines colours in terms of their red, green and blue content. If you regard each parameter as an axis, then three mutually perpendicular axes will define a three-dimensional space, the so-called RGB space. Thus this space will 'enclose' within it all the colours that can be reproduced in a given system. Other colour-space definitions create slightly different spaces, the commonest of which is L*a*b, commonly abbreviated to LAB, which defines a colour in terms of its lightness value and position relative to two colour axes.

Another commonly used colour space is CMYK, representing the four colour separations widely used in mass production printing. CMYK colour space is smaller than that of RGB but note that the files are a third larger: that is because CMYK carries four channels of data, whereas RGB carries three channels. The conversion between one space and another can introduce errors: it should be left to the very last step, and preferably to those who know what they are doing, i.e. professional printers.

the choice of the quantisation factor. This is what you are controlling when you choose the quality setting or adjust sliders: you must balance your desire for small files with consequent loss of image quality. (iii) Coding: the results of the last manipulation are finally coded using yet more compression tricks (including a little zig-zag trick that exploits the fact that the last procedure a lot of zeros in the data) with no data loss. The cumulative effects of these compressions achieve JPEG's high compression ratios: files can be reduced by 70% (i.e. 30% original size) with little image degradation; even 99% reduction is possible – and the image may still have its uses.

Digital to silver

The ink-jet print is photographic fast-food:
very convenient and cheap
but as nourishment for
the soul, it lacks something

To question the future of conventional photography is about as premature as talk about the paperless office. If anything, paper is now more important in the business and commercial environment than ever – paper documents do not get corrupted in hard-disk crashes. Further, you can carry paper around with you and show them to anyone without having to wait for a system to boot up while wondering whether you'll be able to open the file.

It is doubtless wonderful to be able to send images to relatives on the other side of the globe, but it is also still essential to be able to place into someone's hand a print that they can hold up, tuck into their wallet and show someone else. There remains also the issue that conventional analogue techniques are still by far the more efficient, cost-effective way to store image data: a simple disposable camera costing the same as a fast-food meal has imaging capabilities which are out of the reach of thousands of pounds worth of computer and digital camera. In short, there is still room for the roots you have in conventional photography. Digital prints are of course excellent, effective and getting better all the time; but the standards by which they are judged are still those of the conventional photographic print.

Direct to print

It will reward you to keep in mind that the fact that a form of photographic output of a digital file can often provide the best results. Two pathways are available, both provided by professional laboratories. There are large machines, notably from Durst, that write a digital file directly, using laser beams, onto conventional

Some images can be deceptive: this appears to be a digitally manipulated composite but in fact it is a double-exposure. One element is a silhouette of two shepherds in Kyrgyzstan, the other is of richly decorated dresses of Tajik girls. I have found it very difficult to simulate the layering effect of double exposure in image-manipulation software. This image's potential for further manipulation is limited but it was scanned to produce a file of 25MB in size. Some elements were altered and the result written in a film-writer to 35mm colour transparencies. After processing, the slides were used to make R-type prints for an exhibition: the resulting brilliance of colour, contrast and solid blacks fully repaid the effort.

Silhouette: Leica M6 with 35mm f/2 lens @ f/11, 1/60sec on Ilford XP2 ISO 400 film. Colour image: Canon EOS-1n with 80-200mm f/2.8L lens @ 80mm, f/5.6, 1/200sec on Kodak Ektachrome ISO 100 film.

process RA-4 colour-print paper. The only size limit on this form of output is the size of the machine and length of the roll of paper. It is, unfortunately, a relatively slow process. However, you obtain prints with longevity equal to that of conventional colour papers and generally better than ink-jet prints. And of course, you get a print with the physical 'handle' of genuine photographic paper.

Note one interesting point: that as the process uses conventional materials, the printed image does not rely on half-tones but on the nearly perfectly continuous-tone of the dye-clouds in the processed print. This has the effect of smoothing out the boundaries (working rather like stochastic screens which randomise the regular raster pattern) between pixels with the result that the image looks much higher quality than the same file output onto ink-jet. As a result, a relatively small file 'gains' the capacity to produce very good-looking images: in practice I have found a 20MB file able to print convincingly to 20x16".

Direct to film

The alternative pathway is to write the digital file to film, then use the film to make prints or to project the image. The key element needed is also a professional-grade machine because, for high-quality photographic quality output – as opposed to quality suitable for business slides – the machines cost tens of thousands of pounds. However, such a writer can create transparencies or negatives which are quite indistinguishable from a true camera exposure. It works this way: the digital file is displayed on a high-precision TV monitor with a perfectly flat display showing only

When to output from digital to film

The inter-related issues that you may need to consider when deciding how to output your digital files include the following:
• Cost: initial costs of output to ink-jet are low; costs of writing file to film very high for one-offs, but for long runs, writing to film gives better productivity.
• Time: initial output to ink-jet extremely rapid, but repeat prints very slow compared to output to film.
• Convenience: initial output to ink-jet or similar printer incredibly convenient, while output to silver-based very tedious, but with longer runs, silver-based easier.
• Archival issues: even with modern ink-jet inks, some of which claim longevity equal to photographic materials, their archival qualities cannot be guaranteed because of the unknown

black & white with a resolution of 4500 or more lines. The image is drawn line by line and one colour channel at a time. To create a colour image, a separation wheel with red, green and blue filters rotates between the screen and a camera which is pointed at this screen. The camera can be of different formats depending on the machine's design. During exposure, the camera shutter is held continually open for the relatively long time – at least several minutes – it takes to display the file, one line at a time, one colour separation at a time. The exposed film – which can be colour transparency or negative or black & white negative or positive – is then processed as normal.

Once you have the film you can use it to make prints. I have used this approach to produce R-type prints with the gorgeous richness of colour that no other process short of oil-painting can match. Furthermore, in the process of making the prints, I am able to make some final adjustments to colour balance and, more importantly, to burn and dodge as usual to finesse the tonal balance of the final print. As a result, I've had viewers ask me how it was possible to achieve such richness using digital technology: the answer was 'don't'. Using a hybrid of silver-based with digital technology ensures you enjoy the best of most possible worlds.

And one last thought – in case there is any doubt about the wisdom of coming down this output pathway – remember that a black & white print from a digitally produced negative can be archivally permanent (as can the negative itself); which is not something any other digital output can yet boast.

properties of ink-jet papers. Output to film or silver-based printing papers, particularly black & white, are undoubtedly capable of greater longevity.
• Versatility: output to ink-jet is limited to single print whereas output to film or transparency can be projected, used for making prints, re-scanned. Output to film also less dependent on presence of decoding technology i.e. can be used without computers, etc.
• Quality: image quality of digital file written to film and then printed photographically can be noticeably superior to that of ink-jet or similar media.
In summary, for one-off printing and temporary display, ink-jet or similar printers are more convenient and less expensive, but for exhibition or multiple copies, despite the expense and lack of convenience, output to film can be by far preferable.

More resolution

Resolution is the key that unlocks the
digital domain: but it is a
complicated one,
which can lead to confusion

The basic definitions for resolution were discussed on pages 26-7, where it was explained that part of the confusion over the word is because it is used in at least three distinct senses, but often without clear pointers which sense is intended – if indeed the speaker knew. It is also of no help that a mixture of units – pixels, millimetres and inches – is commonly used. Here we deal more with some of the more practical matters, while also covering the vital but technical matter of half-tone cells.

The commonest practical problem for silver pixel workers is to answer the question 'At which resolution should I scan?'. The issues here are not very different from a debate that is familiar to all photographers: how much are you willing to sacrifice in the convenience of small formats for the greater image quality of larger formats? To enjoy the higher quality of larger formats, you pay more for film per shot taken, and need generally more expensive equipment – not forgetting having to carry heavier equipment. You will also need a bigger enlarger and, if you want to scan the images, a larger (and very expensive) scanner. By the same token, higher resolution, i.e. higher-quality digital images, carry larger overheads than do lower resolution images. The images take longer to scan in the first place, the files take up more storage space, they take longer to load and transmit and are more prone to error and, finally, they need more memory to manipulate. Furthermore, a large file grows very big extremely quickly when you work with multiple layers, compared to a small file.

Pixel and file size

The key to a practical understanding of resolution and file size is to keep in mind that a pixel can be of any size you like. A pixel is a virtual picture element. It is not commonly realised that while it is in the computer, in digital form, no size is applied to or can be

This is a composite of the same image at two resolutions: half is at 300dpi and is a 5MB file, the other is at 100dpi and a mere 0.5MB in size. Can you tell which is which? The image is intrinsically low in spatial information and very high in noise so there is little point in scanning it to the highest quality unless the grainy effect was essential to the image: in fact, even if it is, a low-resolution scan of it will still suffice to capture the random pattern of grain. (The answer: the left hand half of the image is at 300dpi, the right, is at 100 dpi.)

Canon F-1n with 350mm f/5/6 catadioptric (mirror) lens @ f5.6, 1/60sec on Polaroid Polachrome ISO 50 film

associated with it; in a sense, a pixel is dimensionless. It is only when the digital data of pixels needs to be transmuted to some physical form, i.e. when it is output, that a pixel must take on dimensions, which is when it is given a size.

Thus a pixel can measure just thousandths of an inch, e.g. when a portrait of a film star is output on a film-writer to produce a 35mm transparency, or it can measure an inch or more, e.g. when the star's face is printed onto the side of a bus. In either case, note that the number of pixels in the image itself may be identical, as indeed will be the file size. For example a file of 25MB can be output into a film writer to make a 35mm transparency and the same 25MB file could be output onto the side of a bus without any modification whatever to the file itself. All that will change is that the output in one case may be 3000 pixels per inch and in the other it could be just 10 pixels per inch. Thus an image containing 3000 pixels will be output to 1 inch long in the first case and 300 inches long in the second.

File size

One easy approach to take is to decide what, in general, is the largest size you really need to work to and make scans giving you the corresponding file size. Few of us need to work to the 25–30MB that is usually taken as the standard for good-quality, magazine reproduction to A4 size. An image needs to be of very good quality and sharp for it to be worth scanning at such a resolution. In fact, there are widely published and highly respected artists and professionals who typically produce finished files of 10MB or less –

Half-tone cells

Modern printers can lay some 1400 separate dots of ink per linear inch. But not all of them are available for defining detail because printers cannot change the strength of the ink. These printers must use groupings of dots – or half-tone cells – to simulate the effect of a greyscale.

Look at a chessboard: seen from a distance, the equal numbers of black squares and white squares blur together and give the impression of a mid-grey. As we colour in more of the squares, the overall appearance will darken (to 100%) and if we paint more squares white, it will lighten. Each time we remove or add a black square, the board can represent a grey level. As there are 64 squares, 64 grey levels can be represented.

In practice we need at least 200 grey levels to give a good

and that is before JPEG compression. And if an important consideration is the need to send files over phone lines or the Internet, your files must obviously be as small as possible.

For ink-jet prints up onto 10x8"paper, starting with 35mm originals, if you scan to a resolution of around 1300 – 1400 dpi, you obtain files sizes of 7MB – 8MB which are a good starting point. If you need more quality you can try scanning to higher resolutions to see if you can get better results. You will find that operations such as a judicious application of a sharpening filter can make more difference to image quality than simply higher resolution. To make a full-size print up to A3 size, the file size rises to some 18MB – 20MB, calling for an input-scan resolution of around 2200 dpi. All this assumes the file size is calculated uncompressed and with an output resolution of 100lpi.

Note that a file generally takes up more space than its actual size: in general, a very small file takes up as much space as a bigger file. Recall that in your filing cabinet, a folder can hold just one sheet of paper while another is stuffed full to capacity. In an analogous way, each separate file on your disk is like a folder: once some data from one subject or image is allocated to the file, you cannot put in data belonging to some other subject. However, unlike folders in your filing system, the equivalent on hard disks (called sectors) cannot change their physical size to accommodate data: they are fixed in size when the disk was first formatted. Note that modern Apple Macs store data much more efficiently than do PC-compatible machines, particularly those with large hard disks.

representation of continuous tone gradation. Therefore a printer must control a large number of dots of ink just to represent grey levels, thus reducing the detail that can be printed. In practice, an actual detail resolution of around 100 dots per inch meets most of our requirements. If the printer can lay, or address, 1400 dots per inch, then it has some 14 dots to use for creating the effect of continuous tone. Now, if you multiply together the four or more inks commonly used, you can see that a good range of tones and colours can be reproduced.

The mathematics of controlling the placement of the dots is horrendously complicated: fortunately, it is down to the software, which is inexpensive to improve compared to costly changes to hardware. That is why ink-jet printers can offer such tremendous value for money.

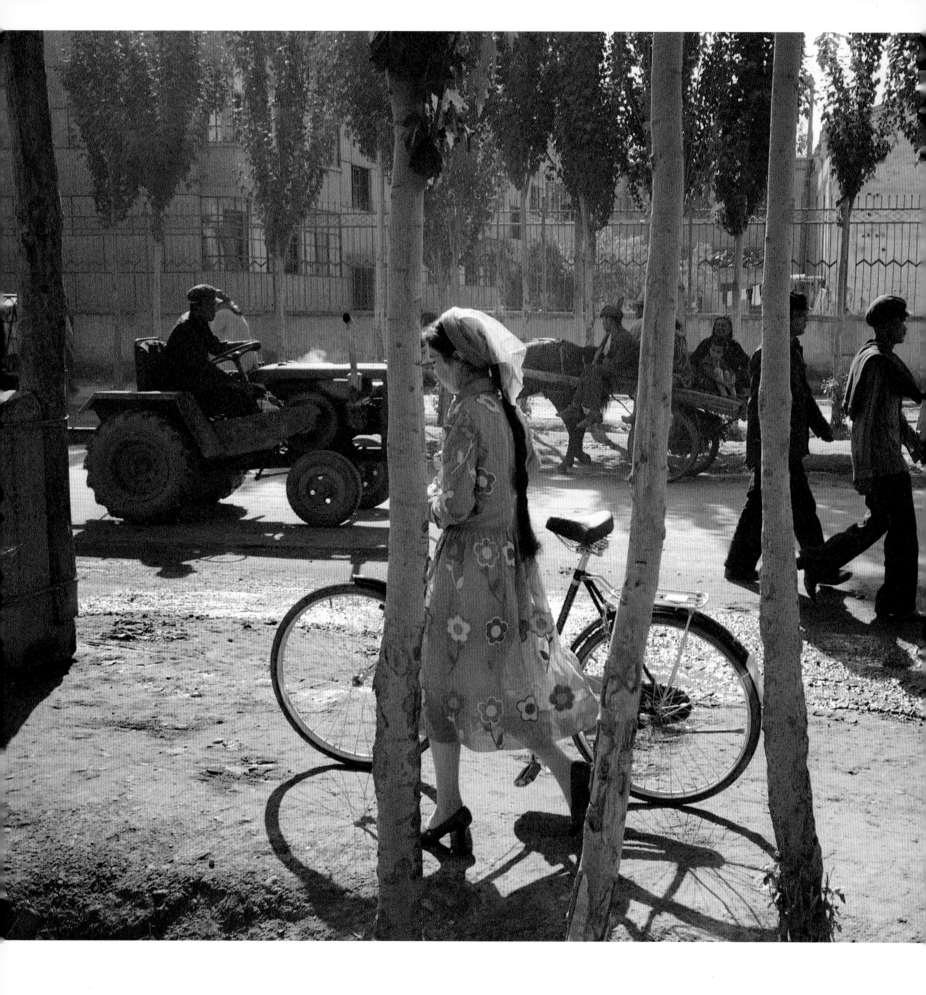

GLOSSARY

In any rapidly growing and
developing field, the jargon
and terminology can
seem to mill around and
grow faster than
the subject itself, sowing
confusion amongst
all who are not initiates.
This Glossary aims
to guide you through some
of the technical terms
... so that you, too,
can soon bluff like
the best of them.

How to use the Glossary

The glossary has been made a quite substantial part of this book because so many new words have entered the lexicon of digital photography in a few short years. For the beginner, the resulting jargon can be a nightmare that discourages further reading. This glossary is, of course, arranged alphabetically – starting with terms expressed by numerals. After the headword will be the definition or, in the case of an acronym or abbreviation, the term spelt out. After the definition, a further explanation or an example may be given, marked by an asterisk: *. No cross-entries have been given, in order to compact the entries.

24-bit Measure of the size or resolution of data that a computer, program or component works with. * A colour depth of 24 bits gives 16,777,216 colours.

2D Two dimensional: usually taken to refer to define a plane.

36-bit Measure of the size or resolution of data that a computer, program or component works with: in imaging, it equates to allocating 12 bits to each of the RGB channels. * Gives billions of different colours.

4x speed Quad Speed: reads data off a CD-ROM at four times basic rate of 150 kb/sec. * CD players standardly reach speeds of 24x and greater. * May refer to 'write' speed of CD-writer.

6500 White balance standard corresponding to normal daylight: appears warm compared to 9300.

8-bit Measure of the size or resolution of data that a computer, program or component works with. * An 8-bit microprocessor works with data that is 8 bits (or 1 byte long).

9300 White balance standard close to daylight: used mainly for visual displays as its higher blue content (compared to D6500) gives better colour rendering in normal indoor lighting conditions.

A

Å Angström unit: unit of length: 10^{10} m, formerly used to as measure of wavelength of light. * Use nanometer (nm) in preference e.g. green light of 55 AU is 550nm.

A/B To A/B (pronounced 'ay-bee') is to make subjective comparisons between two signals by switching back and forth between them in order to determine which is better.

aberration In optics, defect or imperfection of optical image caused by inabilities of lens system to form perfect image. Collective name for deviations of image from that predicted by geometrical (Gaussian or paraxial) optics.

aberration, chromatic Defect of image that shows up as coloured fringes when subject illuminated by white light. Caused by dispersion of white light by glass.

aberration, spherical Defect in image caused by rays of light near edge of lens tending to be focused nearer lens; rays near the lens axis being focused further away.

absolute temperature Measure of thermodynamic state. Measured in Kelvin from theoretically lowest possible temperature i.e. absolute zero: -273.16°C.

absorptance Measure of amount of light absorbed during reflection or transmission. * Equal to one minus reflectance or one minus transmittance.

absorption Partial loss of light during reflection or transmission. Light energy is reduced by absorption after interaction of light with material due to transference of some energy (in form of heat) from incident light to material. * Selective absorption of light causes phenomenon of colour.

accelerator (1) Device designed to speed up a computer e.g. by providing specialist processors optimised for certain software operations. (2) Component of chemical developer formulation that increases its speed of action by creating alkaline environment for developing agent to work in.

accommodation Adjustment in vision to keep objects at different distances sharply in focus. Change in shape of lens of eye by action of ciliary muscles to maintain lens's focal point at the retina surface.

achromatic colour Distinguished by differences in lightness but not of hue or colour e.g. black or greys.

ADC Analogue-to-Digital Conversion: process of converting or representing a continuously varying signal into a set of discrete, digital, values. * For conversion to take place (a) the source signal must be sampled at regular intervals - the quantisation rate or interval: the higher the rate or finer the interval, the more accurately can the digital record represent the analogue original; (b) the quantity or scale of the analogue signal must be represented by binary code.

additive (1) Adjective describing process of producing colours by adding two or more lights of different colours. (2) Noun: substance added to another substance - usually to improve its reactivity or keeping qualities.

additive colour printing Method of making colour prints from colour negatives or transparencies by making three successive exposures of varying duration in register through blue, green and red filters of fixed density.

additive colour synthesis Combining or blending two or more coloured lights in order to simulate or give sensation of another colour. Any colours may be combined. For effective colour synthesis, three primary colours are needed e.g. red, green and blue.

address Reference or data that locates or identifies the physical or virtual position of a physical or virtual item e.g. memory in RAM, sector of hard disk on which data is stored, a point in space corresponding to a dot from an ink-jet printer.

addressable Property of a point in space that allows it to be identified and referenced by some device e.g. a laser printer that can print to 600 dpi can address only the 600 or so equally spaced points that lie on a line one inch long; any point that lie in between these points cannot be addressed.

algorithm A set of rules that define the repeated application of logical or mathematical operations on an object (e.g. a set of numbers) to produce a solution or new object e.g. the long-division rules for dividing a large number by another is an algorithm; another example: the rule for converting degrees Celsius to degrees Fahrenheit.

alias 1) Literally a representation or 'stand-in' for the original continuously varying signal or object, e.g. a line, a sound etc. that is the product of sampling and measuring the signal to convert it into a digital form. (2) In Mac OS, a file icon that duplicates the original. * Used to open application programs, files or folders and such like.

alpha channel Normally unused portion of a file format: designed so that changing the value of the alpha channel changes properties e.g. transparency/opacity of the rest of the file.

analogue Effect, representation or record that is proportionate to some other physical property or change.

anti-aliasing Smoothing away the stair-stepping in an image or computer typesetting.

apps Slang for application software.

array Arrangement of image sensors. * Of two main types. two-dimensional, grid or wide array: rows of sensors are laid side by side to cover an area. One-dimensional or linear array: a single row of sensors or set of three rows: usually set up to sweep over or scan over a flat surface as in a flat-bed scanner. * The number of sensors defines the total number of pixels available.

aspect ratio Ratio between width and height (or depth).

attachment File that is sent along with an e-mail, e.g. image or other complicated or large item.

auto-terminator In a SCSI device, a sensor or switch that detects that it is the last connected device in a SCSI or that there is no terminator installed, and if so automatically terminates the chain, i.e. closes the electrical loop.

B

back-up (1) Verb: to make and store second or further copies of computer files to insure against loss, corruption or damage of the original files. (2) Noun: the copies of original files made as insurance against loss or damage of any kind.

bandwidth (1) Range of frequencies transmitted, used or passed by a device such as a radio, TV channel, satellite, loudspeaker, etc. (2) A measure of the amount of information that can flow through a system, expressed as a frequency. (3) Referring to a filter: measure of the range of wavelengths transmitted by a filter.

baud rate Rate of information transmission measured in number of symbols per second. * As a symbol may have more than two states, the baud rate may not be equal to bits per second e.g. the baud rate for the V32 standard is 2400 but the bit rate is 9600 (there are 4 bits per symbol).

beam splitter Optical component e.g. prism, system of mirrors or semi-reflecting mirror (pellicle) used to divide up a ray of light.

bicubic interpolation Type of interpolation in which the value of a new pixel is calculated from the values of its eight new neighbours. * It gives better results than bilinear or nearest neighbour interpolation, with more contrast to offset blurring induced by interpolation.

bilinear interpolation Type of interpolation in which the value of a new pixel is calculated from the values of four of its new neighbours: left, right, top and bottom. * It gives blurred, soft results less satisfactory than bicubic, but needs less processing.

bit Fundamental unit of computer information: has only two possible values, 1 or 0, representing e.g. on and off, up and down.

bit-depth Measure of amount of information that can be registered by a computer component, hence used as measure of resolution of a variable such as colour or density. * One bit registers two states: 0 or 1, e.g. either white or black; 8 bit can register 256 states.

bit sex A bit must register either 0 (off) or 1 (on) but cannot be neither ... nor, indeed, both.

bit-mapped (1) Image defined by values given to individual picture elements of an array whose extent is equal to that of the image; the image is the map of the bit-

values of the individual elements. (2) An image comprising picture elements whose values are only either one or zero e.g. the bit-depth of the image is 1.

black (1) Adjective describing an area that has no colour or hue due to absorption of most or all light. (2) Noun denoting maximum density of a photograph - of any kind.

bleed (1) Photograph or line that runs off the page when printed. Photograph may bleed on any side and on one, two, three or all four sides (in latter case either a cover or double-page spread) according to position on page. (2) Spread of ink into fibres of support material: the effect causes dot gain. (3) In computer graphics, the diffused spread of colour from one object to another in close proximity.

BMP Bit MaP: file format native to Windows.

bokeh Subjective quality of the out-of-focus image projected by an optical system, usually a photographic lens.

brightness (1) Quality of visual perception that varies with amount or intensity of light that a given element in visual field or optical component appears to send out or transmit, e.g. sunny day, powerful lamp, efficient viewfinder. Antonym: darkness. (2) Brilliance of colour, related to hue or colour saturation e.g. bright pink as opposed to pale pink; also in reference to reproduction of colour e.g. this film produces bright colours; colours on this monitor are bright. (This is British recommended usage in dye industry.)

brightness range Difference between brightness of brightest part of subject and brightness of darkest part of subject. * Do not confuse with contrast.

browse To look through collection of e.g. images or web pages in no preconceived order or with no strictly defined search routine.

brush Image-editing tool used to apply effects such as colour, blurring, burn, dodge, etc., limited to areas the brush is applied to, in imitation of a real brush. * User can set the size, the sharpness of cut-off between effect and no effect and amount of colour applied, and so on. * Some software permits application of entire images as the brush 'colour'.

buffer (1) Memory component in output device such as printer, CD writer, digital camera that stores data temporarily which it then feeds to the device at a rate the data can be turned into e.g. a printed page. (2) Chemical that maintains pH of solution at constant level while chemical reactions take place within it i.e. preserves alkalinity or acidity. Used in developers.

burning in (1) Digital image manipulation technique that mimics darkroom burning in: s. (2) Darkroom technique for altering local contrast and density of print by giving local exposure to areas of high density with rest of print masked off to prevent unwanted exposure in other areas.

byte Unit of digital information: one byte equals 8 bits. * An 8-bit microprocessor handles one byte of data at a time.

C

C Cyan: a secondary colour made by combining primary colours red and blue. * The Cyan separation used in four- or six-colour printing processes.

cache RAM dedicated to keeping data recently read off a storage device (disk cache) or other RAM.

calibration Process of matching characteristics or behaviour of a device to a standard, e.g. film speed, desired result, or neutral colour balance.

camera exposure Quantity of light reaching light-sensitive material or sensors in camera: determined by effective aperture of lens and duration of exposure to light.

capacity Quantity of data that can be stored in a device. * NB: Actual capacity of most removable media must be reduced by an amount which represents the space used for the directory information needed to keep track of files.

cartridge Storage or protective device consisting of a shell e.g. plastic or metal casing enclosing delicate parts e.g. magnetic platter, magnetic tape or magneto-optical disk.

catch light Small highlight, usually reflection of light-source i.e. it is specular: usually referring to highlights in eyes in portraiture. Lack of catch lights often regarded as deficiency in portrait.

CCD (Charge-Coupled Device) Semiconductor device used to measure amount of light hence used as image detector.

CD-ROM (Compact Disk - Read Only Memory) Storage device for digital files invented originally for music and now one of the most ubiquitous computer storage systems.

characteristic curve (1) Graph showing how density of given film and its development is related to exposure given to it. Scale for vertical axis is density and horizontal is logarithm of exposure or relative exposure. (2) Graph relating input values to output values for an image: see tone curve. * For film, characteristic curve is typically a slanted S-shape. Curve characterises film's response to light for given development regime.

On the North Downs Way of southern England, the branches of beech trees in early spring create patterns in which the spaces and gaps are as interesting as the elaborate branching itself. Images with intricate patterns benefit from the use of medium or larger formats, such as this, taken on 6x9cm format roll-film, using a Wista Technical camera and a 90mm lens designed for the 5x4" format.

chroma Colour value of given light-source or patch. * Approximately equivalent to perceptual hue of colour.

CIE LAB (Commission Internationale de l'Eclairage L*a*b*): a colour model in which the colour space is a spherical. The vertical axis is L for lightness i.e. achromatic colours: black at bottom ranging to white at top. The a* axis runs horizontally from red (positive values) to green (negative values). At right angles to this the b* axis runs from yellow (positive values) to blue (negative values).

clipboard Area of memory reserved for temporarily holding items during editing. * Usually making a cut or a copy of selected text, graphic or other item puts it into the clipboard.

CLUT (Colour Look-Up Table): The collection of colours used to define colours in indexed colour files: usually a maximum of 256 colours can be contained.

CMYK (Cyan Magenta Yellow Key): the first three are the primary colours of subtractive mixing, i.e. the principle on which inks rely to create a sense of colour. * A mix of all three as full, solid primaries produces a dark colour close to black, but for good-quality blacks, it is necessary to use a separate black or key ink. * The set of four inks are standardly used to print colour: hence 'four-colour printing'.

codec co(mpression) dec(ompression): routine or algorithm for compressing and decompressing files e.g. JPEG, MPEG etc. * Image-file codecs are usually specific to the format, but it is important that video codecs are not tied to a video format.

cold colours Subjective term referring to blues and cyans. * Cold colour casts are seldom acceptable, i.e. usually regarded as something needing correcting.

colour analyser Instrument for measuring colour balance of image. Used in colour printing to determine filtration to be set for correct colour balance. May also incorporate exposure meter to measure brightness of image.

colour picker Part of operating system or application which enables user to select a colour for use, e.g. in painting, for filling a gradient etc.

colour synthesis Recreating original colour sensation by combining two or more other colours. Two classes of methods: additive colour synthesis, subtractive colour synthesis.

colour temperature Measure of colour quality of source of light: expressed in Kelvin. Colour of light is correlated to temperature of black body radiator when colour of its light matches that of light being measured.

colourimetry Measurement of colour quality of visual sensations,

in particular hue (colour name or dominant wavelength), saturation (purity or depth of colour) and brightness (luminance).

colorize To add colour to a grey scale image without changing the original lightness values.

ColourSync Proprietary colour management software system to help ensure that colours seen on screen match those printed or reproduced.

colour (1) Noun denoting quality of visual perception characterised by hue, saturation and lightness: it is perceived as attributes of things seen. (2) Verb meaning to add colour to an image by hand: using dyes, oil paints with brush or spray (air brush) or in a image-manipulation programme.

colour cast Tint or hint of colour evenly covering an image.

colour gamut Range of colours producible by a device or reproduction system. * Reliable colour reproduction is hampered by differing colour gamuts of devices: colour film has the largest gamut, computer monitors have less than colour film but greater than ink-jet printers; the best ink-jet printers have a greater colour gamut than four-colour SWOP printing.

colour management Process of controlling the output of all devices in a production chain to ensure that final results are reliable and repeatable from the point of view of colour reproduction.

colour model Systematic scheme or theory for representing the visual experience of colour by defining any given perception in terms of three or more basic measures.

colour sensitivity Measure of variation in way film responds to light of different wavelengths, particularly in reference to black and white films. * For example, if film is more responsive to blue light than to red light, it records greater density to blue than to red light of identical luminance or luminous intensity.

colour space Theoretical construct that defines range of colours that can be reproduced by a given output device or be seen by human eye under certain conditions.

complementary colours Pairs of colours which produce white when added together as lights e.g. secondary colours - cyan, magenta and yellow - are complementary to primary colours: respectively red, green and blue. * Note: coloured filters transmit light of its colour and adsorbs light of complementary colour.

compliant Device or software that complies with the specifications or standards set by corresponding device or software to enable them to work together.

compositing Picture-processing technique which combines one or more images with a basic image.

compression Process of reducing size of digital files by changing the way the data is coded. * NB: It does not involve a physical change in the way the data itself is stored; there is no physical squeezing or squashing.

continuous tone image Record in dyes, pigment, silver or other metals in which relatively smooth transitions from low densities to high densities are represented by varying amounts of substance making up image.

contone Adjective describing any system that provides continuous tone reproduction.

contrast (1) Of ambient light: brightness range in scene. * Difference between highest luminance and lowest. High contrast indicates large subject brightness range. (2) Of film: rate at which density builds up with increasing exposure over mid-portion of characteristic curve of film/development combination. (3) Of light source or quality of light: directional light gives high-contrast lighting with hard shadows; diffuse light gives low-contrast lighting with soft shadows. (4) Of printing paper: grade of paper e.g. high-contrast paper is grade 4 or 5, grade 1 is low contrast. (5) Of image quality: usually in reference to measured MTF: high-contrast lens delivers image of object with high MTF. Also subjective evaluation of image quality: high contrast usually preferred to low contrast. (6) Of colour: colours opposite each other on the colour wheel are regarded as contrasting e.g. blue and yellow, green and red.

convolution Transformation of the values of pixels of bit-mapped images by applying a mathematical function to either single pixels or groups of pixels without changing the number or position of the pixels.

copyright Rights which subsist in original literary, dramatic, musical or artistic works to alter, reproduce, publish or broadcast. Artistic works include photographs, i.e. recordings of light or other radiation on any medium on which an image is produced or from which an image may by any means be produced, and which is not part of a film.

CPU Central Processor Unit: part of computer which receives instructions, evaluates them according to the software applications, then issues appropriate instructions to the other parts of the computer. * Often referred to as the 'chip' e.g. G4, Pentium III etc.

crash The sudden, unexpected and unwelcome non-functioning of a computer.

crop (1) To use part of an image for purpose of: improving composition; fitting image to fit available space or format; squaring up image to correct horizon or vertical axis. (2) To scan only that part of an image that is required.

cross-platform Application software, file or file format which can be used on more than one computer platform.

custom colour A specially formulated colour used together with black ink or in addition to the separation colours. * A spot colour.

custom palette Set of colours selected by user or software for specific purpose, usually to ensure satisfactory reproduction of image with minimum number of different colours, in order to minimise file size.

cut and paste To remove a selected bit of text, selection of cell contents, selected part of a graphic or image, etc. from a file and store it temporarily in a clipboard to be used elsewhere, at which point the cut selection is said to be 'pasted'.

cyan Blue-green: primary colour of subtractive mixing; secondary colour of additive mixing. * It is the complementary colour to red.

D

d-max (1) Measure of greatest or maximum density of silver or dye image attained by film or print in given sample. (2) Point at top of characteristic curve of negative film or bottom of curve for positive.

D6500 White-balance standard used to calibrate monitor screens: used primarily for domestic television sets. * White is correlated to colour temperature of 6500 K.

daylight (1) Light that comes directly or indirectly from sun: it varies very widely in brightness, colour and quality. (2) As notional standard: is average mixture of sunlight and skylight with some clouds typical of temperate latitudes around midday. Such light has colour temperature of 5400-5900 K. (3) Adjective describing film whose colour balance is correct for light sources whose colour temperature is 5400-5600 K. (4) Adjective describing artificial light source – e.g. light bulb - whose colour-rendering index approximates that of daylight.

definition Subjective assessment of clarity and quality of detail visible in image or photograph. * Objectively measured by combining different parameters such as resolution and contrast for image produced by optical system; for photographic negative or print other relevant parameters include: acutance, granularity, gamma and other factors such as edge effects.

delete (1) To render a file invisible and capable of being overwritten. (2) To remove an item, such as a letter, selected block of words or cells, selected part of a graphic or an image.

density (1) Measure of darkness, blackening or 'strength' of

A perfect little mausoleum with an illustrious history in a hidden corner of Uzbekistan: I wanted above all to have depth-of-field that covered the pool of water (left in a depression caused by centuries of pilgrims touching the marble) all the way to the door; it was also important to avoid distorting the verticals. The only way to achieve both objectives is to use lens movements: here I used the 24mm f/3.5L TS lens for Canon EOS which offers both shift and tilt: shift to raise the coverage of the lens to include less foreground and tilt to align the plane of best focus so that the wedge of depth of field covers the foreground through to the wall ahead.

image in terms of its ability to stop light, i.e. its opacity. (2) The number of dots per unit area given by a print process.

depth (1) Dimension of picture or page size measured on vertical axis, at right angles to width measurement. (2) Sharpness of image, i.e. how much is sharp; loosely synonymous with depth of field. (3) Subjective assessment of the richness of black in either print or transparency. Loosely synonymous with maximum density.

depth of field Measure of zone or distance over which any object in front of lens will appear acceptably sharp: it lies in front of and behind the plane of best focus.

depth perception Perception of absolute or relative distance of object from viewer. Most acute with binocular vision or stereopsis.

digital image Image on computer screen or any other visible medium such as print which has been produced by transforming image of subject into a digital record, followed by reconstruction of image, or displayed according to e.g. brightness values appropriate for it.

digitisation Process of translating values for brightness or colour into electrical pulses representing alphabetical or numerical code. * A fundamental process that enables optical image to be converted into a form which can be handled electronically. Digital code enables record of image to be manipulated by computer programs and result can be output into visible form using printer or monitor screen.

direct vision finder Type of viewfinder in which subject is observed directly, e.g. through hole or optical device but not via a reflection in mirror.

dispersion Phenomenon of light in which degree to which beam of light is refracted or diffracted depends on its wavelength. * Dispersion of white light causes splitting up of beam into spectrum and is the cause of chromatic aberration.

display Device that provides temporary visual representation of data e.g. monitor screen, LCD projector, information panel on camera.

dissolve (1) In film, audio-visuals, animation or video: process of fading or blending one image into another during projection - first image is dimmed gradually or faded while second is made brighter. (2) Verb: to cause solid substance to go into solution.

distortion, tonal Property of image in which contrast, range of brightness, or colours appear to be markedly different from that of subject.

dithering Simulating many colours or shades by using what is in fact a smaller number of colours or shades.

dodging (1) Technique for controlling local contrast during printing by selectively reducing amount of light reaching parts of print which would otherwise print too dark. * Used to 'hold back' or preserve shadow detail. * Dodging tools are usually small bits of card stuck onto ends of long thin wires.

down-sampling Reduction in file-size when a bit-mapped image is reduced in size: done by systematic discarding of unwanted pixels and information.

dpi Dots per inch: measure of resolution of output device as number of dots or points which can be addressed or printed by the device.

driver Software used by computer to control or drive a peripheral device such as scanner, printer, removable media drive connected to it.

drop shadow Graphic effect in which object appears to float above a surface, leaving a more or less fuzzy shadow below it and offset to one side.

drop-on-demand Type of ink-jet printer in which ink leaves the reservoir only when required. * Most ink-jet printers in use are drop-on-demand.

drum scanner Type of scanner employing a tightly focused spot of light to shine on the subject that is stretched over a rotating drum: as the drum rotates, the spot of light traverses the length of the subject, so scanning the whole area. Light reflected from or transmitted through the subject (in which case the drum must be transparent) is picked up by a photo-multiplier tube.

duotone (1) Photomechanical printing process using two inks to increase tonal range: two half-tone screens are made at different angles. Darker colour ink is used to print solid and near-solid areas, lighter colour ink is used to print mid- and lighter tones. (2) Mode of working in image-manipulation software that simulates printing of image with two inks, each with its own reproduction curve.

DVD-RAM A DVD, i.e. digital versatile disc, variant that carries up to 2.6GB per side that is write many times and read many times.

dye sublimation Printer technology based on rapid heating of dry colourants held in close contact with a receiving layer turns the colourants to gas which transfers to and solidifies on the receiving layer.

dynamic range Measure of spread of highest to lowest energy levels that can be captured by an imaging or recording or play-back device e.g. a top-class scanning camera back can capture a range of 11 f/stops, a good film-scanner may be able to manage about 9 stops. * Concept of energy levels is usually converted to densities in devices such as scanners e.g. dynamic range is 0.2 to 3.0 D units.

E

e-mail electronic-mail: simple files which can be sent from one Internet to another or group of users of the Internet.

edge effects Local distortions of image density in film due to the movement of developer and developer products between regions of different exposure. * Similar effects can be seen with some image-processing techniques.

edge sharpening Process of making edges easier to see, therefore appearing sharper, usually by digitally creating a slight local increase in contrast at image boundaries using so-called image-sharpening filters.

effective *f*-number lens *f*-number corrected for close focusing.

effects filters (1) Lens attachments designed to distort, colour or modify image to give exaggerated, unusual or special effects. (2) Digital filters that have effects similar to their lens-attachment counterparts but also giving effects impossible with analogue filters.

electronic image Synonymous with digital image.

engine (1) The internal mechanisms that drive devices such as printers and scanners. (2) Software: the core parts of a software application.

enhancement (1) Change in one or more qualities of an image in to order improve the visual or other property of the image: e.g. increase in colour saturation, sharpness etc. (2) Effect produced by a device or software designed to increase the apparent resolution of a TV monitor screen.

EPS Encapsulated PostScript: File format that stores an image (graphics, photograph or page layout) in PostScript page description language. * EPS files are vector-based: they must be interpreted and rasterised before they can be seen on screen or printed.

erase To remove or wipe a recording from a disk, tape or other recording medium (usually magnetic) so that it is then impossible to reconstruct the original record.

EV Exposure Value. Measure of camera exposure: for a given EV, there is set of shutter and apertures settings which give the same camera exposure.

event Action or input from human or other generator (e.g. mouse clicks, input from keyboard or a triggering pulse from an infra-red detector) to a software program which initiates a response by that program.

exposure (1) Process of allowing light to reach light-sensitive material to create latent image: by e.g. opening shutter; illuminating dark subject with flash of light or energy. (2) Amount of light energy that reaches film: it is given by H = Et where E is illuminance and t is time in seconds. (3) Having one's work published in magazines, books and such like or having one's work shown in exhibitions.

exposure factor Number indicating degree by which measured exposure should be corrected or changed in order to give proper, corrected exposure.

exposure index Setting used to calculate camera exposure settings. * Exposure index (E.I.) is set on the exposure meter or camera in order to give exposures based not on actual film speed but on an adaptation of it for a special purpose.

F

f/number (1) Setting of lens diaphragm that determines amount of light transmitted by lens. (2) Equal to focal length of lens divided by diameter of entrance pupil.

fade Gradual loss of density in silver, pigment or dye image over time.

fall-off (1) Loss of illuminance in the corners of an image as projected by a lens in e.g. a camera or a projector. (2) Loss of light towards the edges of a scene that is illuminated by a light source whose angle of illumination is too small to cover the required view. (3) Loss of image sharpness and density away from the centre of a flat-bed scanner whose array of sensors is narrower than the width of the scanned area.

false colour Term usually applied to images with arbitrary allocation of colour to wavebands. * E.g. with infra-red sensitive film: green objects are shown as blue, red objects are green and infra-red light from objects is shown as red.

feathering (1) Blurring a border or bounding line by reducing the sharpness or suddenness of the change in value of e.g. colour, brightness etc. (2) Adding equal amounts of space between lines of type i.e. give equal increases in leading in order to force vertical justification in desk-top publishing programs.

file format The way in which a software program stores data: determined by the structure and organisation of the data, specific codes, e.g. for indicating the start and end of a segment of data together with any special techniques used such as compression. * Formats may be generic - shared by different software, or native to a specific application.

fill-in (1) Verb: to illuminate shadows cast by main light by using another light source or reflector to bounce light from main source into shadows. (2) Noun: light used to lighten or illuminate shadows cast by main light.

The most complicated-looking images can result from the simplest of techniques. Here, a print of dancers waiting for their turn on stage was double-exposed in camera onto a print of an architectural detail of a ceiling of a harem. The complexity of the image comes from the interaction between repeated but irregular human forms and the mechanical repetition of the painted decoration. This kind of image is ideal for taking further with digital manipulation as the superimposition of elements has already dragged the image some distance from reality.

film gate Physical aperture in a camera that lies close to the film to mask the image projected by the lens: its size defines the shape and size of the image that is captured on the film.

filter (1) Optical accessory used to cut out certain wavelengths of light or frequencies of data and pass others. (2) Part of image-manipulation software written to produce effects simulating effects of photographic filters. (3) Part of application software that is used to convert one file format to another. (4) Program or part of application used to remove or to screen data e.g. to refuse e-mail messages from specified sources.

fingerprint Marking in a digital image file that is invisible and which survives all normal image manipulations but which can still be retrieved by suitable software.

fixed focus Type of lens mounting which fixes lens at set distance from film: usually focused on hyperfocal distance. For normal to slightly wide-angle lenses this is at between 2 and 4m from camera.

flare Non-image-forming light in optical system.

flash (1) Verb: to provide illumination with very brief burst of light. (2) Verb: to reduce contrast in a sensitive material by exposing it to brief overall burst of light. (3) Noun: equipment used to provide brief burst or flash of light.

flat (1) Low contrast e.g. flat negative or print is low contrast i.e. shows only grey tones. (2) Light or conditions tending to produce evenly lit or low-contrast results.

flat-bed scanner Type of scanner employing a set of sensors arranged in a line and focused via mirrors and lenses on the subject which is placed face down on a flat glass bed facing a light source: as the sensors traverse the length of the subject, they register the varying light levels reflected off the subject.

flatten To combine together multiple layers and other elements of a digitally manipulated or composited image into one. * Usually final step of working with layers prior to saving image in standard image format, otherwise save must be in native format.

focal length (1) For simple lens: distance between centre of lens and sharp image of an object at infinity projected by it. (2) For complex lens systems: distance between rear principal point (or rear nodal point) and rear principal focus for object at infinity.

focus (1) Verb: to make image look sharp, by bringing film or projection plane into coincidence with focal plane of optical system. (2) Noun: rear principal focal point. (3) Noun: point or area on which attention or compositional elements converge visually.

fog Non-image-forming density in film that has effect of reducing shadow contrast.

foreground (1) Part of scene or space around object that appears closest to camera. (2) Element or feature of composition of photograph that is depicted as being nearest viewer.

format (1) Shape and dimensions of image on a film as defined by the shape and dimensions of the film gate of the camera in use. (2) Dimensions of paper, hence also to publication size. (3) Orientation of image: landscape (if image orientated with the long axis horizontal), portrait (if image is oriented with the long axis upright).

fractal Curve or other object whose smaller parts are similar to the whole. * In practice, a fractal displays increasing complexity as it is viewed more closely and where the details bear a similarity to the whole.

frame (1) An entire screen's worth of information. (2) An image in a sequence of animated images.

G

gamma (1) In photography, a measure of the response of a given film, developer and development regime to light, e.g. a high contrast results in higher gamma. (2) In monitors, a measure of the correction to the colour signal prior to its projection on screen. A high gamma gives a darker overall screen image; at the same time, it may also increase the contrast in the mid-range brightnesses.

GIF Graphic Interchange Format: a compressed file format designed to use over the Internet: comprises a standard set of 216 colours (not 256 as often claimed).

grain (1) Film: the individual silver (or other metal) particles that make up the image of a fully developed film. * In the case of colour, grain is the individual dye clouds of the image. (2) Photographic print: the appearance of individual specks comprising the image. (3) Paper: the texture of the surface of a sheet, produced by the calendering or other finishing process.

graphics tablet Input device for fine or variable control of cursor or brush in graphics, painting or image manipulation program. * Comprises tablet – an electrostatically charged board connected to the computer – and the pen, which interacts with the board to locate the pen and give information on the pressure at the pen-tip.

greeking Representation of text or images as grey blocks or other approximation. * Strategy for avoiding lengthy screen redraws allowing rapid scrolling through a document with many graphics or images.

greyscale Measure of number of distinct steps between black and white that can be recorded or reproduced by a system. * A greyscale of two steps permits recording or reproduction of just black or white; the Zone System uses a greyscale of ten divisions; for normal reproduction a greyscale of at least 256 steps, including black and white, is required.

H

half-tone cell Unit used by a half-toning printing or reproduction system to simulate grey-scale or continuous tone reproduction. * In mass-production printing e.g. offset lithography, the half-tone cell is defined by the screen frequency, measured as lpi (lines per inch): continuous tone is simulated by using dots of different sizes within the half-tone cell. * With desk-top printers e.g. laser and ink-jet printers, the half-tone cell comprises groups of individual laser or ink-jet dots e.g. 16 dots arranged as a square of 4 by 4 may represent one cell, giving 17 greyscale steps thus: no dot in the cell is white, 16 dots is black; and greys lie in between.

hardcopy Visible form of a computer file printed more or less permanently onto a support such as paper, film. * As opposed to softcopy.

hints Artificial intelligence built into outline fonts which turn elements of a font on or off according to the size of the font to improve legibility, balance and design.

histogram Statistical, graphical representation showing the relative numbers of variable over a range of values: e.g. with Levels dialogue, the taller the column at a certain value, the more pixels have that value.

HLS Hue, Lightness, Saturation: colour model - good for representing visual response to colours but not satisfactory for other colour-reproduction systems. * Largely superseded by LAB model.

HSB Hue, Saturation, Brightness: see HLS.

hue Name given by observer to their visual perception of colour.

I

image-aspect ratio Comparison of the depth of the image to its width, e.g. the nominal 35mm format in landscape orientation is 24mm deep by 36mm, so the aspect ratio works out to 1:1.5.

indexed colour Method of creating colour files or defining a colour space. * The index refers to a table of e.g. 256 different colours held as normal 8-bit data, but these colours are chosen from a full 24-bit palette (i.e. from 16.8 million different colours). A given pixel's colour is then defined by its position or index in the table (also 'colour look-up table').

ink-jet Printing technology based on the controlled squirting of extremely tiny drops of ink onto a receiving substrate.

intensity (1) Measure of energy, usually light, radiated by a source. (2) Also loosely used to refer to apparent strength of colour as in ink, photograph, monitor colour etc. in a sense roughly equivalent to 'saturation'.

intensity resolution See bit-depth.

interpolation Inserting pixels into an existing digital image. Used to: (1) resize an image file when a bit-mapped image is enlarged; (2) to give an apparent (but not real) increase to resolution, e.g. in scanned images; (3) may be needed when image is rotated and in some other transformations e.g. animation; (4) in some anti-aliasing techniques.

J

jaggies Appearance of stair-stepping artefacts.

JPEG Joint Photographic Expert Group: (1) Acronym referring to a data-compression technique that can reduce file sizes to 75% with nearly invisible loss of quality and as little as 10% of original with a slight loss of image quality. (2) Name of committee sanctioned by CCITT and ISO (hence 'Joint' in name) that researched and set up the standards for data compression.

K

k kilo: one thousand, a round decimal thousand i.e. 1000; e.g. 1kg, kilogram, is a thousand grams.

K (1) KiloByte. 1024 bits or 210 bytes of data; abbreviated to KB. (2) Key colour or black: the fourth colour separation in the CMYK four-colour reproduction process.

KB Kilobyte: often abbreviated K.

kelvin Unit of temperature relative to absolute zero. * Temperature in kelvin is Celsius plus 273.16. * Used to express colour temperature. * Symbol is K (space after number, with no degree sign).

kernel (1) Group of pixels, usually a square from 3 pixels to any number of pixels across (generally up to maximum of 60+), that is sampled and mathematically operated on for certain image-

processing techniques e.g. filtering for noise reduction, sharpening, blurring.

kerning In desk-top publishing and typesetting: the spacing between pairs of letters.

key (1) Noun: Part of a computer or other keyboard that produces a character. (2) Verb: To enter characters or text from a keyboard. (3) Noun: Any artwork, guide or (in printing) physical form that establishes the relative positions of graphics elements, type or other printing element. (4) Noun: A piece of information that unlocks an encrypted message. (5) Noun: Key ink or the black separation.

key tone (1) The black in an image. (2) The principal or most important tone in an image.

keyboard shortcut Keystrokes that execute a command.

L

layer mode Picture-processing or image-manipulation technique that determines the way that a layer in a multi-layer image combines or interacts with the layer below. * For example: in normal mode, the upper layer covers the layer below; in darken mode, pixels are darkened only where the top layer is darker than the base layer; in colour mode, pixels in the upper layer add hue information to the lower pixels without changing brightness.

light (1) That part of the electromagnetic spectrum, from about 380 - 760 nm (420 to 760nm for older people), that can be sensed by human eyes by the stimulation of the receptors of the retina and give rise to visual sensations. It is radiant energy by which agency human vision operates. * Light of different wavelengths are perceived as light of different colours. (2) To manipulate sources of light and light-shapers to alter the illumination on a subject.

light-box Viewer for transparencies and films consisting of translucent diffusing top that is lit from below by colour-corrected fluorescent tubes to give daylight equivalent light. * Also applies to print-viewing box with standard lighting.

lightness (1) Amount of white in a colour, which affects the perceived saturation of the colour: the lighter the colour the less saturated it appears to be. (2) Loosely, an antonym of 'density'.

line art Artwork that consists of black lines and areas, with no intermediate grey tones.

load (1) Verb: to copy enough of the application software into the computer's RAM for the computer to be able to open and run the application. (2): Verb: to copy a file into the computer's RAM so that it can be used.

lossless compression Computing routine or algorithm that reduces the size of a digital file without reducing the information in the file.

lossy compression Computing routine or algorithm that reduces the size of a digital file but also loses information or data.

low-pass filter Filter of software or optical type that lets through low-frequency data and blocks higher frequency data. * E.g. softening filters used for portraiture are low-pass: they let through the low-frequency data of facial shape and main features, but block high-frequency data such as wrinkles and spots.

lpi lines per inch: measure of resolution or fineness of photo-mechanical reproduction.

LZW compression Lempel-Ziv Welch: a compression algorithm that is widely used for lossless file compression, particularly applied to TIFF files.

M

Mac Apple Macintosh computer. * Also the operating system used on Apple computers.

macro (1) Close-up range giving reproduction ratios within the range of about 1:10 to 1:1 (life-size). (2) Small routine or program within larger software program that performs a series of operations: may also be called 'script' or 'action'.

marquee Selection tool used in image-manipulation and graphics software: so-called presumably because it covers a rectangular area as it is used.

mask (1) Technique used to obscure selectively or hold back parts of an image while allowing other parts to show. (2) Array of values that are used by the computer in digital image processing to calculate digital filter effects such as unsharp masking, noise reduction or increase etc.

master (1) Noun: original or first, and usually unique, incarnation of a photograph, file or recording: the one from which copies will be made. (2) Adjective: qualiyfing things from which further copies are to be made e.g. master duplicate. (3) Verb: To make the first copy of a photograph, file or recording e.g. master a CD is to create a new CD from which others may be made.

matrix (1) The flat, two-dimensional array of CCD sensors. (2) Mathematical technique that arranges sets of numbers into rows and columns for the purpose of performing calculations.

matte (1) Finish on paper that reflects light in a diffused way. (2) Box-shaped accessory placed in front of camera lens to hold accessories. (3) Board whose centre is cut out to create a window to display prints. (4) Mask that blanks out an area of image to allow another image to be superimposed.

megapixel Million pixels. Used to describe class of digital camera with sensor resolutions of approximately a million pixels or more.

Moiré Pattern of alternating light and dark bands or colours, usually of varying width and density, caused by interference between two or more superimposed arrays or patterns which differ in phase, orientation or frequency.

monochromatic (1) Light made up of one wavelength only e.g. light from a laser. (2) Photograph or image displaying a very limited range of hues e.g. a cyanotype (blues) or a landscape consisting largely of adjacent hues e.g. reds and yellows.

monochrome Photograph or image made up of black, white and greys which may or may not be tinted.

N

native (1) File format belonging to an application programme, usually optimised for the programme. (2) Application program written specifically for a certain type of processor e.g. for RISC processors of Power Mac.

nearest neighbour Type of interpolation in which the value of the new pixel is an average of the neighbouring pixels. * Quick and dirty interpolation, that gives rather ragged results.

node (1) Computer linked to others in a network or on the Internet. (2) Word or short phrase that is linked to other text elsewhere in a hypertext document.

noise Unwanted signals or disturbances in a system that tend to reduce the amount of information being recorded or transmitted.

Nyquist rate Signal-processing theory: the sampling rate needed to turn an analogue signal to into an accurate digital representation of it is twice the highest frequency found in the analogue signal. * For example: if the highest frequency we want to record is 20kHz, then the Nyquist rate is 2 x 20kHZ = 40kHZ = the sampling rate. * Applied to determine quality factor relating image resolution to output resolution: pixel density should be at least 1.5 times but not more than 2 times the screen ruling e.g. for 150 screen or lpi, resolution should be at least 225, not more than 300 dpi. Higher resolutions do not increase quality.

O

off-line Mode of working with data or files in which all required files are downloaded or copied from a source to be accessed directly by the user, without continual connection with the data source.

offset (1) Verb: to transfer ink or dye from one surface to another before printing on final surface; also adjective, e.g. offset lithography transfers ink from the plates to a rubber mat which then transfers the ink to the paper. (2) Adjective: calibration or other marks or parts of image which are set off alignment with each other.

on-line Mode of working or operating with data or files in which the operator maintains connection with a remote source.

operating system The software program that underlies the functioning of the computer, allowing applications software to use the computer. It controls internal workings such as the way data is sent in and out and also regulates communications between the computer and its peripheral devices. * Differences between operating systems are gradually disappearing although it remains true that different OS are better at some tasks than others.

optical viewfinder Any type of viewfinder that shows subject directly, through an optical system, rather than via a monitor screen such as the LCD screen common on digital cameras.

OS See operating system.

out-of-gamut Colour or colours that are visible or reproducible in one colour space but which cannot be seen or reproduced in another. * For example, many bright and highly saturated colours visible as well as some pastel colours in RGB space of colour monitors are out-of-gamut in the CMYK space of offset lithography, i.e. these RGB colours cannot be printed with process colours onto paper.

output (1) Result of any computer calculation, i.e. any process or manipulation of data. * Depending on context, output may be in form of new data, set of numbers or used to control an output device. (2) Hard copy printout of digital file, e.g. as ink-jet print or separation films.

P

paint (1) Verb: apply colour, texture or effect with a digital 'brush'. (2) Noun: colour applied to image, usually by altering the underlying pixels of bit-mapped images or by filling a defined stroke in graphics objects.

palette (1) In drawing, image-manipulation programs etc., a set of tools e.g. brush shapes and their controls presented in a small window that is active together with other palettes plus the main document window. (2) Range or selection of colours available to a colour reproduction system, e.g. monitor screen, photographic film or paper, depending on the colour characteristics of phosphors, dyes or processing used. (3) Specific data set of colours that can be addressed by a system to reproduce a range of colours, e.g. as used in obsolete video graphics standards. (4) Selection of colours for painting or filling in that floats on screen in graphics and image applications ready for paintbrush etc. to 'pick-up' colour.

Pantone Proprietary name for system of colour coding, management and classification.

peripheral Any device connected to a computer, e.g. printers, monitors, scanners, modems.

Photo CD Proprietary system of digital image management based on storage of image files (called Image Pacs) onto CDs. * The system scans an image to digitise it into Kodak's YCC format which is stored on the CD at five different levels of resolution; maximum capacity of disk is about 100 images. * The CD can be played back on any CD-ROM player in any computer that is multi-session compatible.

photodiode Semi-conductor device that responds very quickly and proportionally to light falling on it.

photograph (1) Noun: Record of physical objects, scenes or phenomena made with a camera or other device, through the agency of radiant energy, onto sensitive material from which a visible image may be obtained. * A recording of light or other radiation on any medium on which an image may be produced. (2) Verb: To make, create, take or arrange for the taking of a photograph.

photomontage (1) Noun: Photographic image made from the combination of several other photographic images etc. (2) Noun: The process or technique of making a photomontage

PICT Graphic file format widely used on Mac OS: contains raster as well as vector information but is nominally limited to 72dpi, being designed for screen images. * PICT2 supports colour to 24-bit depth.

picture element See pixel.

piezoelectric Type of material that produces electricity when distorted, e.g. by bending, squeezing or which itself is distorted when an electric field is applied to it.

pixel Picture element: the smallest atomic unit of digital imaging used or produced by a given device. *

Usually, but not always, square in shape. * Device may capture image in sets of three or more contiguous pixels (one for each primary colour) but delivers image as a single, interpolated, pixel.

pixellation Appearance of a digital image whose individual pixels are clearly discernible.

platform Type of computer system, usually defined by the operating system used, e.g. Apple Macintosh platform uses Mac OS.

plug-in Application software that works in conjunction with a host program into which it is 'plugged' so that it appears in a menu, operating as part of the program itself.

posterisation Representation of an image using a relatively very small number of different tones or colours which results in a distinctively banded appearance and flat areas of colour.

PostScript Language designed to specify elements that are printed on a page or other medium: used by drawing and desk-top publishing programs to instruct printers and image setters what to print and is therefore device and resolution-independent.

ppi points per inch: measure of resolution, e.g. of scanning device, measured as the number of points which are seen or resolved by the device per linear inch on a given axis.

pre-scan In image acquisition: a quick 'snap' of the object to be scanned, taken at a low resolution for adjustment of cropping etc.

primary colour One of the colours red, green or blue. * 'Primary' in the sense that the human eye has peak sensitivities to red, green and blue and that visible colours are perceived through the agency of varying sensations of red, green and blue combined.

process colours Colours which can be reproduced with standard web-offset press (SWOP) inks of cyan, magenta, yellow and black. * With introduction of six-ink printing, the gamut of process colours has been significantly enlarged.

proofing Process of checking or confirming the quality of a digital image before final output. * Proofing systems include soft-proof on monitor screens calibrated to appropriate printers as well as hard proofs onto paper.

pyramid Coding technique for image files in which the basic large file is compiled in such a way that it can easily provide increasingly smaller, lower-resolution files: this improves speed of working on the computer as only the visible part of the image is used for image manipulation. * Do not confuse with proxy images.

From the Old Fort in Mombassa, you can have a birds' eye view of a beach below: hessian sacks being dried made an ideal pattern that was both regular enough to be highly structured and irregular enough to be lively and not mechanical. It was possible then to take any number of effective shots: that was only a matter of squeezing off enough exposures before the pile of sacks ran out and the man left the scene.

Q

quality factor In pre-press work: multiplication factor used to ensure that graphics or image file size – i.e. amount of information – is sufficient for requisite quality. * Normally file size should be sufficient for 1.5 to 2 times the screen frequency e.g. for a screen of 133 lpi, the image file should have available at least 200 pixels per inch.

QuickDraw Object-oriented graphics language native to the Mac OS: it tells the computer how to draw what is seen on the monitor screen and may also control printing.

R

RAM Random Access Memory: component of the computer in which information can be stored or accessed directly. * Most rapid form of memory, but is volatile i.e. it requires continuous power to hold information. * Measured in MB: megabytes.

raster The regular arrangement of addressable points of any output device such as printer, film writer etc. * Means much the same as 'grid'.

resizing Changing the resolution or file size of an image.

refresh rate The rate at which one frame of a LCD or computer monitor screen succeeds the next. * Measured in Hertz (Hz) i.e. cycles per second.

res Measure of the resolution of a digital image expressed as the number of pixels per side of a square measuring 1 x 1mm.

resampling Addition or removal of pixels from an image by sampling or examining the existing pixels and making the necessary calculations. * Part of the process of interpolation. * Nearest Neighbour interpolation is most approximate, giving rough results; Bilinear looks at four and Bicubic looks at eight contiguous pixels to calculate the new values, giving better increasingly accurate results.

RGB Red Green Blue: colour model that defines colours in terms of relative amounts of red, green and blue components, e.g. lack is defined as zero amount of the components, white is created from equal and maximum amount of the components. * May be used to refer to colour space of monitors.

RIP Raster Image Processor: software or hardware dedicated to the conversion of outline fonts and vector graphics into rasterised information i.e. to turn outline instructions like 'fill' or 'linejoin' into an array of joined-up dots. * Requires a great deal of computing power to effect, and easily goes wrong.

S

scanner Opto-mechanical instrument used for analogue-to-digital conversion of photographs.

scanning Process of using scanner to turn an original into a digital facsimile, i.e. a digital file of specified size.

scrolling Process of moving to a different portion of a file too large for the whole of it to fit onto a monitor screen.

SCSI Small Computers Systems Interface: a standard and protocol for connecting devices to enable them to share data. * SCSI chains in basic form support up to seven devices, each of which must have its unique ID or identification number from 0 to 6, where 0 is usually the computer itself. * The last device in a chain has to be terminated, i.e. close the electrical circuit. * Various forms, with different data speeds.

soft-proofing Use of monitor screen to proof or confirm the quality of an image.

stair-stepping Jagged, rough or step-like reproduction of a line or boundary that is originally smooth.

SWOP Standard Web Offset Press: a set of inks used to define the colour gamut of CMYK inks used in the print industry. * Needed as variations in inks create different colour gamut. * To extend the gamut, one may cheat by adding a fifth or even sixth ink.

Syquest Proprietary name of removable media (now obsolete).

system requirement Specification defining the minimum configuration of equipment and version of operating system needed to open and run application software or device. * Usually describes type of processor, amount of RAM, amount of free hard disk, version of operating system and, according to software, number of colours that can be displayed on monitor as well as need for a specific device.

T

terminator terminal adaptor: a device that closes the circuit on a SCSI chain.

thumbnail Representation of image as small, low-resolution version. * Used to make it easier for computer to put image onto screen and to show many images at once. * May be saved as a separate file attached to the main file or created as needed.

TIFF Tagged Image File Format: extensively used format that supports up to 24-bit colour per pixel. Tags are used to store image information, e.g. dimensions.

tile (1) Noun: sub-section or part of a larger bit-mapped image: often used for file-storage purposes and for image processing. (2) Verb: to print in smaller sections a page that is larger than the printing device is able to print, e.g. an A2 poster may have to be printed in tiled sections if using an A4 printer.

tint (1) Colour reproducible with process colours; a process colour. (2) An overall, usually light, colouring that tends to affect areas with density but not clear areas (in contrast to a colour cast).

transparency (1) Film in which the image is seen by illuminating it from behind, e.g. colour transparency. (2) Degree to which background colour can be seen through a pixel of a different colour in the foreground.

transparency adaptor Accessory or part of a scanner that enables scanning of transparencies: usually consists of a light source that keeps step with the array.

trap Technique for preventing gaps or overlaps between adjacent blocks of colour in printing by introducing slight reductions or overlappings of colours.

truecolour display (also trucolor) Any device, particularly colour monitors, that can show as many colours as can be distinguished by the human eye - some 16 million. * Monitors displaying millions of colours or working to 24-bit depth are truecolour.

TWAIN Toolkit Without An Important Name: driver standard used by computers to control scanners. * Also a format in its own right, but rarely used as such.

U, V

undo Reverse an editing or similar action within application software to a previous action.

upload Transfer of data between computers or from network to computer. * Usage tends to refer to act of transferring data from a local machine onto a remote site, e.g. from your computer to web server for your web-site.

USB Universal Serial Bus: standard port design for connecting peripheral devices, e.g. digital camera, telecommunications equipment, printer, etc. to computer. * It is hot-pluggable, i.e. equipment can be connected while the computer is still on and up to 127 devices may be attached.

USM UnSharp Mask: Image-processing technique that has effect of improving apparent sharpness of image. * Note it is the mask that is unsharp: the intended result is that the image is made more sharp. * USM mimics the effect of using an unsharp mask in the darkroom by applying a 'hat' convolution or filter.

variable contrast Coating formula mixing emulsions of different speeds with the effect that the mid-tone contrast can be varied by changing the spectral qualities of the illumination. * Used primarily for black & white printing papers.

vignetting (1) Defect of optical system in which light at edges of image is cut off or reduced by obstruction in construction, e.g. lens tube is too narrow. (2) Visual effect of darkened corners used to help frame image or soften frame outline.

VRAM Video Random Access Memory: Rapid-access memory dedicated for use by computer or graphics accelerator to control the image on a monitor. * 2MB VRAM can give millions of colours up to a resolution of 832x624; 4MB VRAM can give millions of colours up to a resolution of 1024x768; 8MB VRAM is needed to give millions of colours at higher resolutions (all assuming a refresh rate of about 75Hz).

W

warm colours Subjective term referring to hues such as reds through oranges to yellows. * A warm colour cast is generally more acceptable than a cold colour cast.

watermark (1) Mark left on paper to identify maker or type by creating a design on the wire side of paper-making frame. (2) Element in a digital image file used to identify the copyright holder. * A visible or invisible element is that may (a) render the image unsuitable for reproduction unless removed or (b) which is invisible and cannot be removed without destroying the image but can be read by suitable software to audit use and interrogate copyright ownership.

windows Rectangular frames on the screen of computer software that 'open' onto applications: operations take place within these frames or windows.

Windows Proprietary name for a family of applications program interfaces developed by Microsoft.

wysiwyg what you see is what you get: feature of computer interface that shows on the monitor screen a good (but seldom very accurate) representation of what will be printed out. * To distinguish from character-based or plain text displays (which could not display e.g. different-sized, bold or italicised text) from those that could display such differences directly.

Z

Zip drive Proprietary name of drive manufacturer Iomega for removable storage device: each 3.5" disk holds up to about 100MB.

Books and web-sites

Young boys sell hand-tinted postcards of film stars at a stall in Urgut Market, Uzbekistan.

Books as sources of information are very hard to beat. Generally the information can be trusted – particularly from specialist publishers. And although technology changes faster and continually, you will find that most books do not date very quickly. But for certain kinds of up-to-date information, there is nothing to beat access to the World Wide Web: here you can access the latest information from software houses and manufacturers; you can up-date your software with fixes for bugs; you can download cheap but very useful shareware (application software that you can try out for a time – usually a week to a month – and pay a small fee for if you keep) as well as practical information and help from experienced digital workers. However, apart from the official sites and well-regulated ones, the information may be less than reliable. The listing here does not guarantee reliability and has been deliberately limited in scope because many less well-established sites flower but for a few months and lapse quickly into dotage.

General digital imaging

DIGITAL PHOTOGRAPHY

Ang, T; Mitchell Beazley Publishers

A bridge between silver-based photography and digital: highly illustrated introduction to camera techniques, projects and digital image manipulation with unique masterclass workshop section.

AN INTRODUCTION TO ELECTRONIC IMAGING FOR PHOTOGRAPHERS

Davies, A and Fenessey, P; Focal Press

Sound but stolid all-round text; strong on image manipulation and Photo CD, with CD; for the technically inclined.

REALWORLD SCANNING AND HALFTONES

Blatner, D and Roth, S; Peachpit Press

Excellent read with sound practical advice clearly coming from wide experience: a must for all who take their scanning seriously. Highly recommended.

LINOTYPE COLOR BOOK
Legrand, D; Trait d'union graphique, Paris (from Linotype-Hell)
Superbly illustrated and concise introduction to colour and printing – helps make sense of colour printing.
START WITH A SCAN
Ashford, J and Odam, J; Peachpit Press
Colourful and lively inspirational book on what to do and how to do what to scanned images.
THE COMPUTER IN THE VISUAL ARTS
Morgan Spalter, A; Addison-Wesley
Superb overview textbook of digital imaging in all its forms and implications; written by a writer of rare skills with numerous excellent illustrations. Highly recommended.

Photoshop
PHOTOSHOP 5 BIBLE
McClelland, D; IDG
Probably the most widely recommended text: nearly a thousand pages of more than you'd ever want to know about Adobe Photoshop. Highly recommended.
REALWORLD PHOTOSHOP 5
Blatner, D and Fraser, B; Peachpit Press
Production and practical techniques oriented towards quality output: the best text for advanced users. Highly recommended.
ADOBE PHOTOSHOP 5 PRODUCTIVITY KIT
Adobe Press
Many useful ready-made projects to follow, with CD containing all sample files. Concise, no-nonsense and very practical. Recommended.
PHOTOSHOP CHANNEL CHOPS
Biedny, D, Monroy, B and Moody, N; New Riders Publishing
Advanced, specialist text on channels and masking: but full of insights and useful advice in this vital but usually poorly understood aspect of Photoshop. Highly recommended for the advanced worker.
ADOBE PHOTOSHOP 5 FOR PHOTOGRAPHERS
Evening, M; Focal Press
Mixed-quality coverage, poorly edited but with many techniques explained; highly illustrated; CD with tutorials.
PHOTOSHOP 5 WOW! BOOK
Dayton, L and Davis, J; Peachpit Press
Best of the introductory texts, with numerous excellent illustrations and many walk-through tutorials. Commendably comes in separate versions for Mac and PC. Highly recommended.

Other topics
DIGITAL PROPERTY
Harris L E; McGraw Hill
Good basic guide to intellectual property rights applied to digital media and new media; with US bias.
RELEASE 2.1
Dyson, E; Viking
Intelligent and lucid discussion of many of the issues and debates of the digital age, especially the Internet, new media and their impact on society. Highly recommended.
CATCHING THE LIGHT
Zajonc, A; Oxford University Press
Goes back to the very basic of basics: what is light and how do we see? Interesting mix of history, philosophy and science. Highly recommended.
COMPUTER & INTERNET DICTIONARY
Pfaffenberger, B; Que Corporation
A clear, comprehensive and accurate dictionary covering a wide field of computing, internet and imaging, etc. Recommended.

World Wide Web
Among the best sites are:
Kodak at www.kodak.com
Adobe at www.adobe.com
Apple at www.apple.com
It is well worth visiting the main manufacturers such Nikon, Olympus, Epson, Agfa, Fuji, Sony, Ricoh, Hewlett Packard and so on.
At the time of writing, the following sites are worth visiting for general information on digital cameras, scanners etc:
welcome.to/digicam, www.bjphoto.co.uk,
www.pcphotoforum.com, www.dcforum.com, www.peimag.com,
www.dcresource.com, www.photo-on-pc.com, www.nyip.com,
For information on large-format, professional-quality digital photography, try: www.digital-photography.org
Excellent glossaries of computer, photo-electronic terms etc., which lead you to other web-sites, are at:
www. laurin.com, www. foldoc.doc.ic.ac.uk
There are numerous sites offering hints and advice on using Photoshop, try:
www.tema.ru/p/h/o/t/o/s/h/o/p, www.photoshoptips.i-us.com
as well as the Photoshop home page on the Adobe site.
For useful software and software news try visiting:
www.techpointer.com, www.techweb.com, www.apple.com,
www.digitaltoolbox.com, www.extensis.com

How this book was produced

In the mid-1990s I first heard news of a new Apple Macintosh computer. It used a new generation of computer chip, the PowerPC. At around the same time I watched the steadily growing numbers of digital cameras and also marvelled at the steadily dropping prices of scanners. I noticed that the number of models of digital cameras was nearly the same as the conventional single-lens reflex cameras available.

I made a decision. It was plunge time. It was the right time to take a financial dive and go digital. With the help of my partner – who specialises in beating up large, bullying institutions such as banks – I arranged what seemed like an enormous loan to fund the purchase of a basic outfit to create digitally manipulated images. It is largely on that original outfit, four years old as I write this, that I produced this book. It turned out to be a canny decision. By the time I actually knew how to use the programmes which I had bought and eagerly loaded onto the computer – which took well over two years – digital photography had come of age. There are now many more models of digital camera than single-lens reflex. Cameras costing less than a good quality SLR camera can give reproduction-quality pictures to at least half-page size … and my computer can be bought for a fifth of what it cost me.

The heart of the book's production is the Apple Power Macintosh 9500/120, which has been upgraded with a new processor card carrying a G3 chip working at 300MHz with 1MB of backside cache. In fact it works generally works twice as fast as it originally did. The original 2GB hard-disk, which seems rather tiny now, has been supplemented by a 4GB internal hard-drive – which seemed ample at the time but is now constantly full. The computer has 392MB of RAM and ran on the Mac OS 8.5 for most of the writing of the book. I view work on a Sony Trinitron 20" screen which has been calibrated to its nominal standards which has served as a good fit to printers we have used. The computer is networked with either a PowerBook G3 series running at 266MHz or a 333MHz iMac, depending on the kind of work I needed to do and which machine happened to be in the studio at the time.

For scanning, the mainstay of all my work is the excellent and so far totally reliable Nikon LS-2000 film-scanner. I still think its Kai-inspired interface is an irritating hindrance, but it produced excellent scans – or, better still, judge for yourself: nearly every image scan in this book was produced by the Nikon. I set it for an output resolution of 300-pixels-per-inch to match the 175 lpi screen specified for this book – giving files up to about 26MB in size. I set the defect-correction set to 'on', plus sharpen (to make up for the tendency of the dust-removal application to blur image detail) and an oversampling of 4x. Colour bit-depth was standard 8-bit. Scanning on the Nikon was slow, but the scanned images came out so clean I had hardly any work to do on them apart from slight tweaks of tonal reproduction.

The other scanner used was the Linotype-Hell Saphir Ultra II: this produced truly excellent scans from reflection originals. It was occasionally used for medium-format originals but I found it was stretched unless given perfectly exposed with a very average tonal range and average overall density.

The backbone for digital back-up was the combination of Jaz 2GB disks as well as a One Technologies CD-ROM writer. Other digital storage systems used were the now obsolete but still functioning SyQuest EZ135 (it seemed a good buy at the time). And for compatibility with others not so well endowed, I use Zip 100MB disks. For proof-printing, I worked both the Epson Stylus Photo and Photo EX printers very hard.

Obviously, the mainstay software for this book was Adobe Photoshop, in version 5 for almost all of the time with some late work done with a beta release of version 5.5. Other manipulation software used was Equilibrium DeBabelizer: useful for resizing and renaming pictures in batches. My favourite MetaCreations Painter version 5 was unfortunately not greatly used for this book, but contributed to a couple of images. Extensis utilities which were useful included PhotoTools for improving the Photoshop interface and Portfolio for organising my image files.

On the photographic front, my main cameras are the Canon EOS-1n (with 17-35mm f/2.8L, 20mm f/2.8, 24mm TS, 28-70mm f/2.8L, 50mm f/3.5, 80-200mm f/2.8L and 300mm f/4L IS lenses) and Leica M6 (with 35mm f/2 lens), with occasional use of a Rolleiflex SL66 (50mmf/4 and 80mm f/2.8 lenses), Nikon F70 (with the excellent 70-180mm Micro-Zoom lens) and a Mamiya 645 ProTL (75mm f/2.8 lens) for 6x4.5cm negatives – perfect for nude studies. The black & white films most relied on are Ilford's Delta 400 and XP-2 Super. For colour slides, my current preference is for Kodak Ektachrome Elite 100. Black & white prints were made on a De Vere 203 or a Leica Focomat V35 enlarger, mostly using Ilford Multigrade or Agfa Record-Rapid.

Acknowledgements

The key to writing books at the leading edge of developments is to keep one chapter ahead of everyone else. If this book succeeds in bringing together the exciting developments in the cost-effective access to technology with the know-how and craft skills of traditional photography, it is in no small measure due to my privileged access to experts in their field (also themselves expert in keeping one or two chapters ahead). Many thanks, then, to Simon Joinson, editor of What Digital Camera magazine, for his encyclopaedic knowledge and willingness to share so much of it with me. And thanks also to Eddie Ephraums, who knows more than he will admit to (which is wise).

To colleagues who arranged sabbatical leave which enabled me to complete this and other projects go my thanks: Professor Brian Winston, Professor Paddy Scannell and Andy Golding. Other colleagues I am pleased to thank are: Shirley O'Loughlin, for so competently taking over the course leadership; Matthew Williams, for his habit of opening new conceptual windows for our delight and to Catherine McIntyre, for her e-mails which enliven the day.

Manufacturers and distributors have generously contributed to the success of this project both directly and indirectly: it is, after all, their risk-taking, investment and vision that have given us the tools to haul the protesting darkroom into the digital light. A range of Extensis software (e.g. Portfolio) as well as Equilibrium's DeBabelizer from Computers Unlimited helped throughout. Nikon's LS-2000 scanner was indispensable as was their superlative 70-180mm Micro-Zoom lens. From Linotype-Hell came the fine Saphir Ultra II scanner. Finally, Ilford ensured availability of their ever-excellent XP-2 and Delta 400 films.

To my publisher, Gary: many thanks for your faith in the book and your efforts on its behalf.

Leaving the greatest debt to last, I thank Wendy for her support as well as judicious whip-cracking – both of which ensured this book actually got started, then written at all.

Tom Ang
London

Index

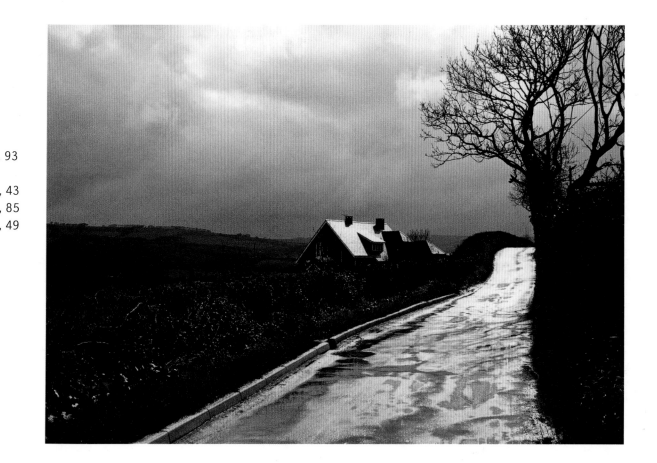